# New

# Mexico II

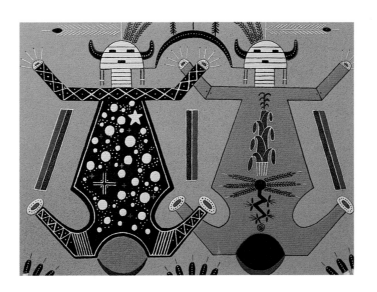

# NEW
# MEXICO II

FOREWORD BY FREDERICK TURNER

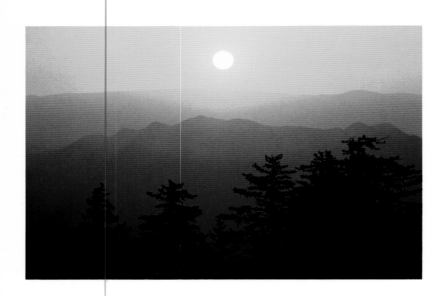

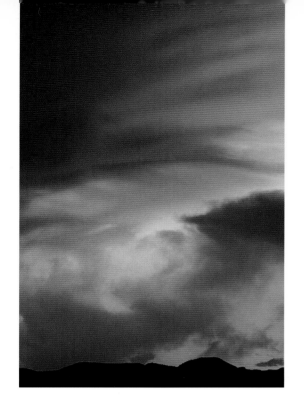

PHOTOGRAPHY

BY

■

DAVID  MUENCH

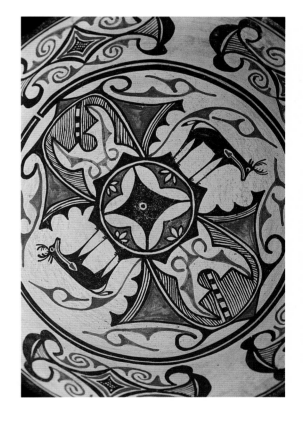

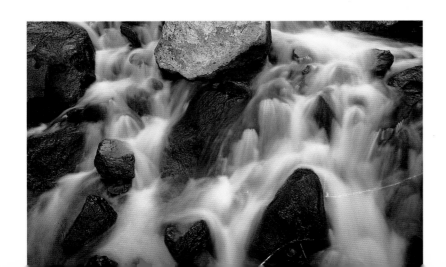

INTERNATIONAL STANDARD BOOK NUMBER 1-55868-048-9

LIBRARY OF CONGRESS NUMBER 91-71771

© MCMXCI BY GRAPHIC ARTS CENTER PUBLISHING COMPANY

P.O. BOX 10306 ■ PORTLAND, OREGON 97210 ■ 503/226-2402

PRESIDENT ■ CHARLES M. HOPKINS

EDITOR-IN-CHIEF ■ DOUGLAS A. PFEIFFER

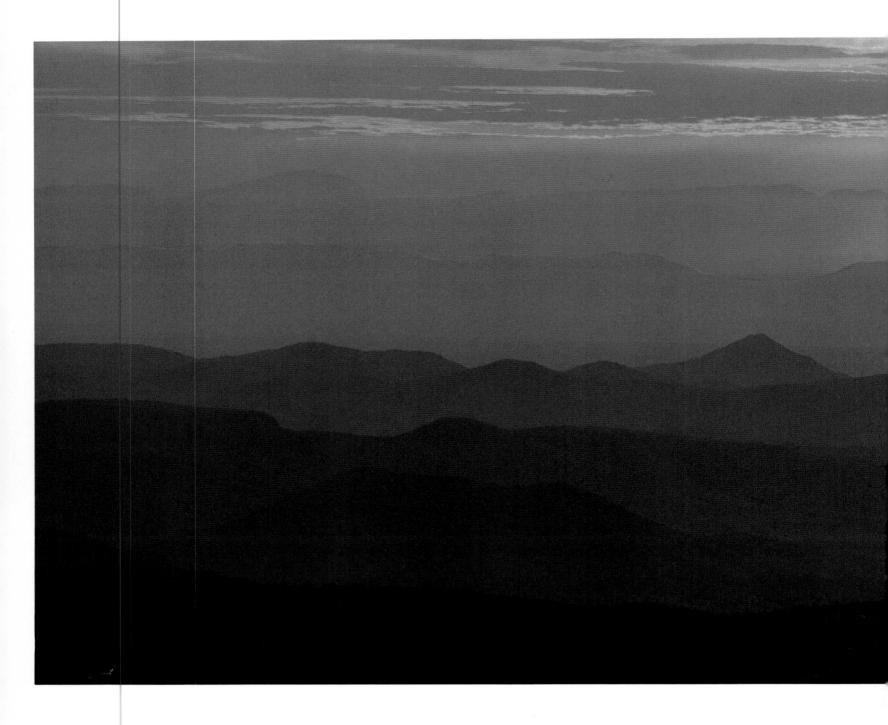

MANAGING EDITOR ■ JEAN ANDREWS

DESIGNER ■ BONNIE MUENCH

CARTOGRAPHER ■ MANOA MAPWORKS

TYPOGRAPHER ■ HARRISON TYPESETTING, INC.

SEPARATIONS ■ WY'EAST COLOR, INC.

PRINTER ■ GRAPHIC ARTS CENTER, INC.

BINDERY ■ LINCOLN & ALLEN

PRINTED IN THE UNITED STATES OF AMERICA

■

*BELOW: RIDGES EXTEND EAST ACROSS THE VALLEY OF*

■

*THE RIO GRANDE FROM THE BLACK RANGE,*

■

*ALDO LEOPOLD WILDERNESS.*

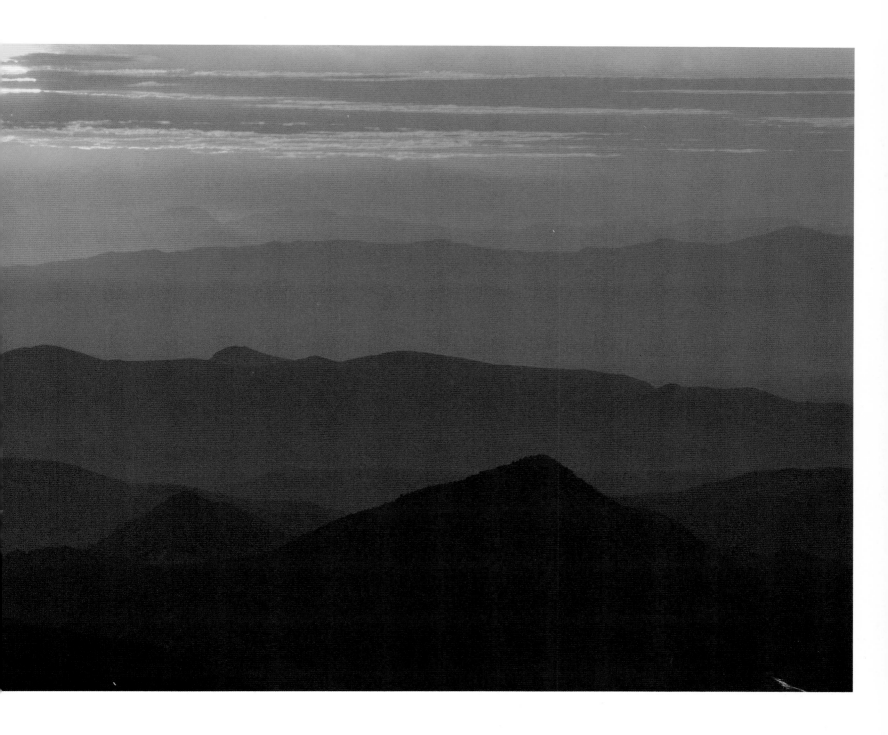

*DEDICATION: TO THE PEOPLE*

*WHO KEEP THE UNIQUE SPIRIT*

*OF TRADITIONS ALIVE IN NEW MEXICO.*

# NEW MEXICO

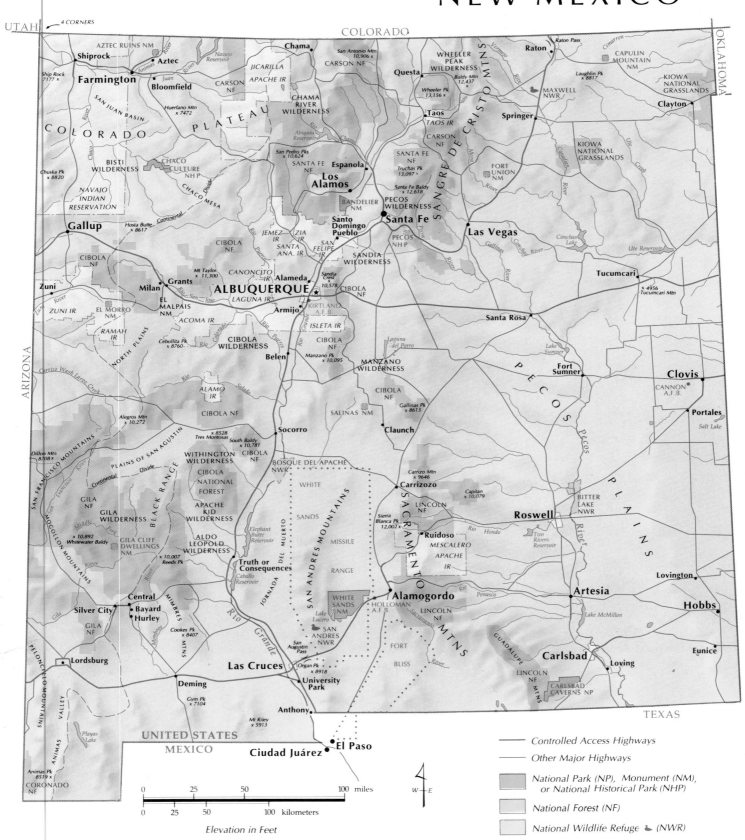

Controlled Access Highways

Other Major Highways

National Park (NP), Monument (NM), or National Historical Park (NHP)

National Forest (NF)

National Wildlife Refuge (NWR)

Elevation in Feet

BELOW: EROSION SCULPTURES IN THE CLAY HILLS OF

SAN JUAN COUNTY, BISTI BADLANDS WILDERNESS.

FOLLOWING PAGES: CUMULUS REFLECT IN POOL, TULAROSA VALLEY.

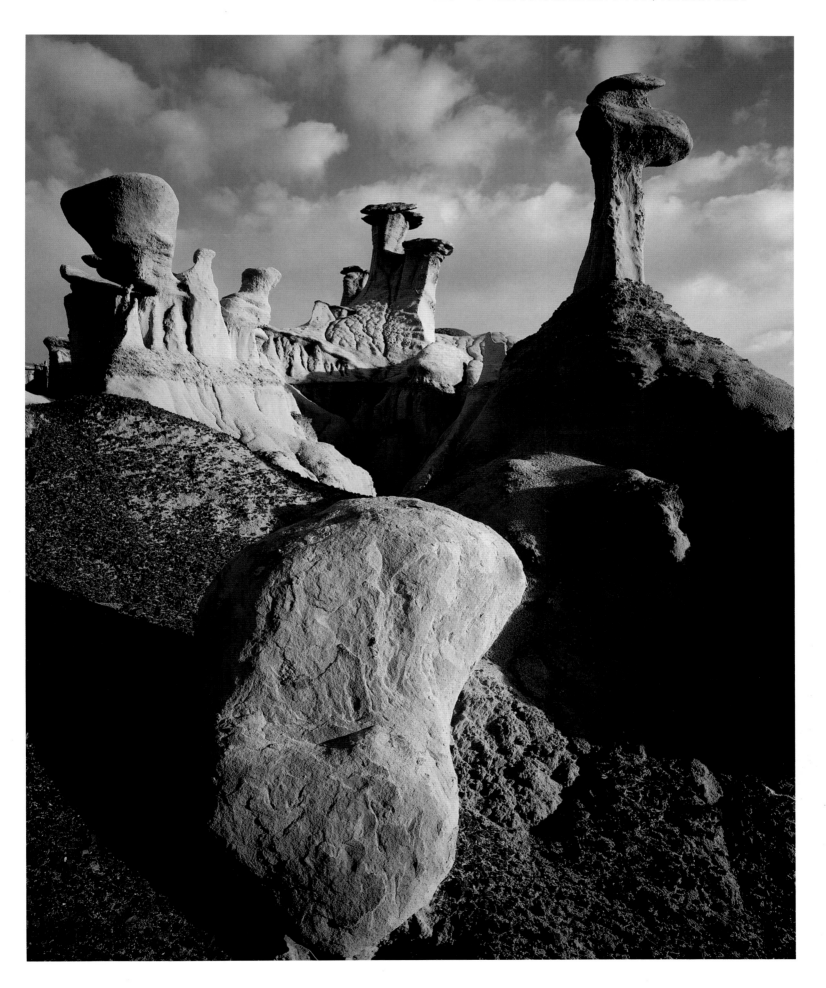

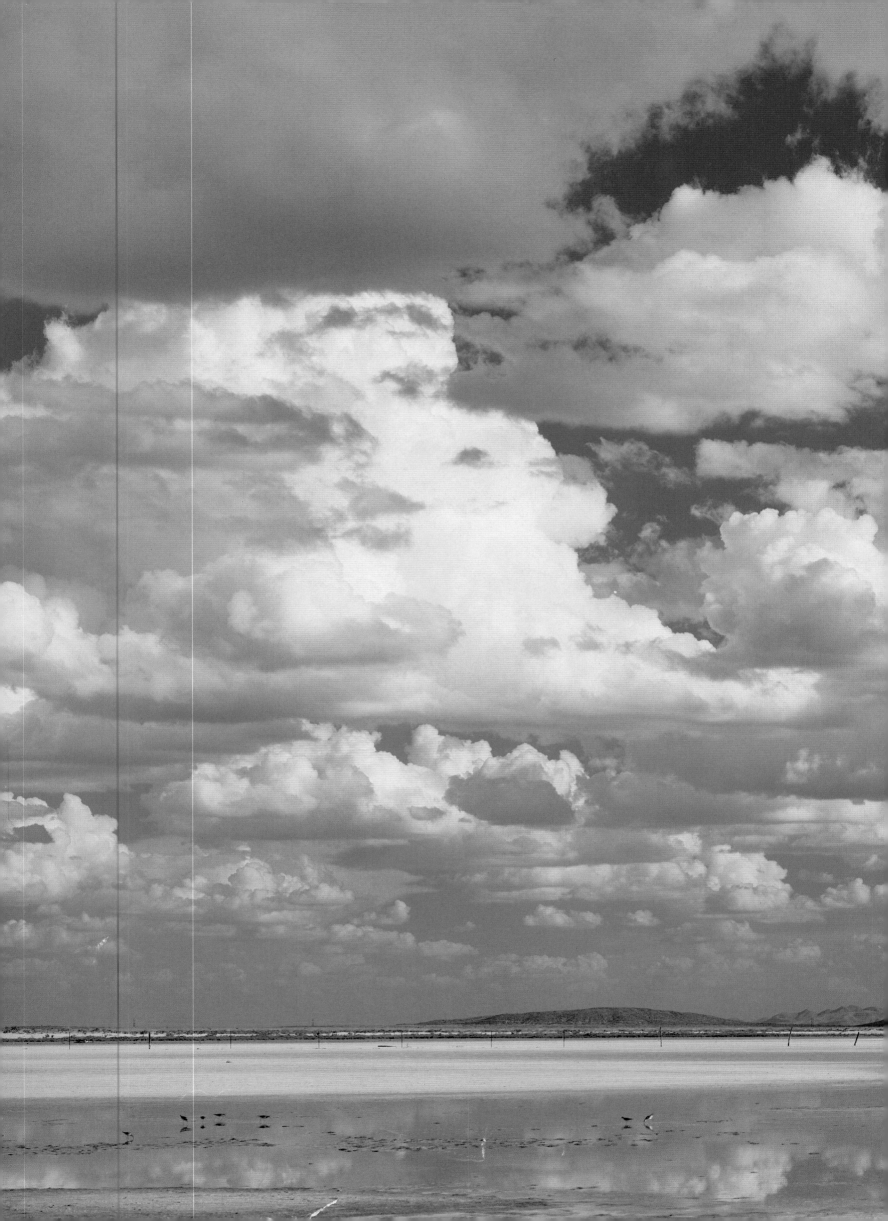

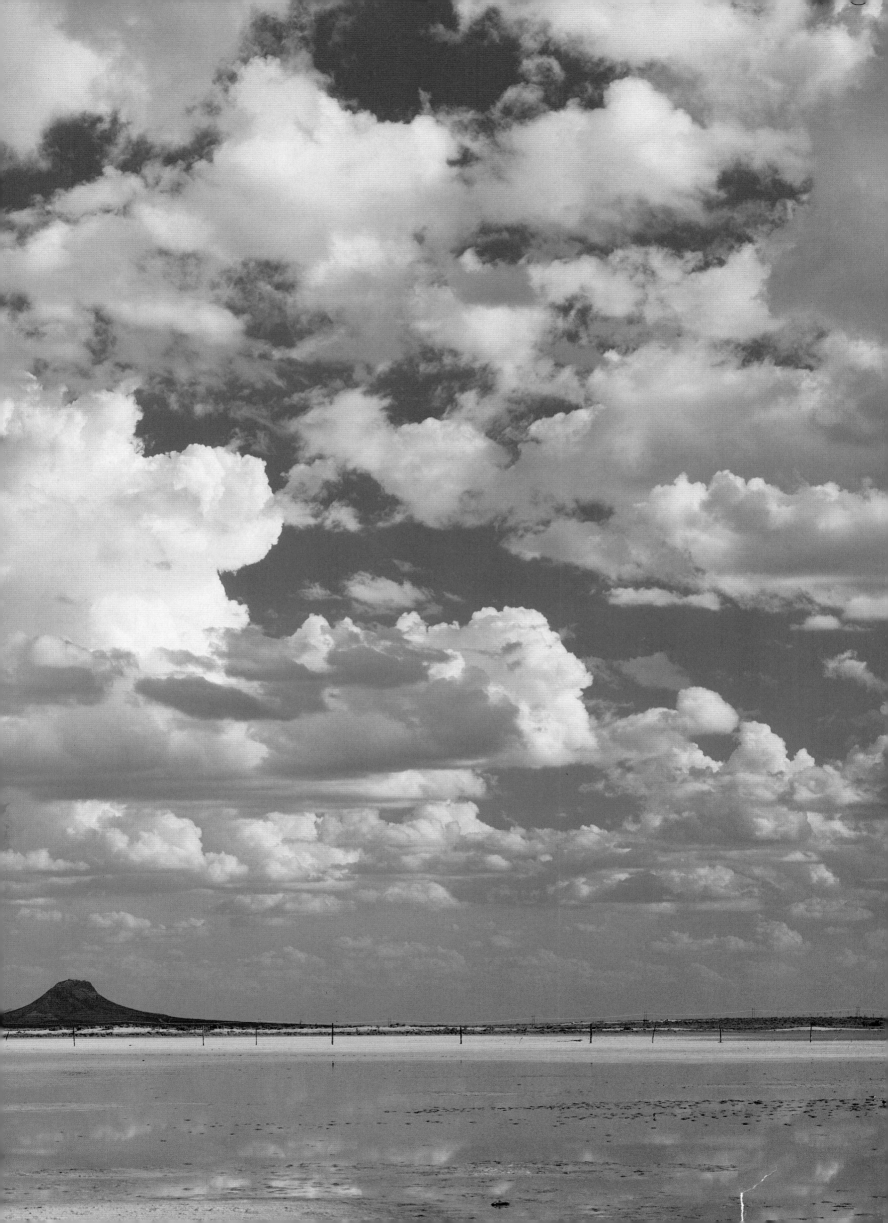

## NEW MEXICO

For some years now, David Muench has been influencing my behavior. I don't mean personally, for I have never met him. I mean through his images that celebrate what is perdurable about the American West. This began in 1975, when I was living in what I believed to be the heart of the country—New England, with all its colonial associations; its slanting, slate tombstones speaking in blurred syllables of the past; its craggy, humanized landscape. In the late winter of that year, I got pneumonia—again. It was the third time in the last five years.

The happenstance enraged me, and my patient and gentle wife was forced to avert her gaze as I lapsed into a period of loutish self-indulgence, often tumbling fully clothed into bed midafternoons, hoping to sleep until health or springtime. One day, I dragged myself into a Concord, Massachusetts, bookshop on some obscure errand and there purchased the biggest, sunniest book I could lay hands on. Then, back in our drafty old farmhouse, I dived into the Muench/Tony Hillerman evocation of New Mexico. "This summer," I said to my wife after I had rushed through the book, "if I'm still alive, we're going to go there!" And we did.

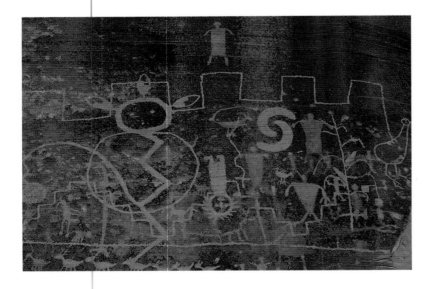

This, so help me, explains how it was that we happened to end up living in this place, and if David Muench had done nothing else for me, I would still feel that special kind of debt you feel toward someone whose work has changed your life but whom you have never met. I wonder if this isn't the most genuine kind of debt you can feel, because there can be nothing of the ultimately personal in it: just the work itself.

On that first trip to New Mexico in the summer of 1975, we packed along Muench's book. We had its images in our heads like a vivid, pointed road map as we cleared New England into the Adirondacks, fragile-seeming in this late-coming spring, with only the faintest blush of buds to clothe the trees and slopes.

Coming out of Iroquois country with its marvelous names—Oneida, Oswego, Canandaigua—and still thickly wooded enough to allow us to imagine that fierce empire, we were mostly thinking ahead to blue skies, mesas, and the descendants of the Anasazi. We clung desperately to those images through the blighted stretch of Lake Erie's eastern shore with its rusting cities and mills, the lakeshore itself littered with a poisonous harvest of dead fish—Hamburg, Erie, Ashtabula, Cleveland; then continued across the flatnesses of Indiana and eastern Illinois that once had seemed so promising in their prairie openness to pioneers who had hacked their ways out of the eastern hardwood forests.

West of the Illinois River, we felt as if we were truly on our way—the skies opening, widening; grain elevators, silos, and Aeromotor windmills replacing smokestacks and shopping malls as mile markers. Going over the Mississippi is, of course, the real rite of passage, for on its other side, the West begins, and we weren't daunted by the fact that we had all of Iowa to go yet, most of Nebraska—that all-day sucker—and Colorado, too. Nor do I recall that we felt at all foolish at our excitement over this micro-reenactment of the nation's central historical experience, westering: that, I think, is testament to the power it still has for many of us.

At last we entered New Mexico at the tiny settlement of Los Pinos, but what I remember is San Antonio Peak, rolling west of the road, a grand blue whale with new aspens like harpoons on its back. That and a wind-whipped little gas station where the proprietor squinted into the blowing dust and muttered to no one in particular,

"Well, if it didn't blow, I guess I don't know what it would do."

That summer from a rented three-room cabin in the Pecos wilderness, we explored New Mexico, using Muench as a kind of guide: his work is not prescriptive and denotative but, instead, suggestive and connotative, and this is always the best sort of material to have when coming into a country. We took day-hikes northward along narrow trails through dense aspen groves where the straight beige boles were dusty with pollen and scored by elks' teeth. We dipped into mountain lakes so cold they made your body burn; when you emerged from their soft, mucky bottoms, you were yellow with the rotted residue of generations of woody decay and felt a little like an elk yourself.

In July and August, there were daily afternoon rains that announced themselves at ten in the morning by heavy, blue-edged billows to the north over Pecos Baldy and Truchas Peak. By one o'clock, rain had begun to drum on the roof in big, hard pellets that often solidified into hail, whitening the meadow before us. Then the creeks would bulge, and our gravity-flow tank would silt up if I hadn't remembered to disconnect the line from the spring. Inside the cabin, the dampened aspen logs sent up a smoky, fitful blaze from the copper-sheathed fireplace.

We went south into Lincoln County and Billy the Kid country, watching the land change aspect on our way down, the firs quickly giving way to piñon and juniper and then only juniper, the patches of barren soil growing larger, the sun more insistent. Finally in the Capitans outside Lincoln, all this was arrested, and an alpine habitat reasserted itself for a final time before the Chihuahuan Desert said, "This is mine." East of Lincoln, along the Bonito, we stopped for a sweating jug of black-cherry cider at a roadside stand. I thought we must be close to the place where the Kid and his "posse" executed two members of the rival faction in the Lincoln County War and asked the cider seller if this weren't so. He didn't know about that, but he had plenty of other Kid stories he could tell me if I wished.

We went west to Acoma, clambered partway up Mesa Encantada, and waited for the sun to clear the top of the mesa and break into the tumbled red lands to the west. In the Jemez Mountains we were in ponderosas again and well-watered parks like those of the Pecos. Valle Grande, the immense caldera, looked like an English bowling green from the road above it—except for the tiny brown dots that were grazing cattle. Still farther west we entered the time-frozen sphere of the Anasazi at Chaco Canyon where the ruins stood silent, apparently as enduring as the sky above them, the *metates* set down by the doorsills as if their owners had merely wandered away on some casual errand and would presently return to surprise our trespass.

We did not explore eastward. I think this was because we knew that, too soon, that was the way we would have to return from all this—as indeed we did when autumn's first frosts spangled the meadow grasses and laced the aspen leaves with gold. One morning, when we found that a leak in the water line had frozen into a tiny menhir of ice, we knew further delay was futile.

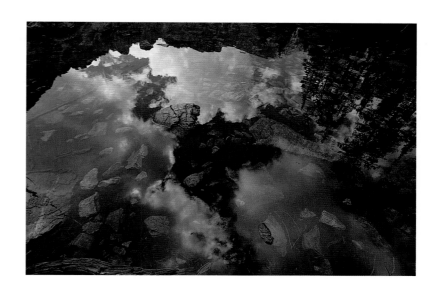

That was then, and though I have now been privileged to live in the magic of New Mexico for more than a decade, I have never gotten over that primitive sense of wonder it occasioned when first I met it in Muench's photographs and then in our explorings of that summer. Nor have I become immune to Muench's capacity to evoke that magic.

On a recent Sunday, I was looking through the images of this second New Mexico book when I came across those

of the petroglyphs in Galisteo Basin, some twenty miles south of where I live. Until that moment, I had not realized that an impatience had been kindled within me as I gazed upon Muench's photographs of mission ruins, clay washes, rippled dunes, and river bends shimmering in the sun. But now it blazed out: what was I doing inside when I could be out in this very country? I knew where the Galisteo Basin petroglyphs were. In minutes, I could put my hands on them.

Half an hour later, I was in the Galisteo Basin, but not at the site where Muench photographed the warrior figures with their shields. His images preserve what is authentic there, but the site has been so vandalized by the clumsy forgeries of modern-day rock artists that it is depressing, rather than inspiriting. Where I was in the basin was just as surely white man's land now, part of a cattle ranch below Lamy, but on this blue February day, it looked unvisited and undamaged, and I felt confident it would be mine to enjoy in solitude.

Before me lay a long, level expanse of grama grass, the twisted cruciforms of the cholla cacti, and—a mile or so southwest—a hogback ridged with junipers and boulders. Behind me, the Sangre de Cristos rose in blue and white-shouldered splendor. Under my feet, the red clay of northern New Mexico, now breathing again and sloughing at the end of winter, spilling open in cracks and tiny rills, the exuviae of our globe here.

I hadn't walked ten minutes before I began to pick out the potsherds this spring earth movement had exposed. Scattered fragments of aboriginal industry, they lay in little villages, their dark markings still quite visible against their lighter backgrounds and all of them stained by the same earth out of which they had been fashioned, by hands now themselves gone back to earth. Each time I stepped across them, I felt compelled to stop, to stoop and gather, to hold them in hand, if only for a moment, as if the fragments were due at least some pausing gesture of respect. As I neared what I took to be a herder's abandoned stone-and-adobe cabin, the sherds abruptly gave out, replaced by the remains of the white man's implements: heavy, sun-blackened bits of tin that were now twisted into unrecognizability.

The plain was cut east to west by an arroyo with forty-foot drops in places. In the shadows produced by the sheer banks and the junipers that clung to them, there were coyote tracks in purposeful, straight trot lines. Beyond the arroyo, the grasses straggled away into the hogback's stony slope that near its summit still had a few hold-out patches of shank-deep snow, though we hadn't had more than a spit since the holidays.

On the ridge's southern side, the land fell steeply away to the plain again, and the wind, swooping over that expanse, gathered up dust and chaff and flung it against rocks that rose ever more sharply as the ridge tended west. Stones stained a fresh lime white told me ravens hung out here, but there seemed no other sign of life until, with one hand resting on a sun-warmed rock, I looked straight into the face of the New Mexico past once again. It was a petroglyph, a faded, gray, snakelike shape against the rock's dusty chocolate, still making its obscure statement who knew how many hundreds of years after it had been carved on a day perhaps much like this one. In those intervening years, the world, America, and the West had all been profoundly altered. In the West, the tribes and wildlife had dwindled away or entirely vanished, roads had been punched across arid spaces, rivers diverted or dammed or sucked dry, and urban centers created where former inhabitants had not thought there was enough water to sustain so much as a village. From where I now stood before the ghostly carving, I could see Los Alamos where an even more profoundly altering device had been created.

And yet some things had endured beneath or beyond change, and the carving was reminding me of that, even as a jet from Kirtland Air Force Base hurtled through the blue on a steep trajectory. Surely, one of the primary functions of art is to do this reminding of what is, and must be, enduring—whether it be in the form of petroglyph or photograph. And though the American West lies under the threat of changes greater than those that have already transpired, there is still the great and heart-breakingly beautiful land, still the human impulse to create something in celebration of it, for the human to say not only, "I was here," but also, and more significantly, "I was *here*."

BELOW: A NOVEMBER EVENING CURTAIN OF BLUE

DESCENDS ON THE TRES HERMANAS

MOUNTAINS, LUNA COUNTY.

▲

BELOW: A RAGGED-EDGED AA LAVA FLOW IN EL MALPAIS NATIONAL

▲

MONUMENT CONTRASTS WITH THE NAVAJO

▲

SACRED PEAK OF MOUNT TAYLOR, CIBOLA COUNTY.

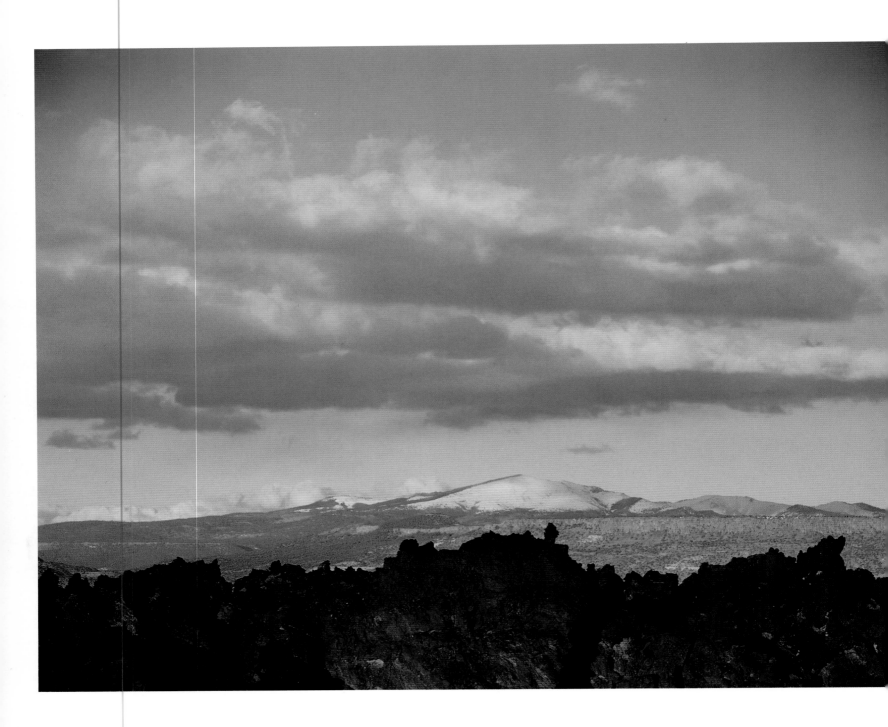

RIGHT: THE SANDSTONE SPAN OF A VENTANA ARCH CATCHES

THE LAST OF A FEBRUARY SUN IN CIBOLA WILDERNESS,

EL MALPAIS NATIONAL MONUMENT.

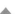

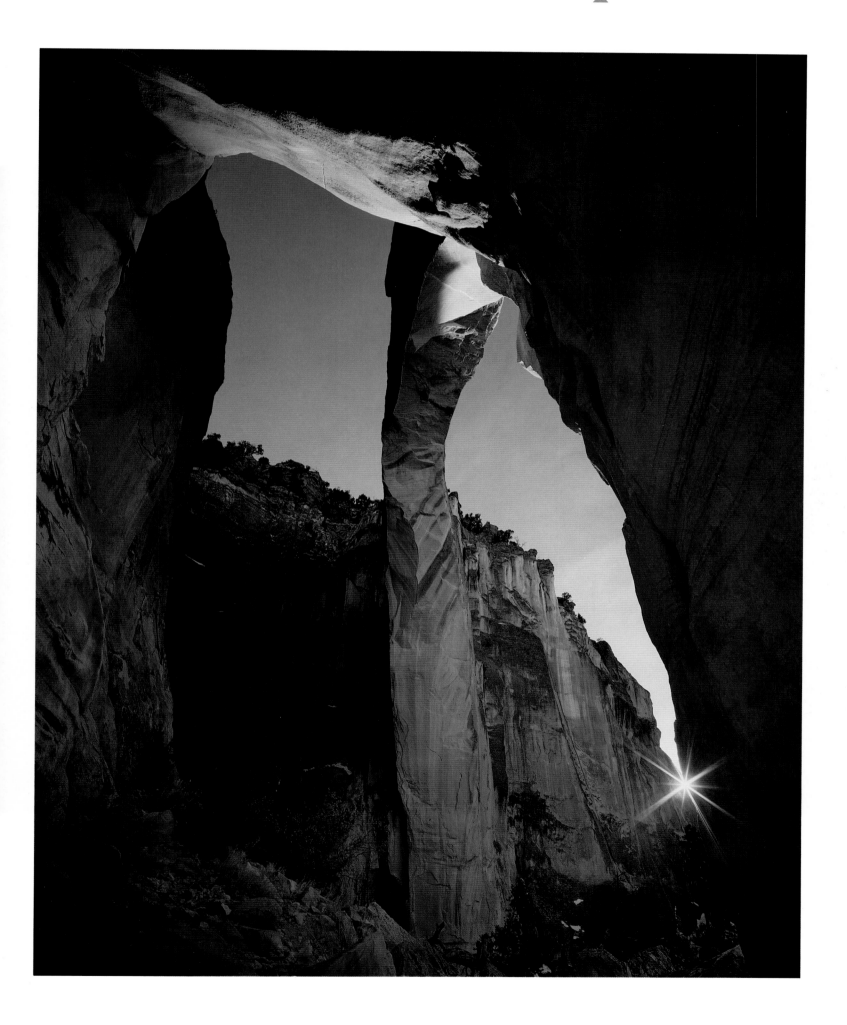

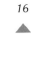
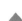

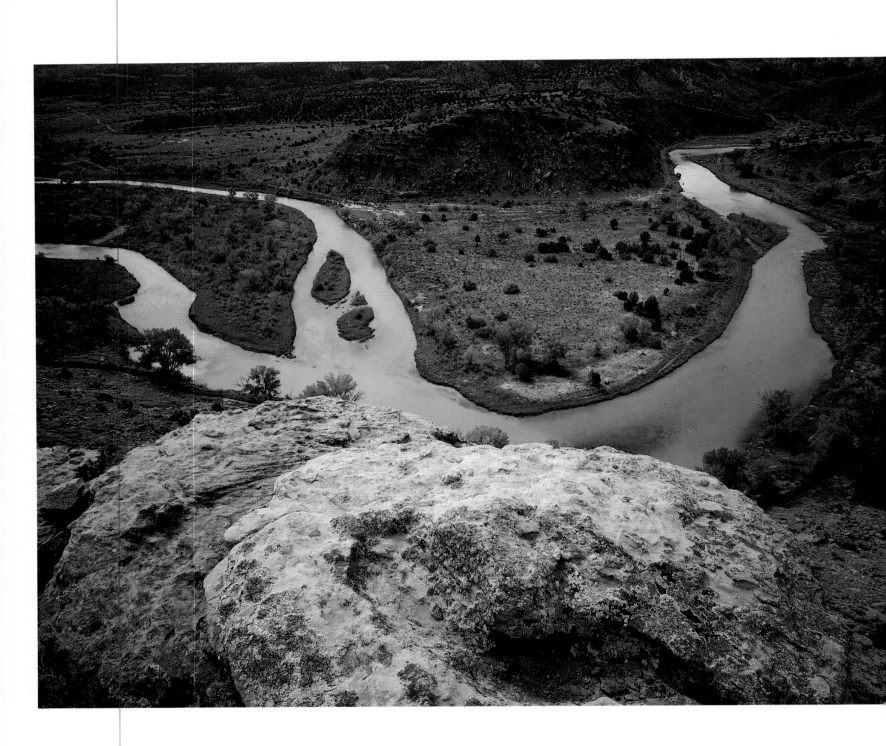

▲

*BELOW: CEREMONIAL KIVA DESIGNS OF THE PUEBLO*

▲

*BONITO RUIN FROM THE SANDSTONE RIM,*

▲

*CHACO CULTURAL NATIONAL HISTORICAL PARK.*

*THE ANASAZI OCCUPIED THIS TRADE CENTER IN*

*THE ELEVENTH AND TWELFTH CENTURIES.*

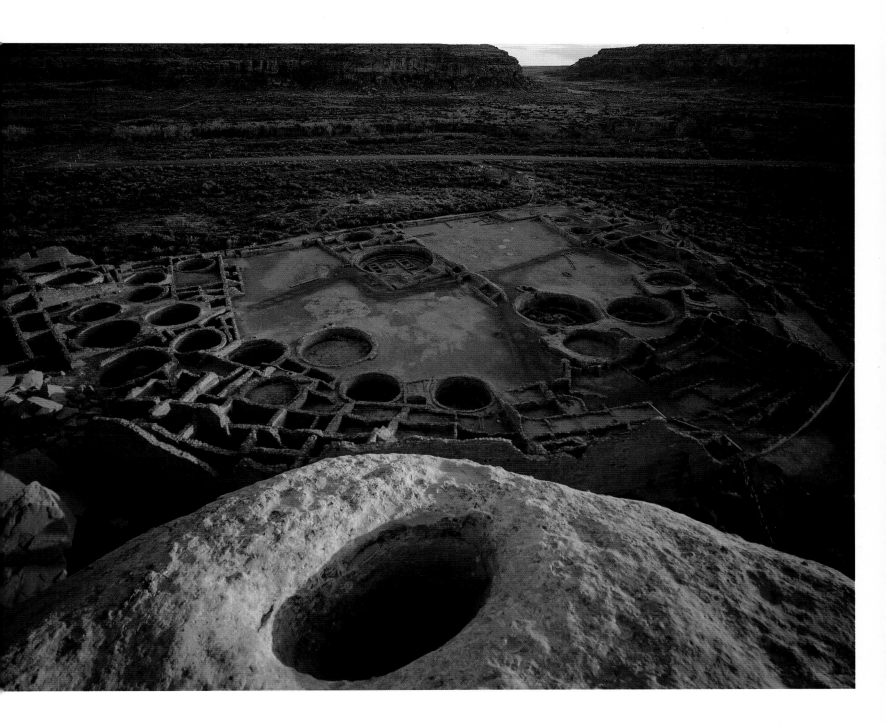

▲

*LEFT: A LATE SEPTEMBER FLOW OF THE CHAMA RIVER*

*IN THE JEMEZ MOUNTAINS, AS IT ENTERS*

*THE UPPER RIO GRANDE VALLEY, RIO ARRIBA COUNTY.*

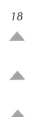

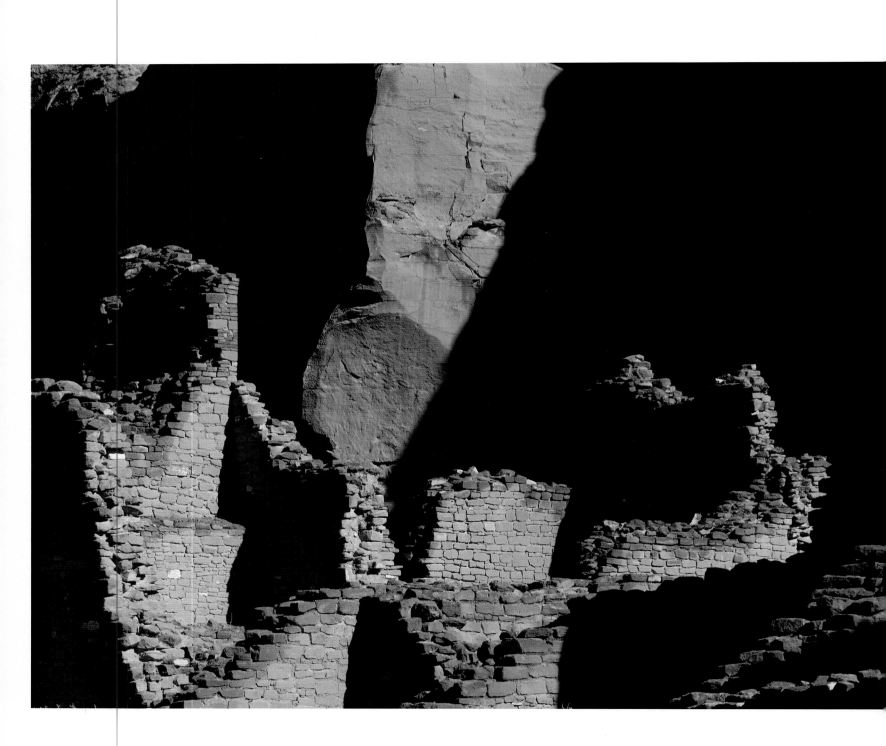

BELOW: A MAY EVENING CLOUDBURST ILLUMINATES

TWELFTH-CENTURY RUIN WALLS AND KIVA AT PUEBLO BONITO,

CHACO CULTURAL NATIONAL HISTORICAL PARK.

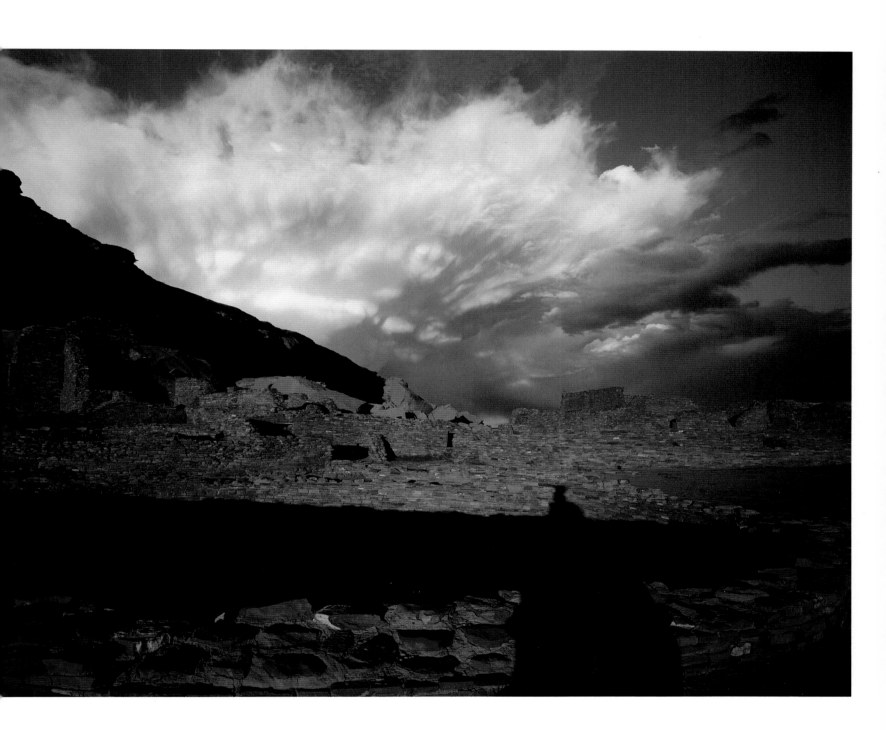

LEFT: A DESIGN OF SEPTEMBER MORNING LIGHT

ON A SANDSTONE WALL AND RUIN.

WALLS OF KIN KLETSO MAKE A TIMELESS IMPRESSION,

CHACO CULTURAL NATIONAL HISTORICAL PARK.

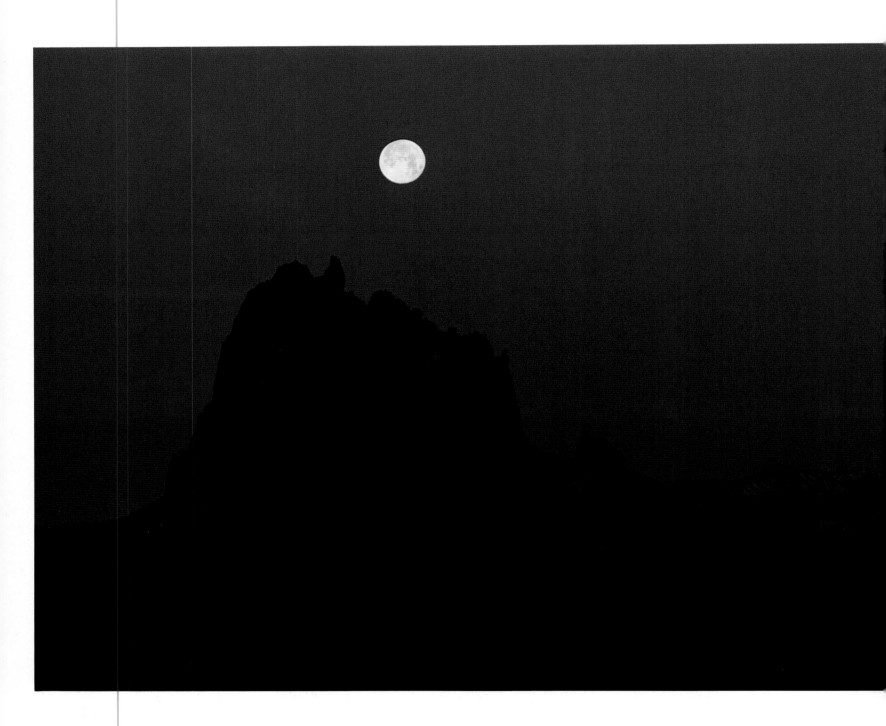

BELOW: KIVA WITH AN EVENING ILLUMINATION IN THE

CEREMONIAL CAVE, FRIJOLES CANYON,

BANDELIER NATIONAL MONUMENT. THE SITE IS FROM

THE LATE FOURTEENTH AND FIFTEENTH CENTURIES.

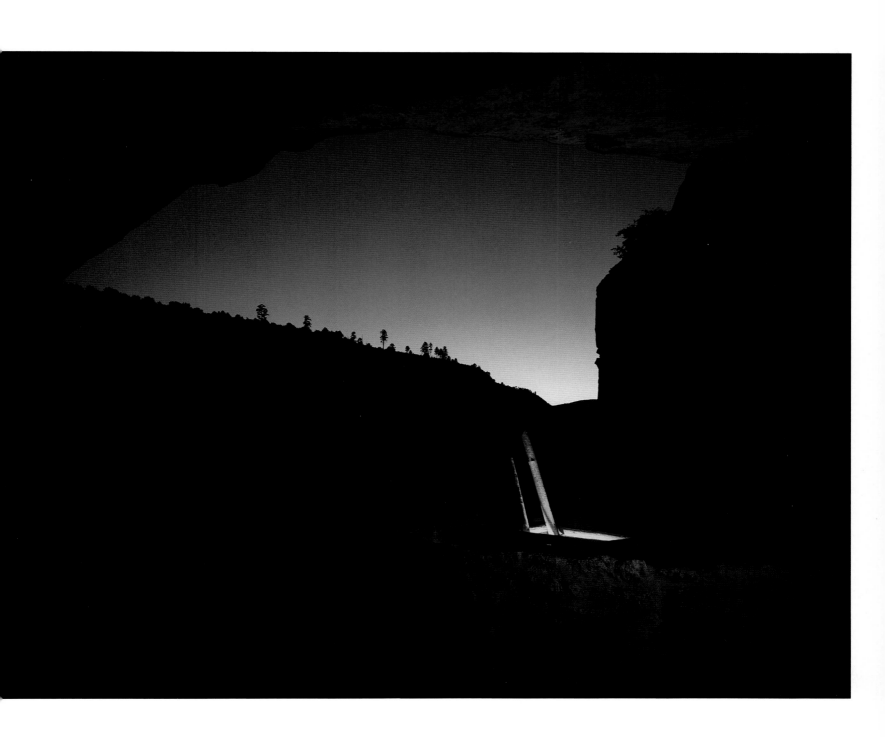

LEFT: A FEBRUARY MOON SETS AT DAWN

OVER THE IMPOSING LANDMARK OF

SHIPROCK, A FOURTEEN-HUNDRED-FOOT

VOLCANIC REMNANT IN SAN JUAN COUNTY.

▲

*BELOW: AN APRIL SUN HIGHLIGHTS A THIRTEENTH-CENTURY*

▲

*KIVA IN THE CEREMONIAL CAVE ALONG THE*

▲

*PAJARITO PLATEAU, BANDELIER NATIONAL MONUMENT.*

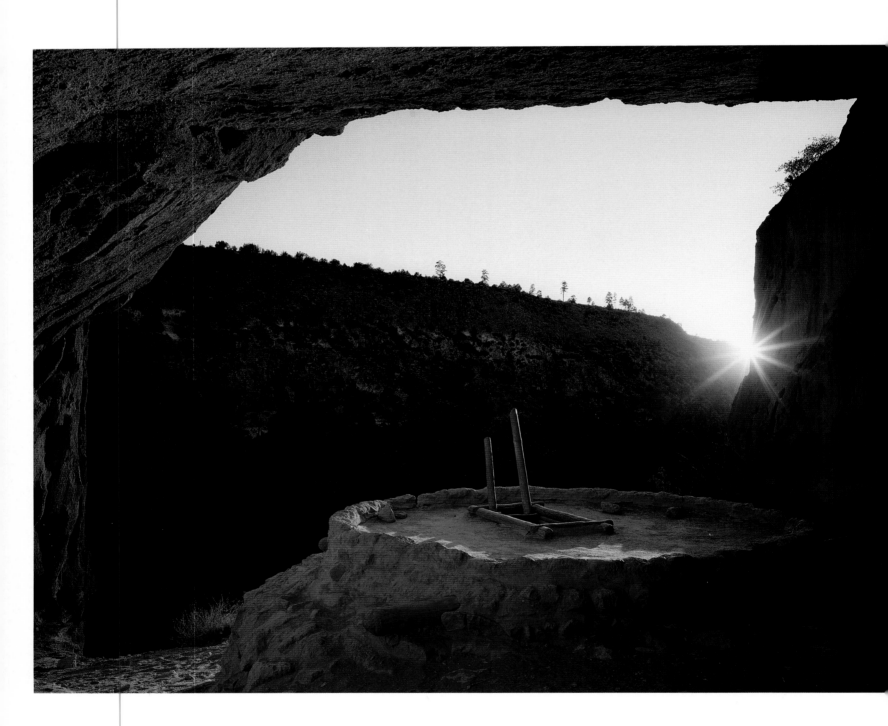

▲

*RIGHT: PERCHED ON A SANDSTONE BOULDER,*

*THE CITADEL RUIN IS A MASONRY NAVAJO*

*REFUGEE SITE FROM THE EIGHTEENTH CENTURY,*

*FOUND IN THE LARGO AND GOBERNADOR REGION.*

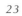
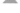

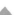

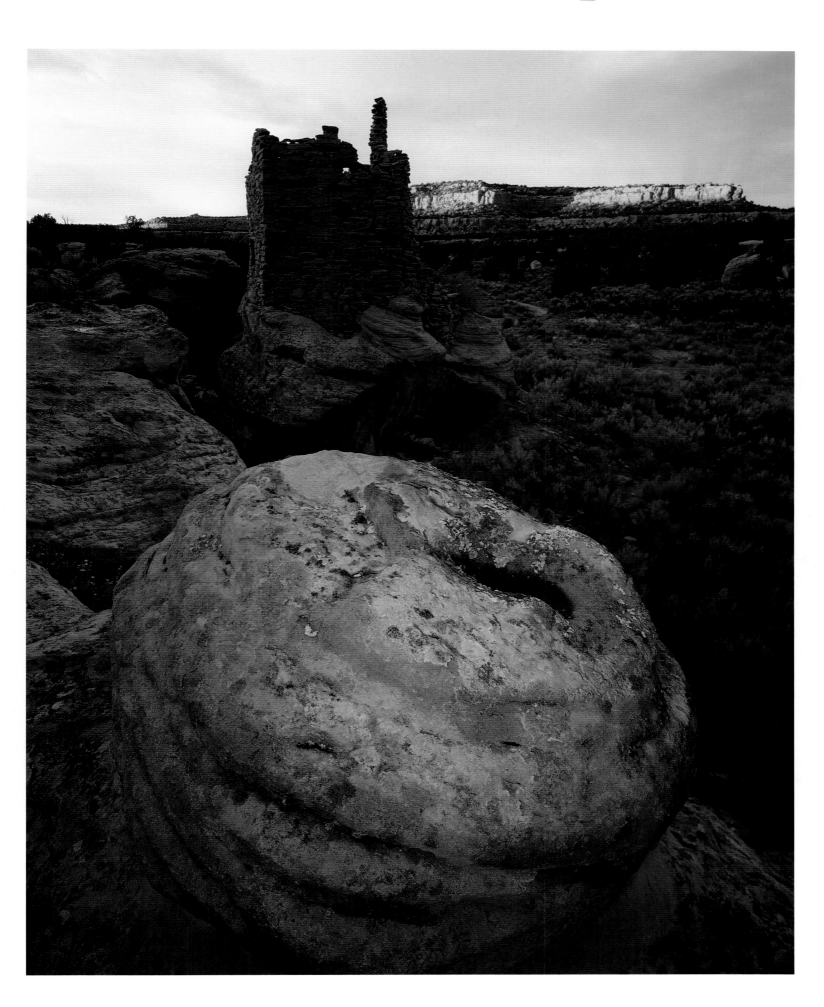

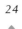

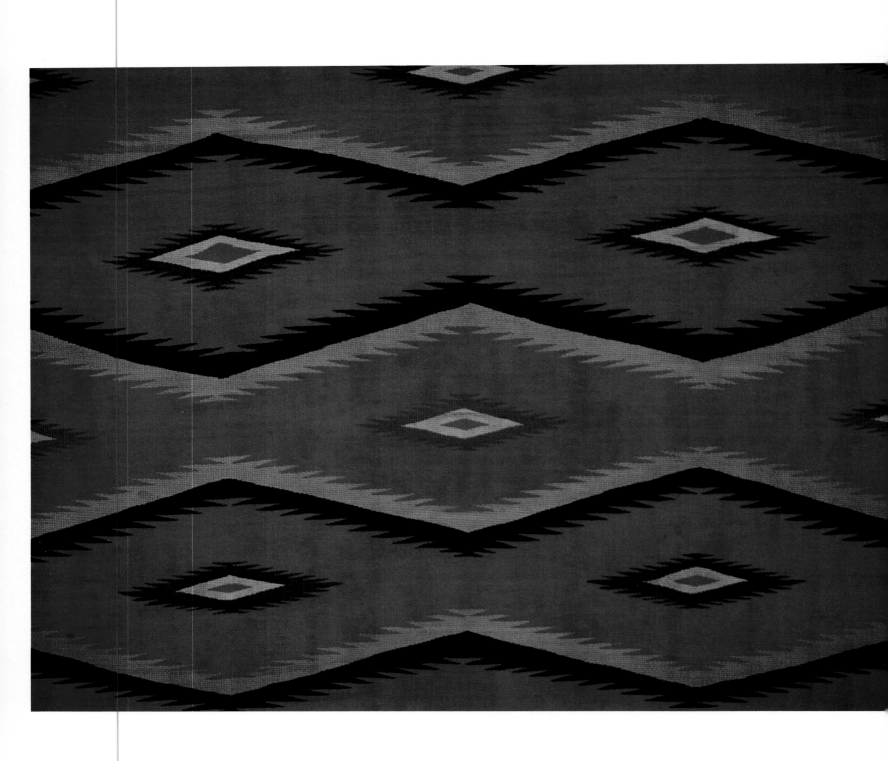

▲

BELOW: AN EVENING SKY IN JULY CREATES A FLAMBOYANT MOOD

▲

OVER THE LARGO SCHOOLHOUSE RUIN IN LARGO CANYON.

▲

THE DWELLING IS A NAVAJO REFUGEE SITE.

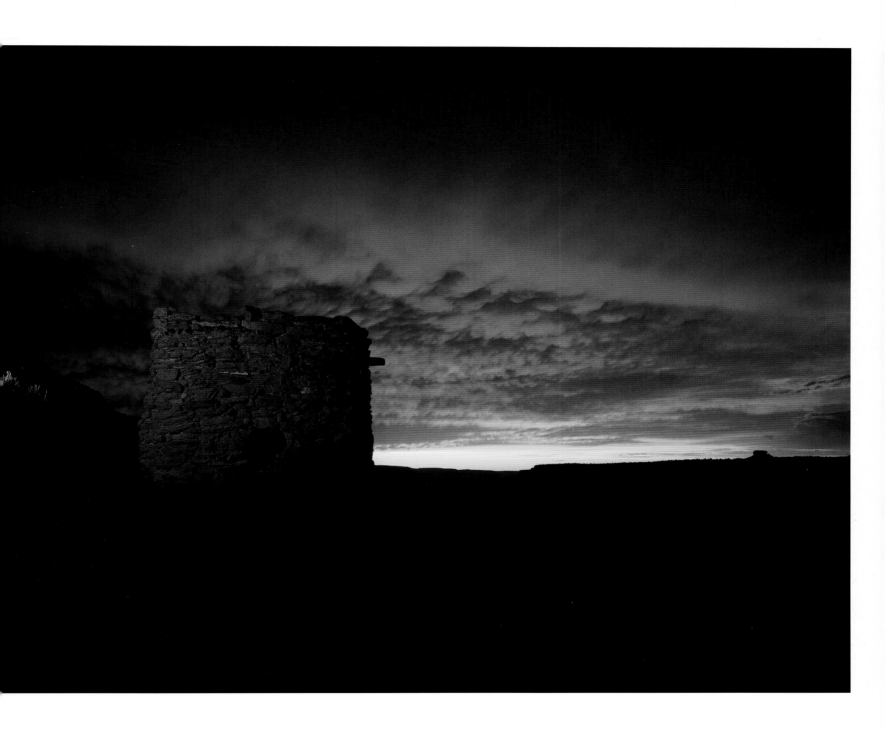

▲

LEFT: THE BRILLIANT DESIGN OF THIS 1880 NAVAJO

WEAVING FROM THE TRADITIONAL PERIOD HANGS

AT THE MUSEUM OF INDIAN ARTS AND CULTURE, SANTA FE.

▲

*BELOW: A REMNANT OF A FIVE-MILE-LONG VOLCANIC DIKE*

▲

*FRAMES THE LANDMARK KNOWN AS SHIPROCK*

▲

*IN FOUR CORNERS COUNTRY, SAN JUAN COUNTY.*

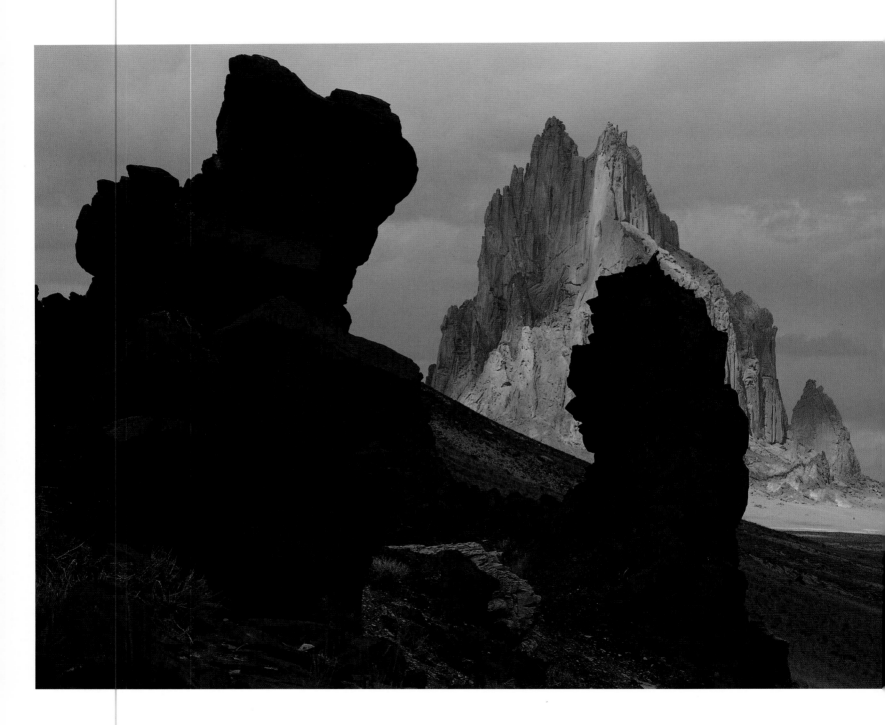

▲

*RIGHT: COAL AND CLAY SILTS MINGLE*

*IN A DRY WASH OF BISTI BADLANDS WILDERNESS,*

*FOUR CORNERS COUNTRY.*

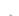

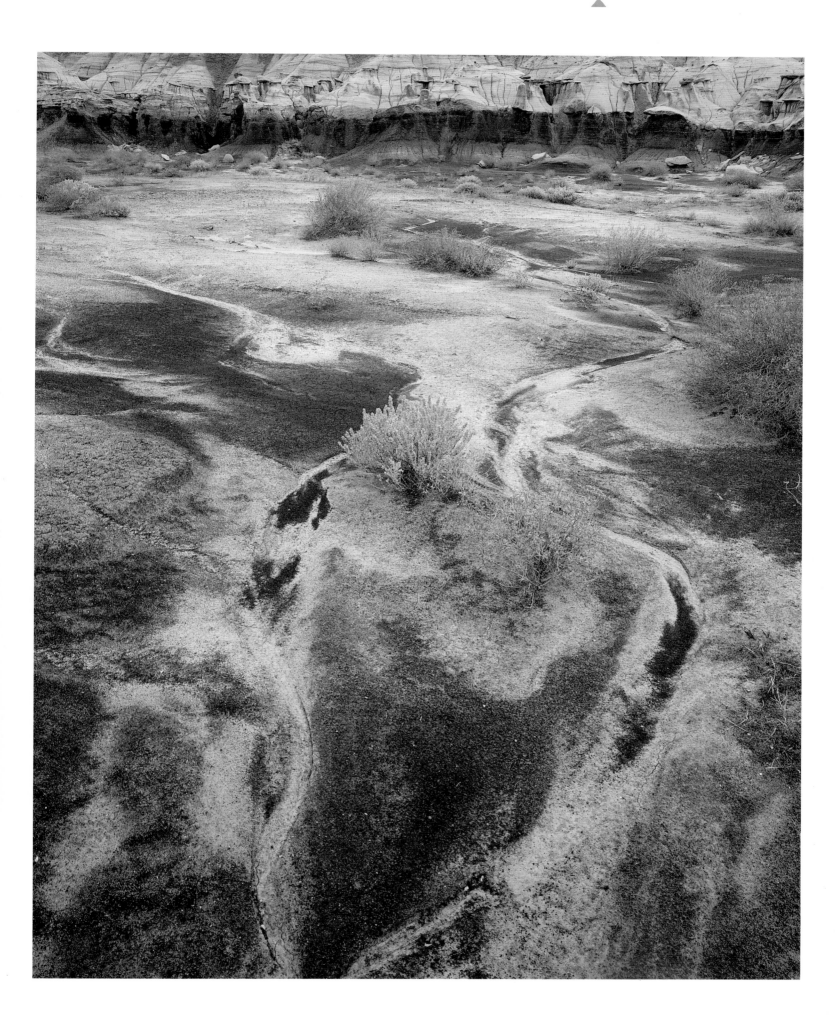

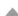
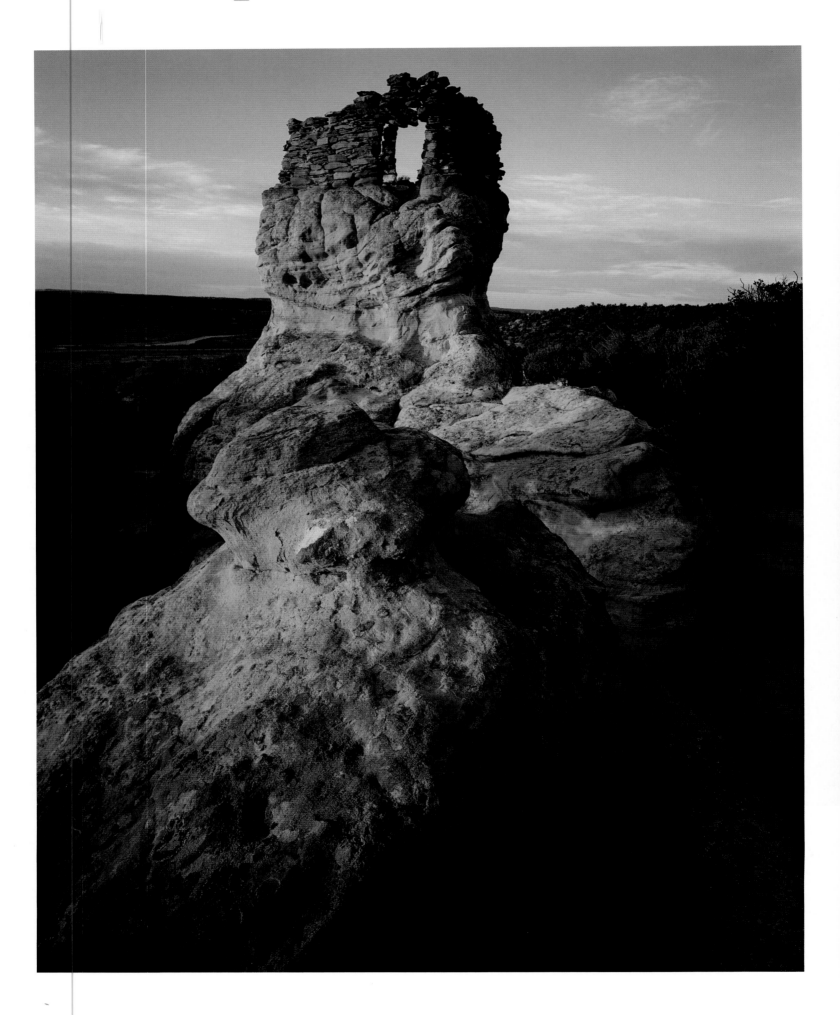

▲

*BELOW: THE VOLCANIC SCHOONER OF SHIPROCK*

▲

*FLOATS ON A SEA OF MAY SUNFLOWERS,*

▲

*AFTER SPRING RAINS IN SAN JUAN COUNTY.*

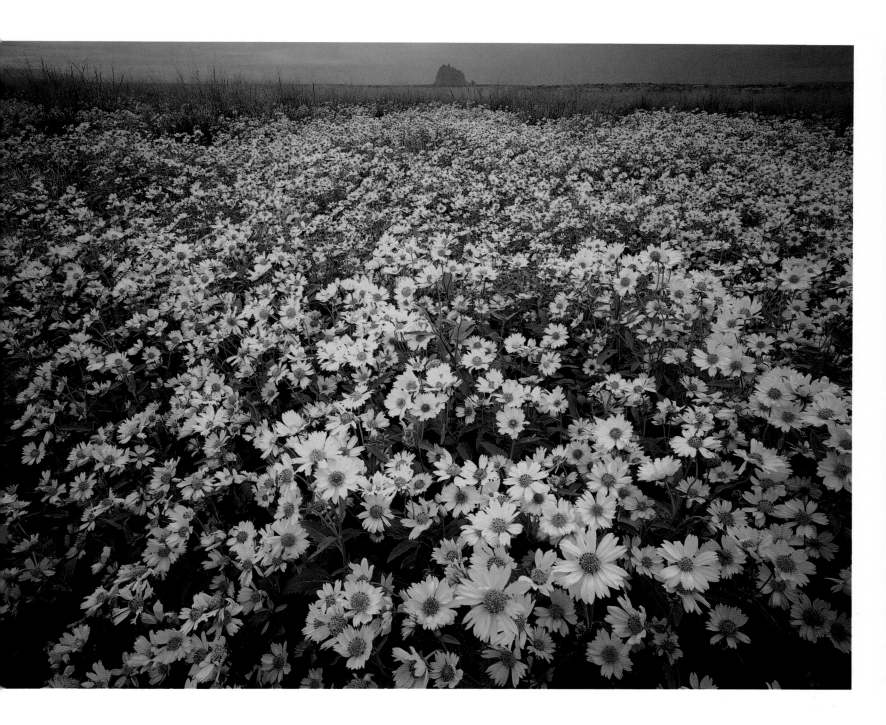

▲

*LEFT: AN EIGHTEENTH-CENTURY NAVAJO REFUGEE RUIN*

*OF KIN YAHZE SITS PRECARIOUSLY ON A SANDSTONE*

*PEDESTAL ALONG THE RIM OF LARGO CANYON.*

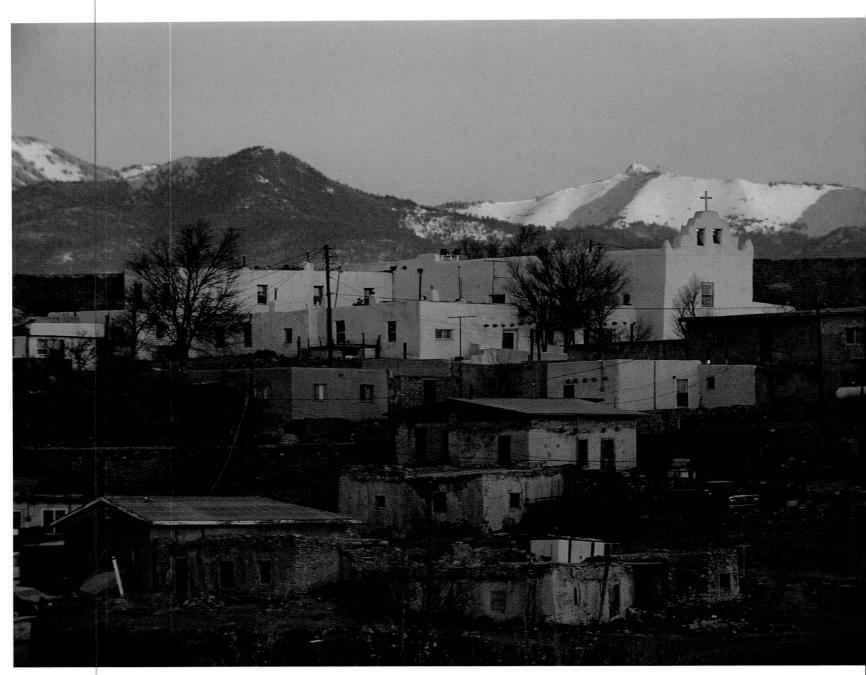

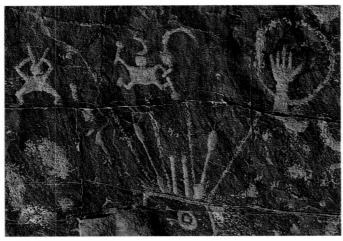

▲

BELOW: THE LAST GLOW ON AN AUGUST THUNDERSTORM

▲

ABOVE THE CONTINENTAL DIVIDE TO THE EAST

▲

CONTRASTS WITH A NAVAJO DEFENSIVE MASONRY RUIN

ALONG GOBERNADOR CANYON.

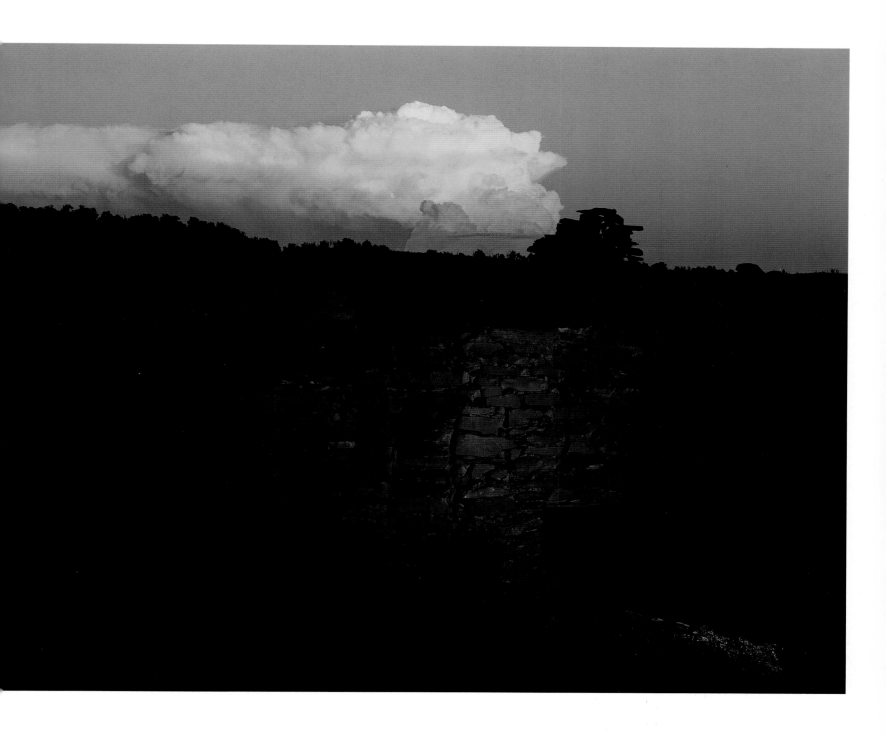

▲

UPPER LEFT: FEBRUARY DAWN LIGHT ILLUMINATES

CONTEMPORARY PUEBLO OF LAGUNA AND MOUNT TAYLOR.

LOWER LEFT: ANASAZI PETROGLYPHS

ADORN A SANDSTONE FACE ABOVE

RIO PUERCO DRAINAGE, SANDOVAL COUNTY.

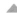

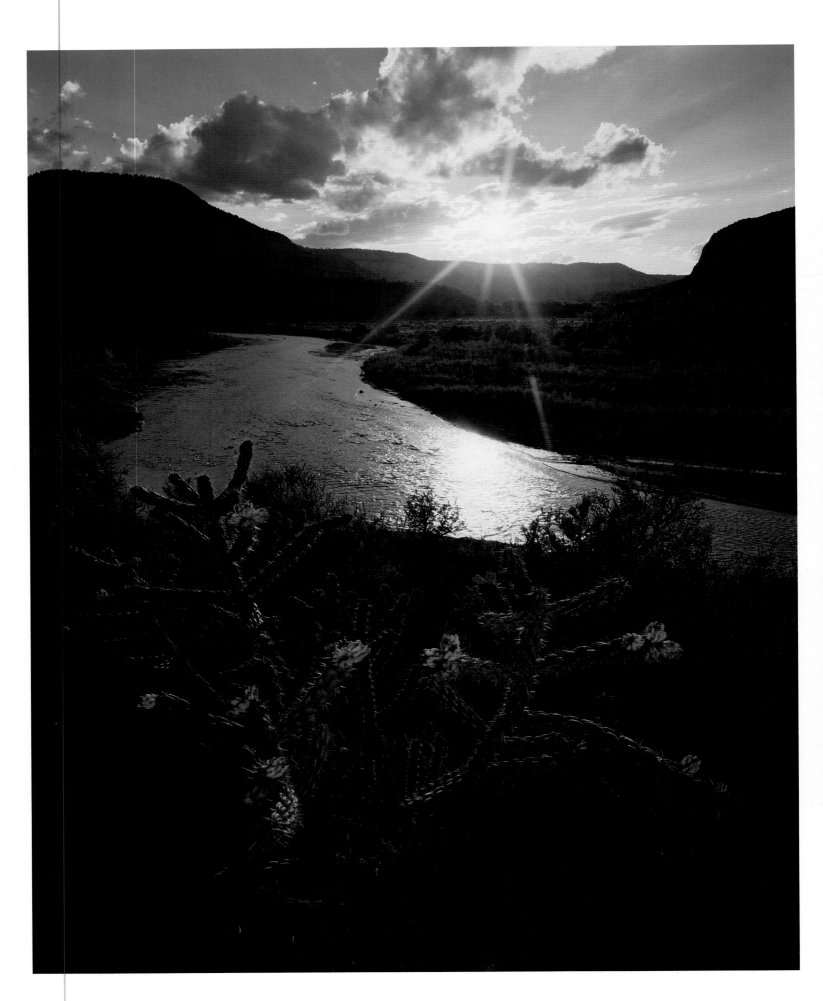

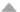

BELOW: AN APRIL DRIZZLE IN JEMEZ RIVER CANYON

ENHANCES VOLCANIC TUFA FORMATIONS AND

FRUIT TREE BLOSSOMS IN A PRIVATE GARDEN BELOW.

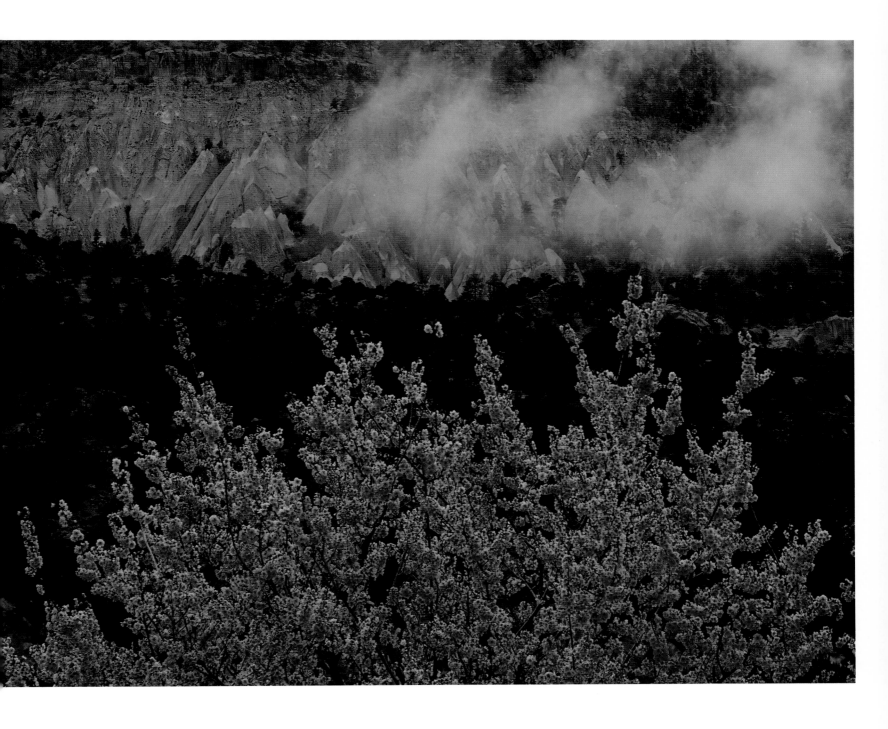

LEFT: A DESERT COMMUNITY OF CANE CHOLLA AND SAGE

BORDERS A MAY FLOW OF THE WILD AND SCENIC

CHAMA RIVER NEAR CHRIST OF THE DESERT MONASTERY.

▲

*BELOW: A TWENTIETH-CENTURY ADOBE MASONRY*

▲

*GENTLY MELTS BACK INTO THE LAND*

▲

*ALONG THE JEMEZ RIVER, SANDOVAL COUNTY.*

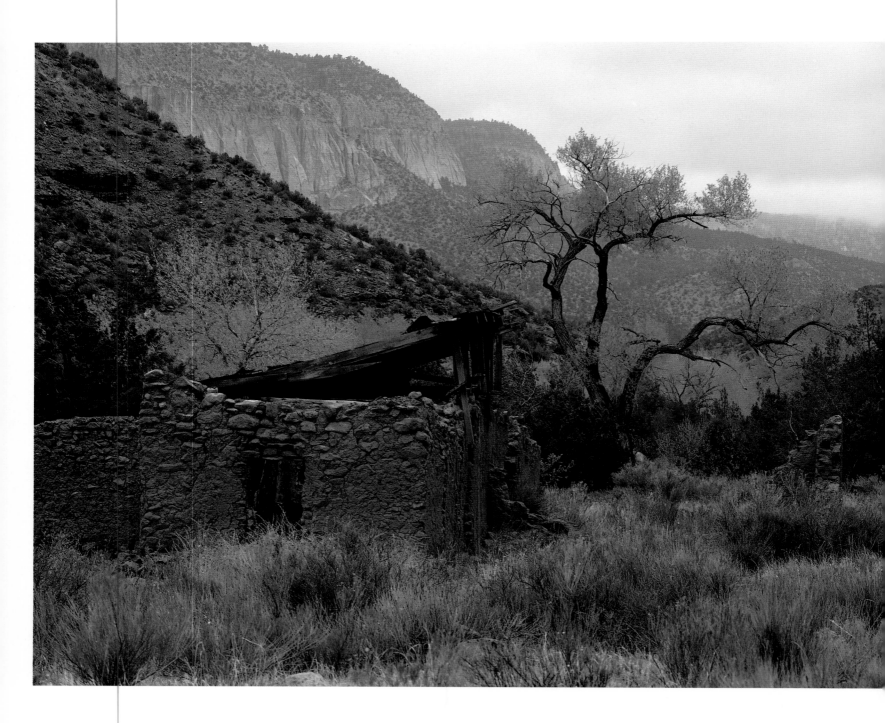

▲

*RIGHT: IN SEPTEMBER, CATTAILS, MULIEN, AND GRASSES*

*LINE A COOL MOUNTAIN POOL ALONG*

*CANJILON CREEK, A TRIBUTARY OF THE CHAMA RIVER.*

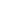
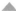
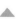

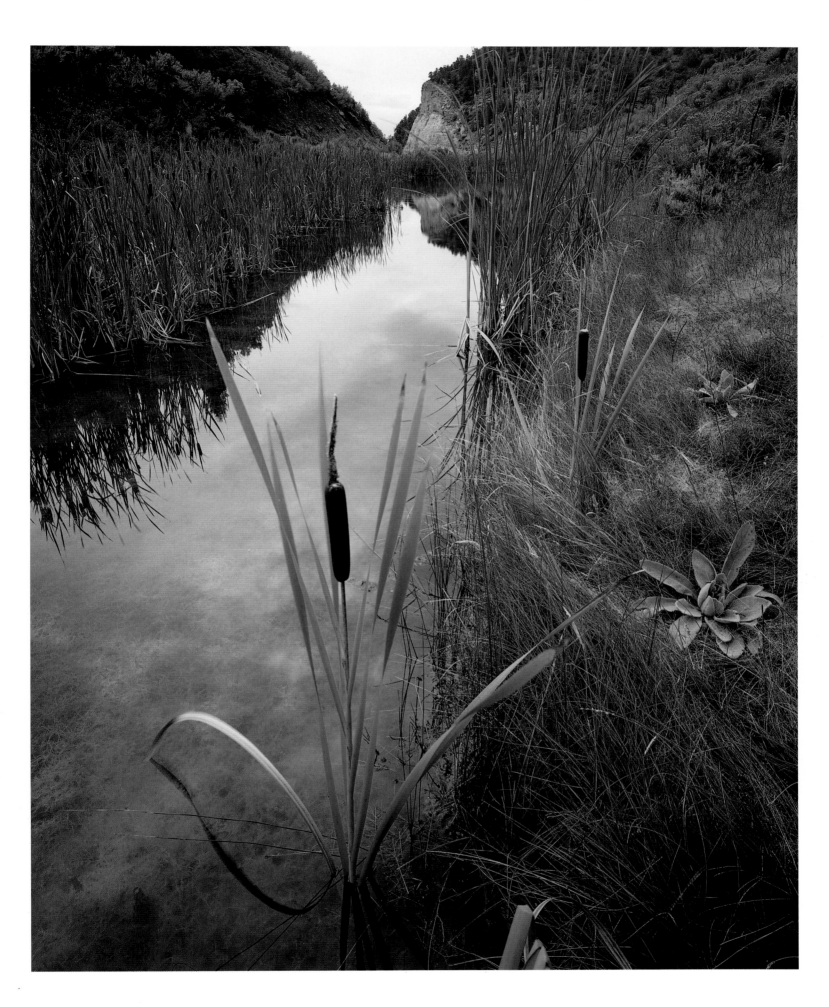

BELOW: THE UPPER JEMEZ RIVER HAS CARVED

A NATURAL BRIDGE OUT OF A HOT SPRINGS FORMATION,

JEMEZ SPRINGS STATE MONUMENT.

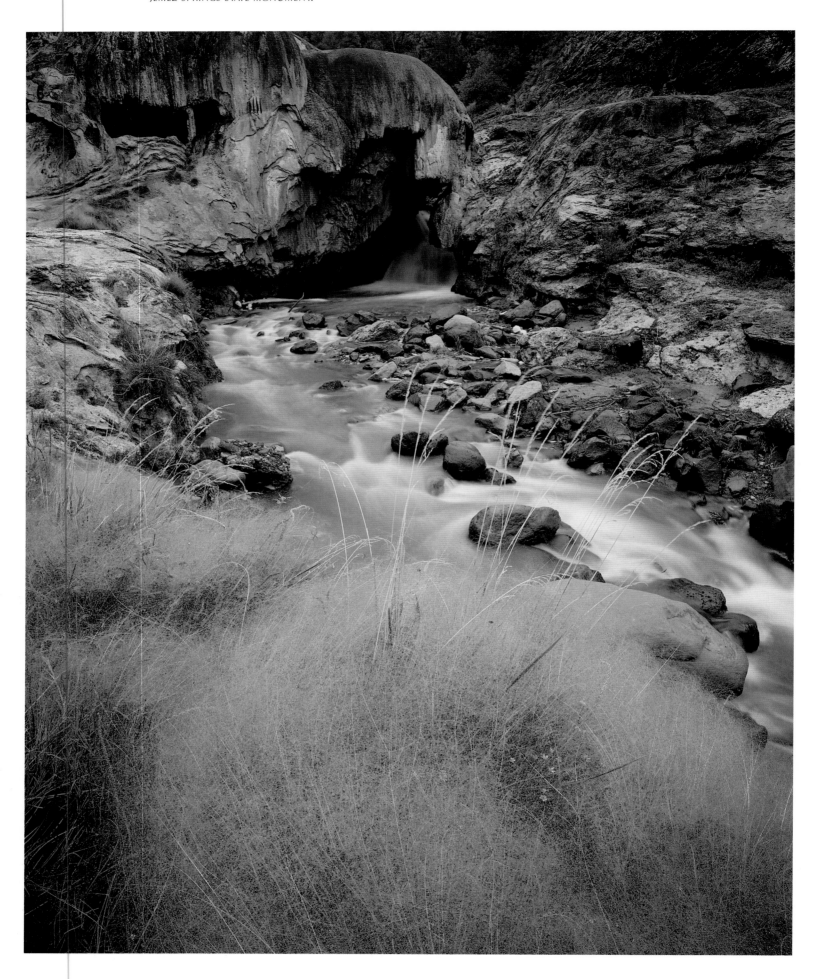

BELOW: A LICHEN-COATED VOLCANIC BOULDER STANDS

AMID THE LUSH GREENS OF SPRUCE FOREST

AND MEADOW, VALLE GRANDE, JEMEZ MOUNTAINS.

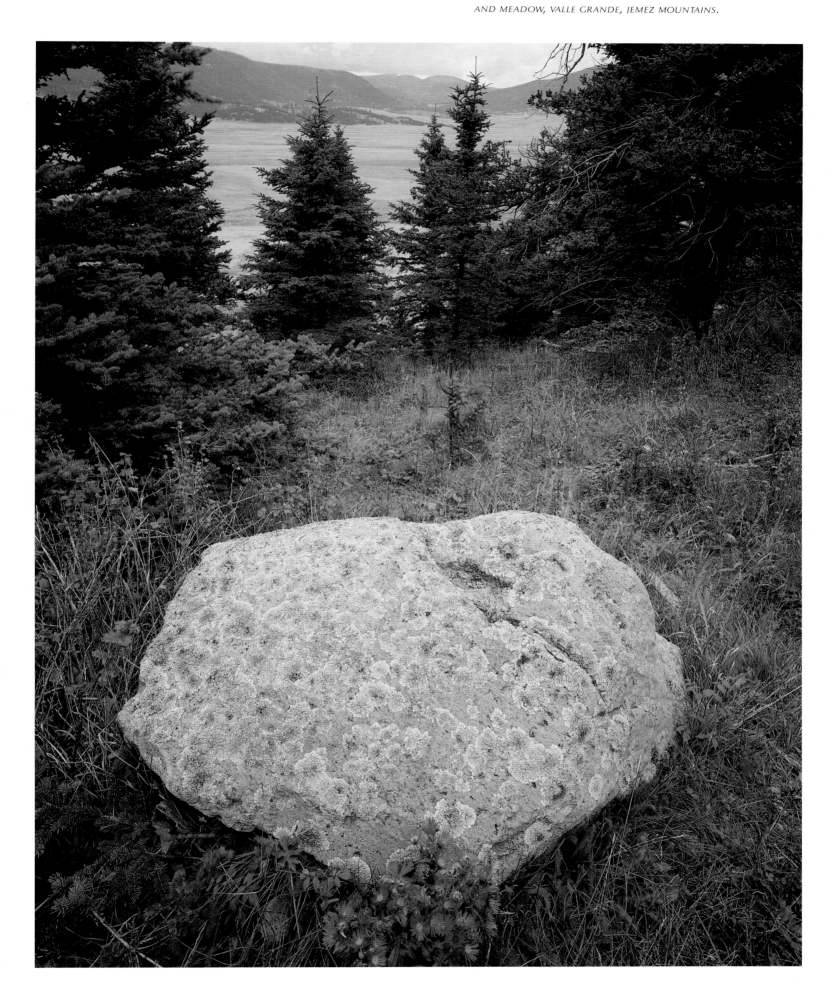

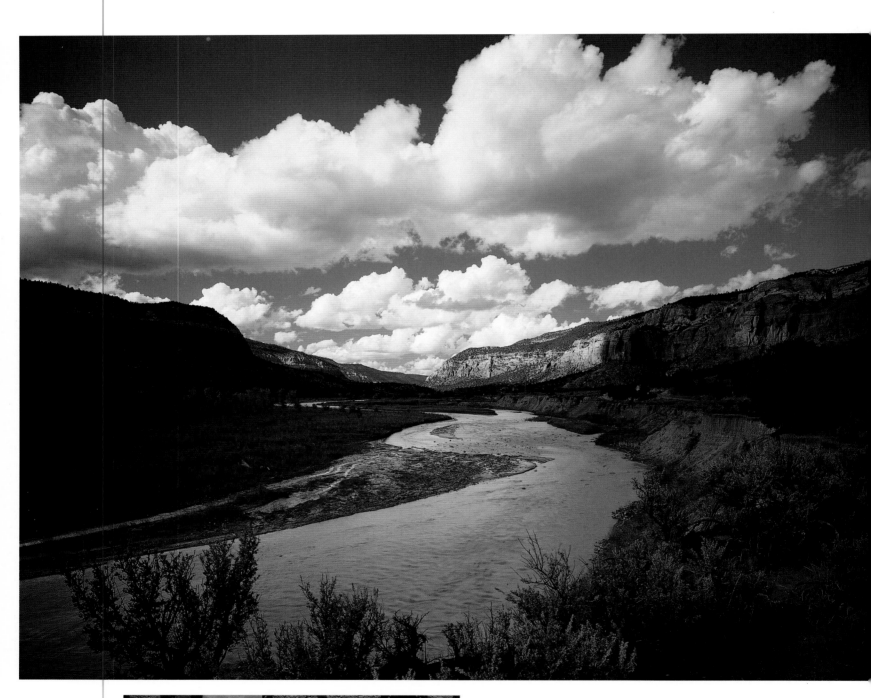

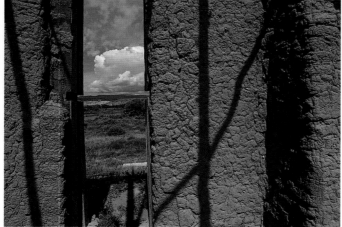

▰

BELOW: A WOOD-AND-ADOBE GATE ENCOMPASSES THE

▰

QUAINT CHURCH TOWERS AND ENTRANCEWAY

▰

TO SANTUARIO DE CHIMAYO

AT THE FOOT OF THE SANGRE DE CRISTO MOUNTAINS.

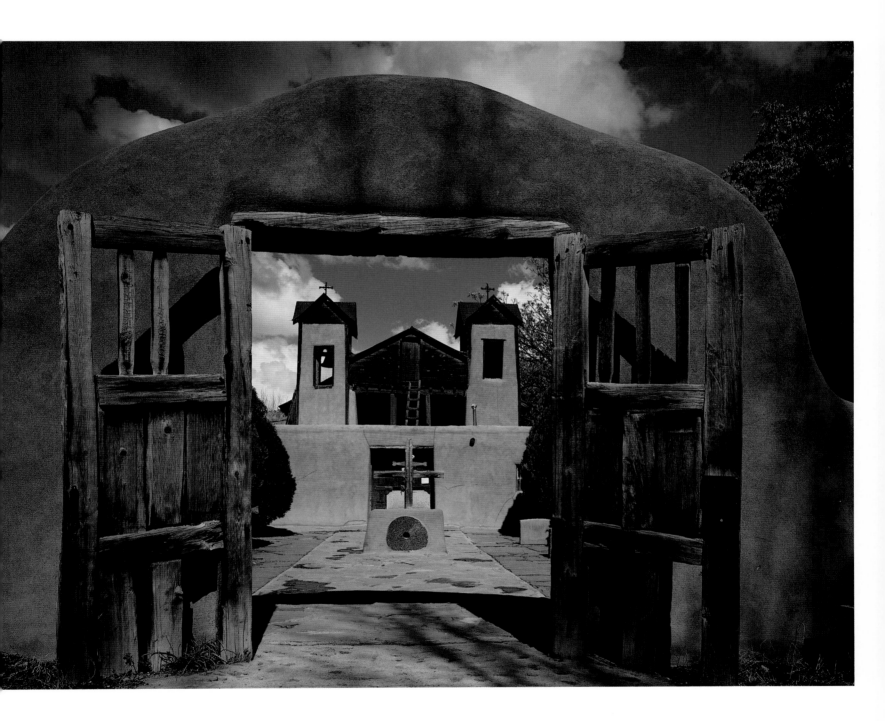

▰

UPPER LEFT: UPSTREAM ALONG THE WILD AND SCENIC

CHAMA RIVER NEAR CHRIST OF THE DESERT MONASTERY.

LOWER LEFT: AN ABANDONED ADOBE WALL AND

DOORWAY FRAME THE CHAMA RIVER, NEAR ABIQUIU.

BELOW: THE TILTED LIMESTONE RIMS OF THE SANDIA MOUNTAINS

WILDERNESS. THE SANDIA, A DELICATE PINK

DURING SUNSETS, MEANS "WATERMELON" IN SPANISH.

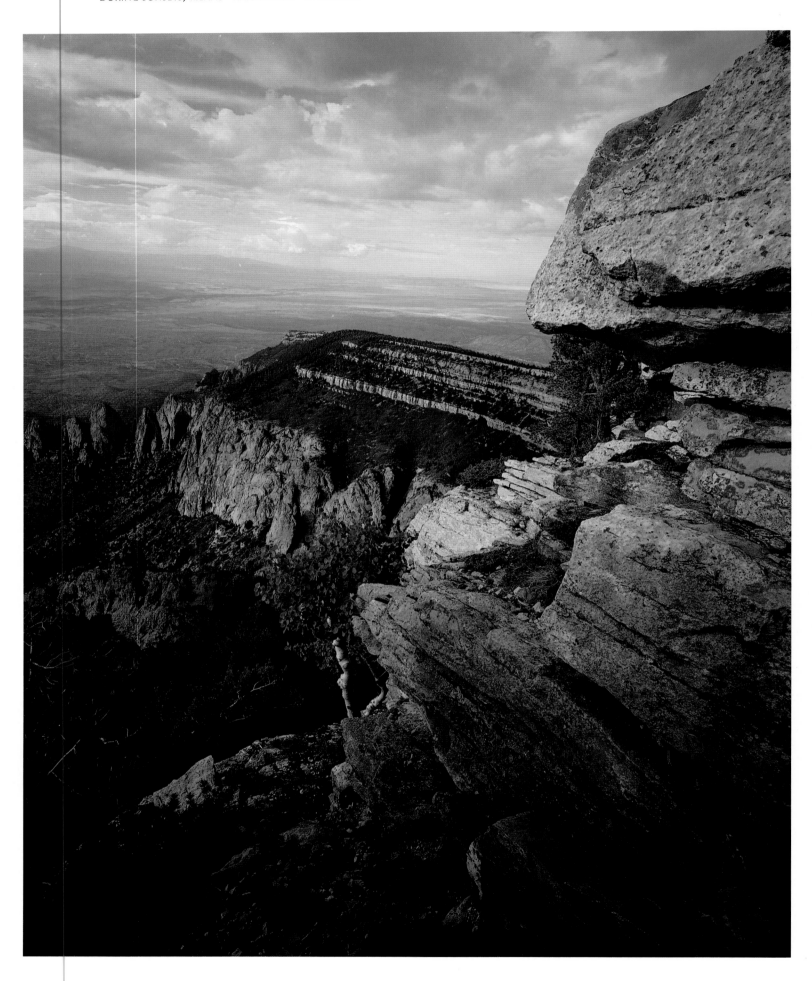

BELOW: MAY BLOOMS, INCLUDING YARROW, PENSTEMON,

AND INDIAN PAINTBRUSH, ON THE LIMESTONE RIMS

OF SANDIA CREST. VIEW IS SOUTH TO MANZANO MOUNTAINS.

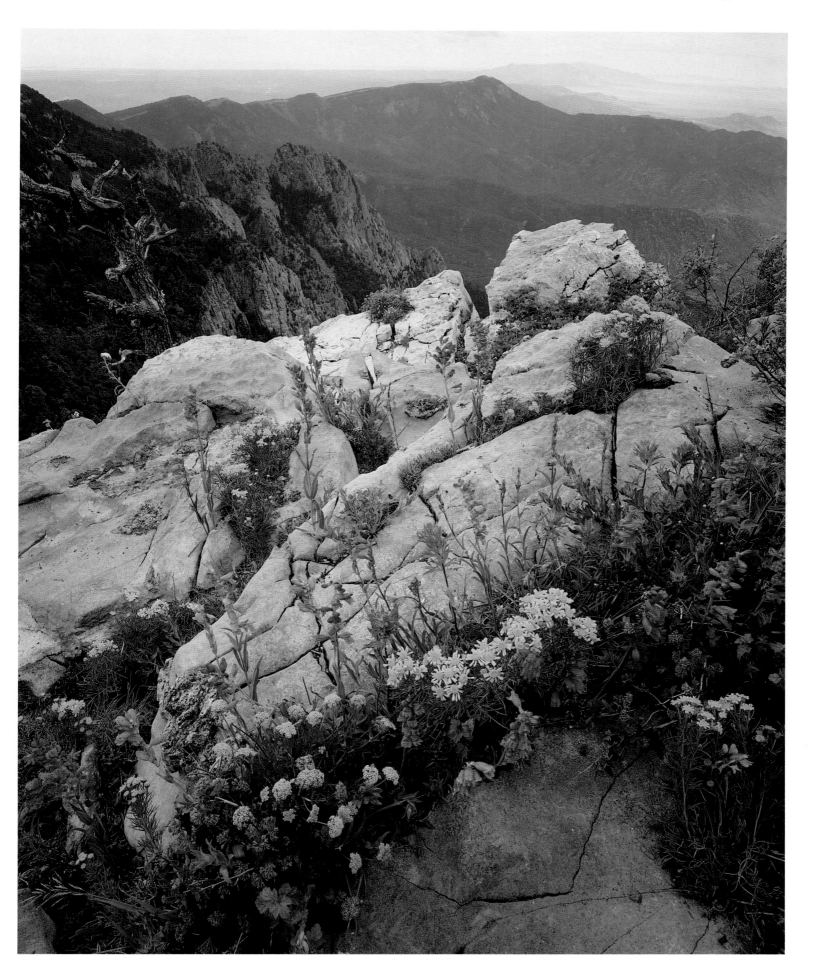

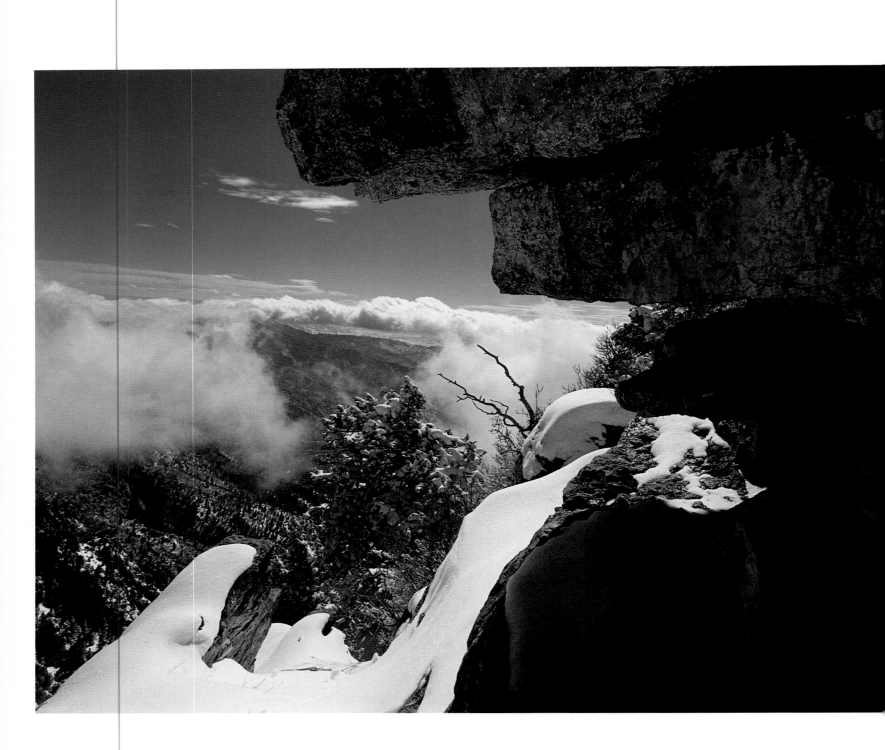

BELOW: CLOUDS OF A LATE SEPTEMBER DAY

GATHER QUICKLY ABOVE THE THIRTEEN-THOUSAND-FOOT

PEAKS OF NORTH TRUCHAS AND CHIMAYOSOS

IN THE PECOS WILDERNESS, SANGRE DE CRISTO MOUNTAINS.

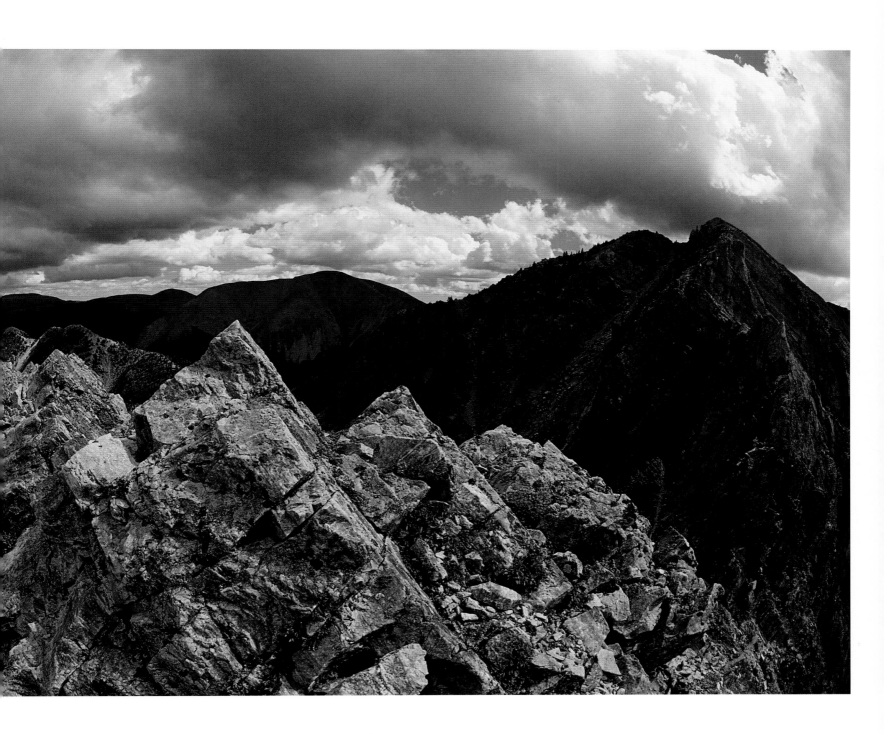

LEFT: A MARCH SNOW COATS THE LIMESTONE CREST ON

SANDIA. SOLITUDE AND SPACE PREDOMINATE

ON MUCH OF THIS MOUNTAIN ABOVE ALBUQUERQUE.

BELOW: IN NOVEMBER, DRIED STALKS AND

CHILI PEPPER RISTRAS ADORN A KNOTTY PINE WALL

AT MADRID, IN THE ORTIZ MOUNTAINS.

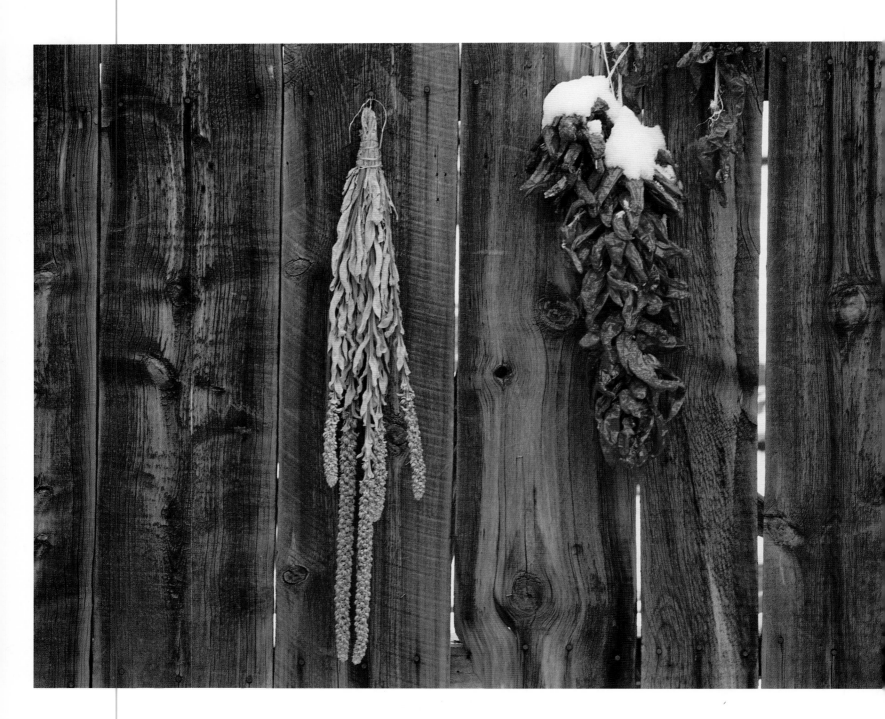

RIGHT: ADOBE AND A BLUE GLASS TILE WINDOW BECOME

A DELICATE DESIGN IN DECEMBER

IN THE VILLAGE OF CERILLOS, NEAR SANTA FE.

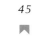

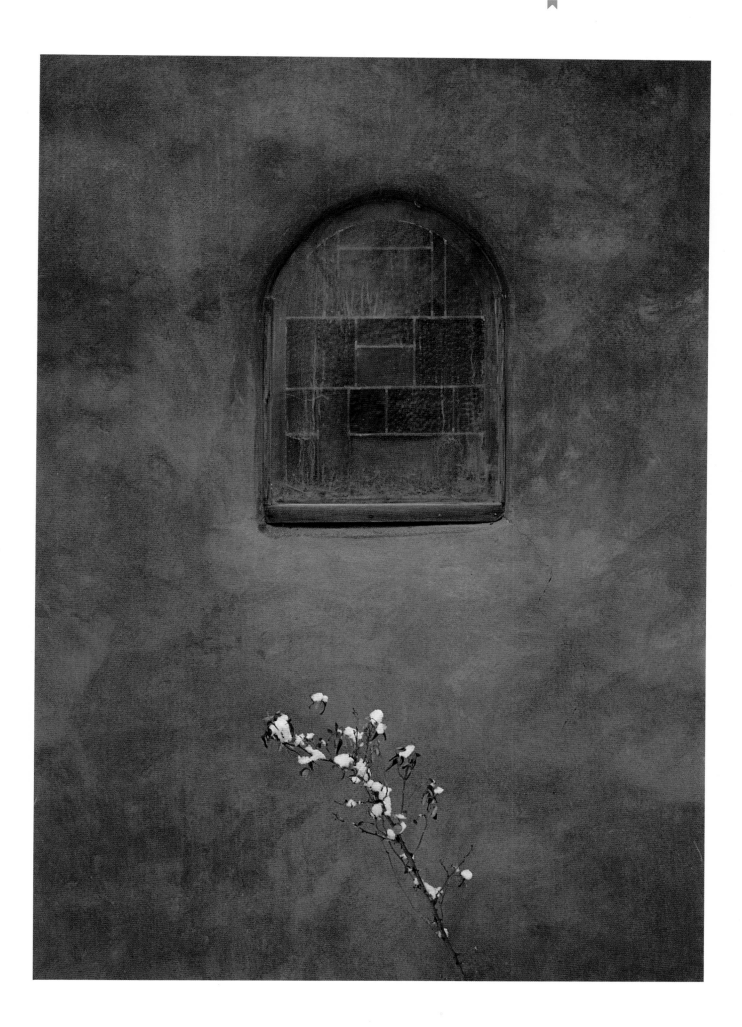

*BELOW: SKY WINDOWS*

*IN A ROCK WALL ARE*

*REMNANTS OF A MINING PAST*

*IN ELIZABETH TOWN.*

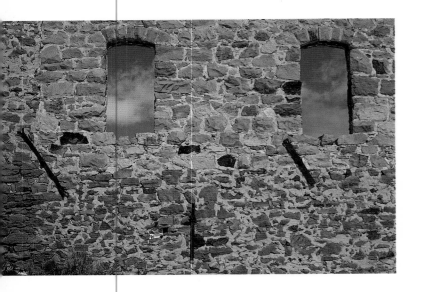

*RIGHT: CHILI PEPPER*

*RISTRAS LEND COLOR IN*

*OLD TOWN ALBUQUERQUE.*

*BELOW: INDIAN CORN COBS*

*ON ADOBE, TAOS PUEBLO.*

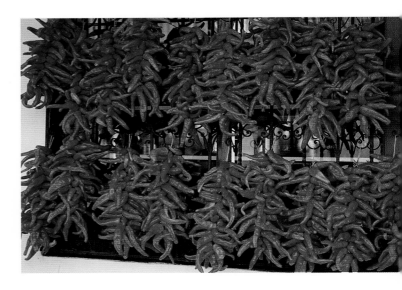

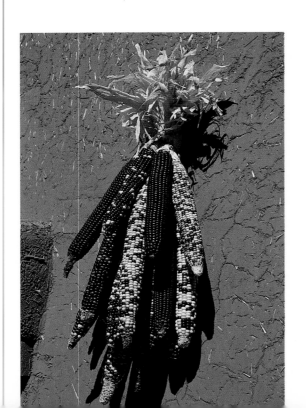

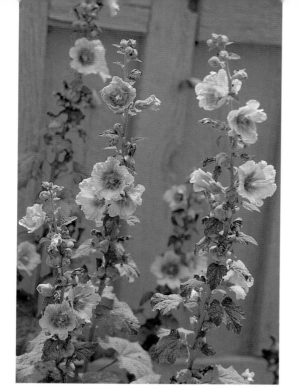

◣

*LEFT: HOLLYHOCK BLOOMS ARE*

◣

*EVER-PRESENT ALONG THE SIDE STREETS*

◣

*AND PATHWAYS OF TAOS.*

*BELOW RIGHT: A CIRCULAR DESIGN*

*OF STONEWORK IN CERILLOS.*

*BELOW LEFT: LANTERN AND ADOBE*

*DESIGN, VILLAGE OF LAMY.*

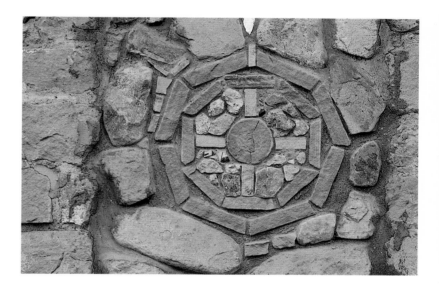

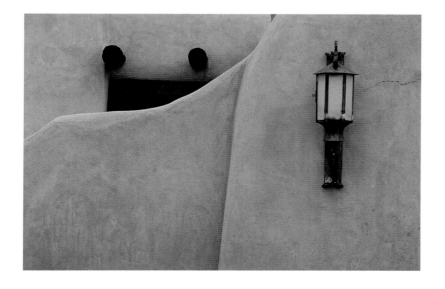

BELOW: A HEAVY BLANKET OF SNOW

IN DECEMBER ISOLATES THE SOUTH PUEBLO

AND RIO PUEBLO DE TAOS,

AT FIVE-HUNDRED-YEAR-OLD TAOS PUEBLO.

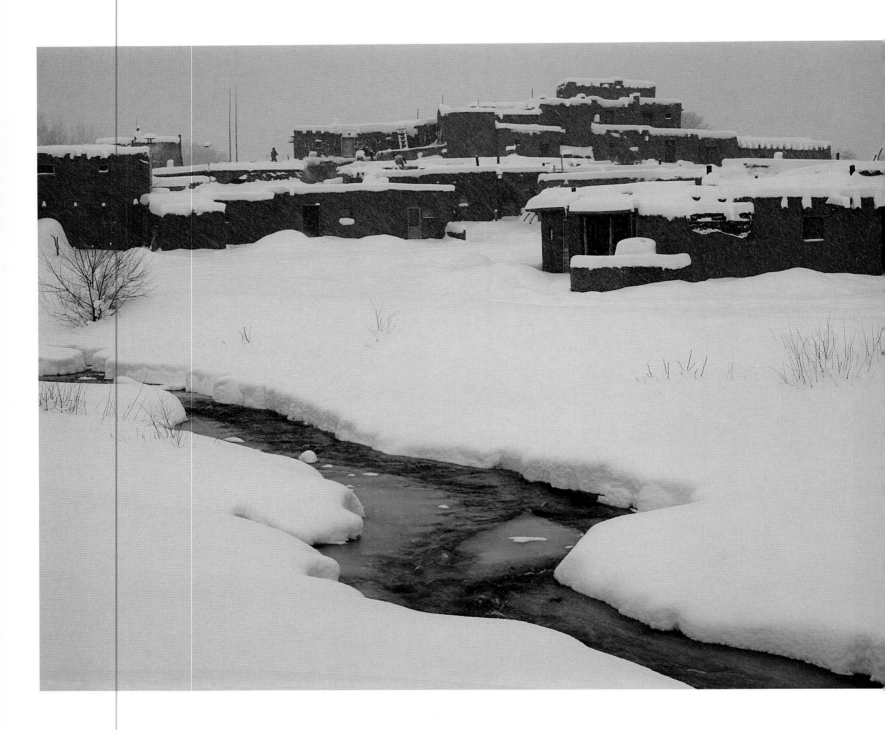

RIGHT: UPPER RIO GRANDE GORGE NEAR TAOS.

THE RIO GRANDE FLOWS INTO THE WILD AND SCENIC AREA

FROM COLORADO, TRAVELING SOUTH MORE THAN

FOUR HUNDRED MILES BEFORE LEAVING THE STATE AT EL PASO.

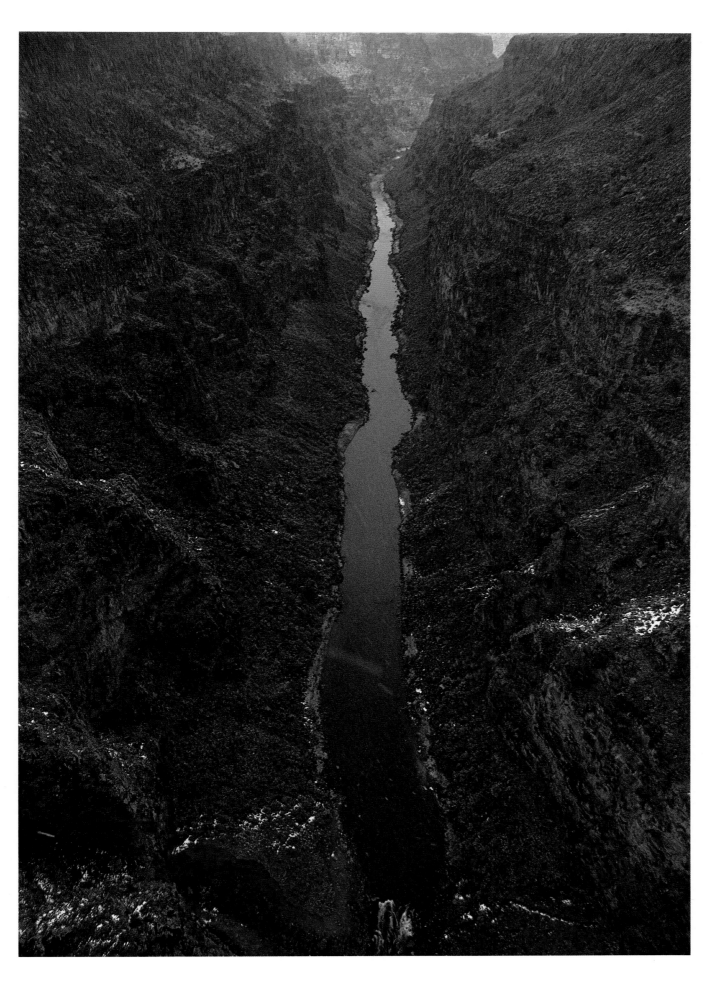

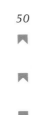

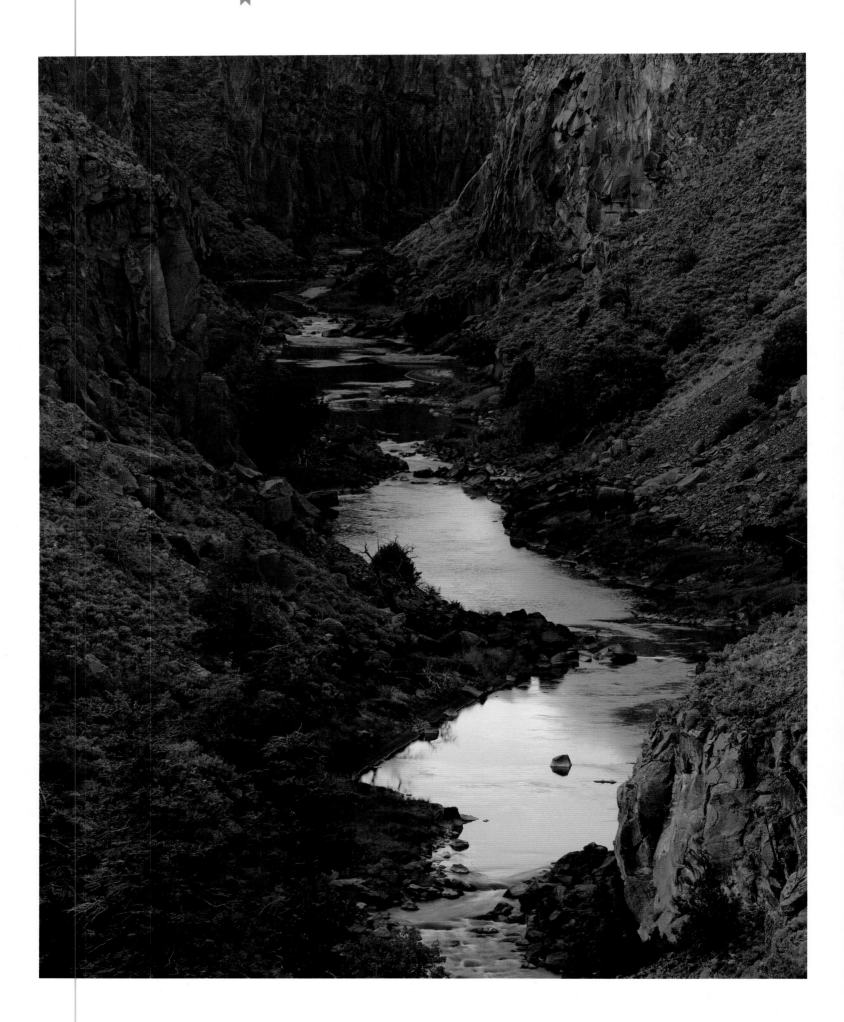

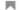

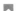
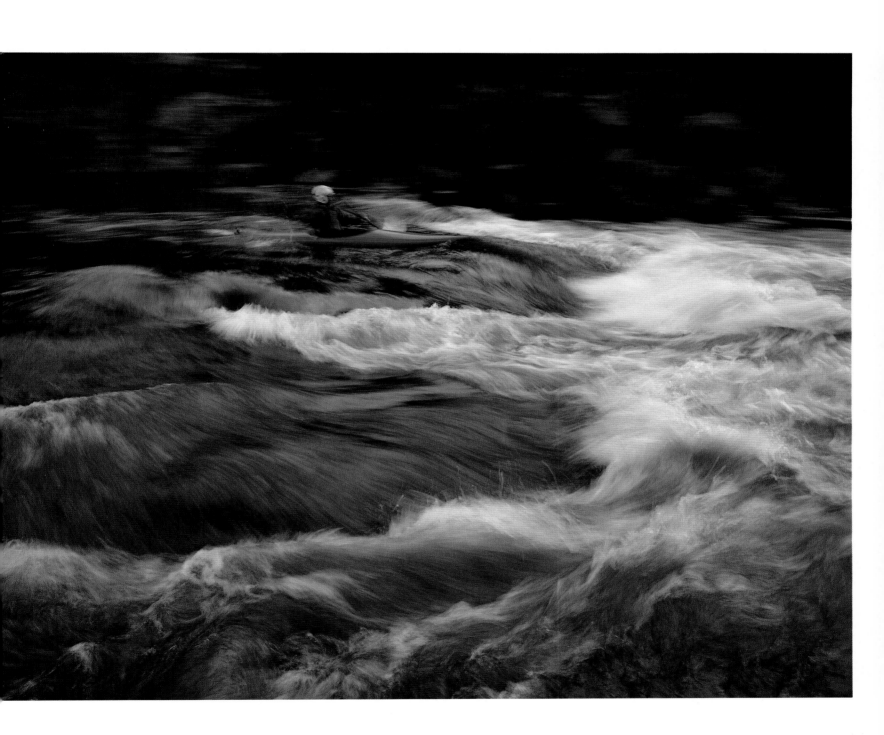

LEFT: VOLCANIC WALLS NARROW IN A GORGE AT

BEAR CROSSING, SIX HUNDRED FEET DOWN

FROM THE RIMS ALONG THE

RIO GRANDE NATIONAL WILD AND SCENIC RIVER.

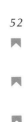

52

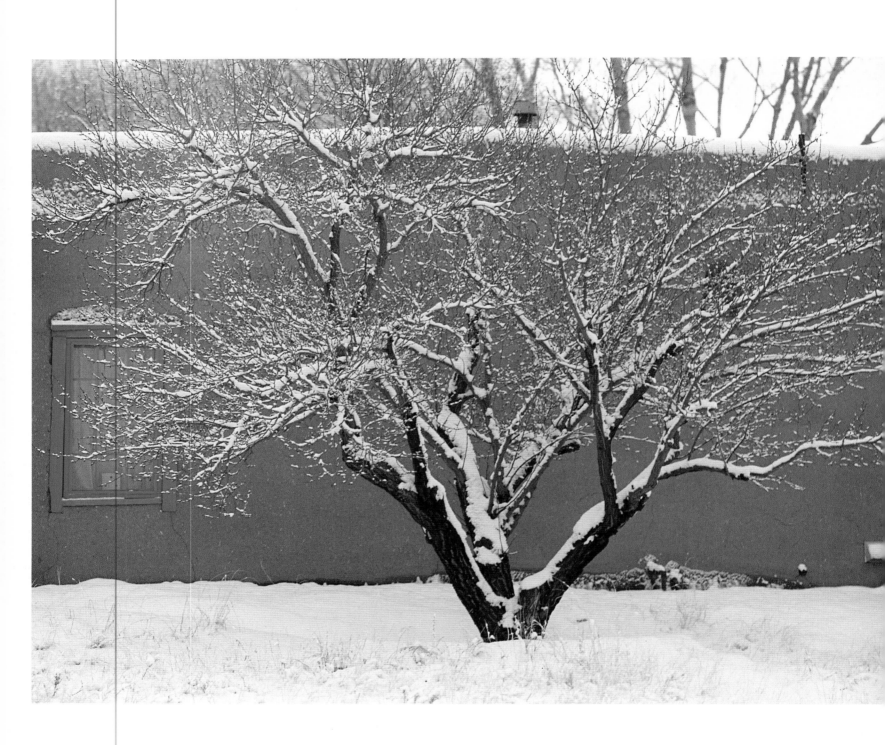

*BELOW: A JANUARY SNOW SILENTLY TRANSFORMS*

*THE ENTRANCE GATE AND BELL TOWERS OF*

*SAINT FRANCIS DE ASSISI CHURCH, RANCHOS DE TAOS.*

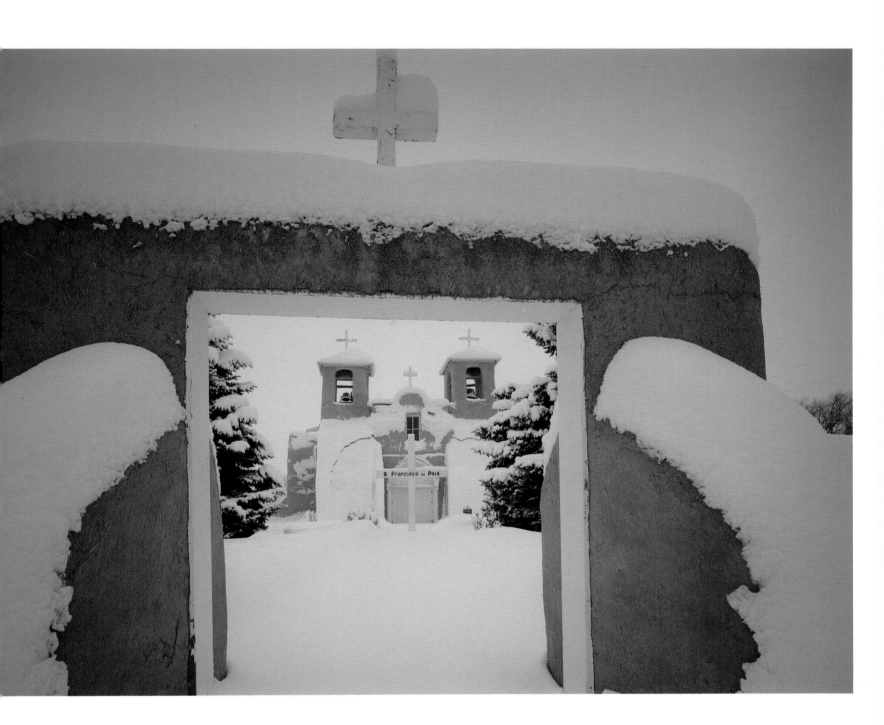

*LEFT: A LIGHT FEBRUARY SNOW DECORATES*

*A FRUIT TREE, BACKDROPPED BY AN ADOBE WALL WITH A*

*BLUE WINDOW, THE VILLAGE OF CHIMAYO.*

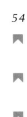

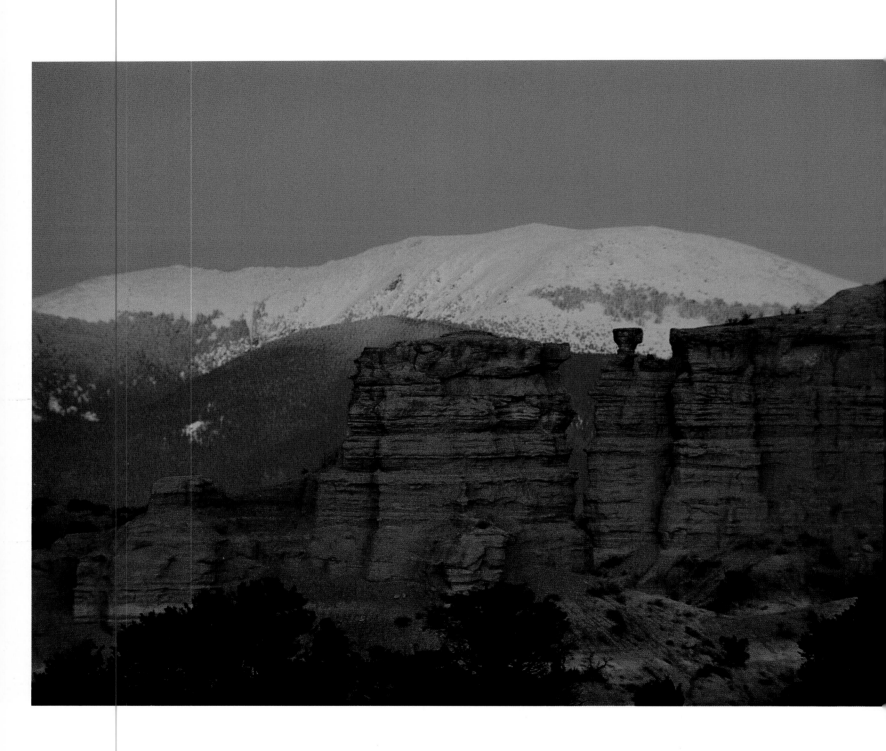

BELOW: A HANDMADE EARTHEN BUTTRESS ON THE

WEST SIDE OF THE SAINT FRANCIS DE ASSISI CHURCH AT

RANCHOS DE TAOS IN AN EVENING SNOWSTORM.

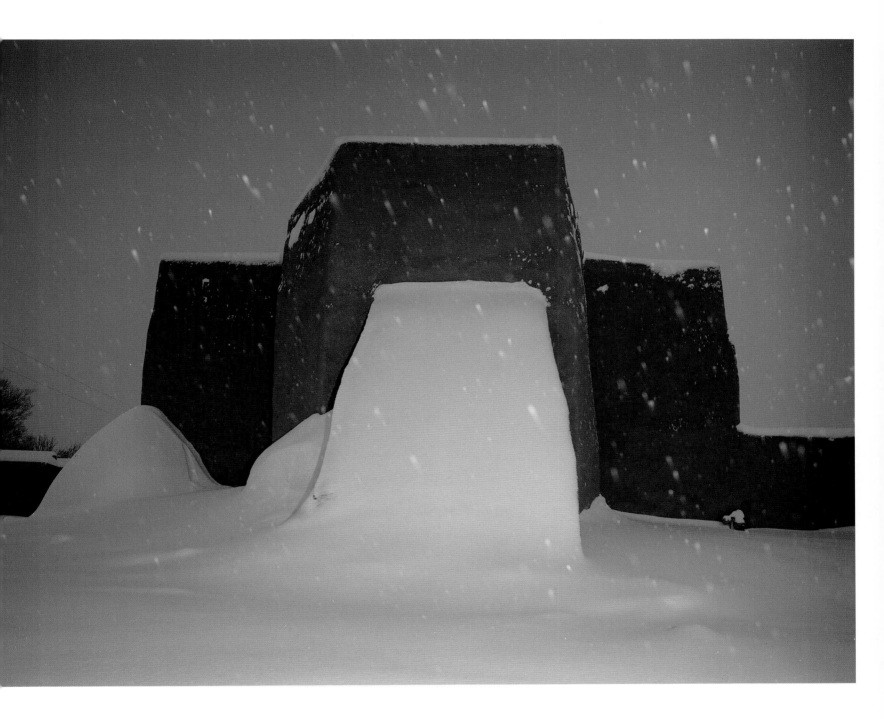

LEFT: A NOVEMBER SNOW FALLS LIGHTLY ON SANTA FE BALDY

ABOVE THE ERODED CLAY CLIFFS NEAR THE

VILLAGE OF TESUQUE, SANGRE DE CRISTO MOUNTAINS.

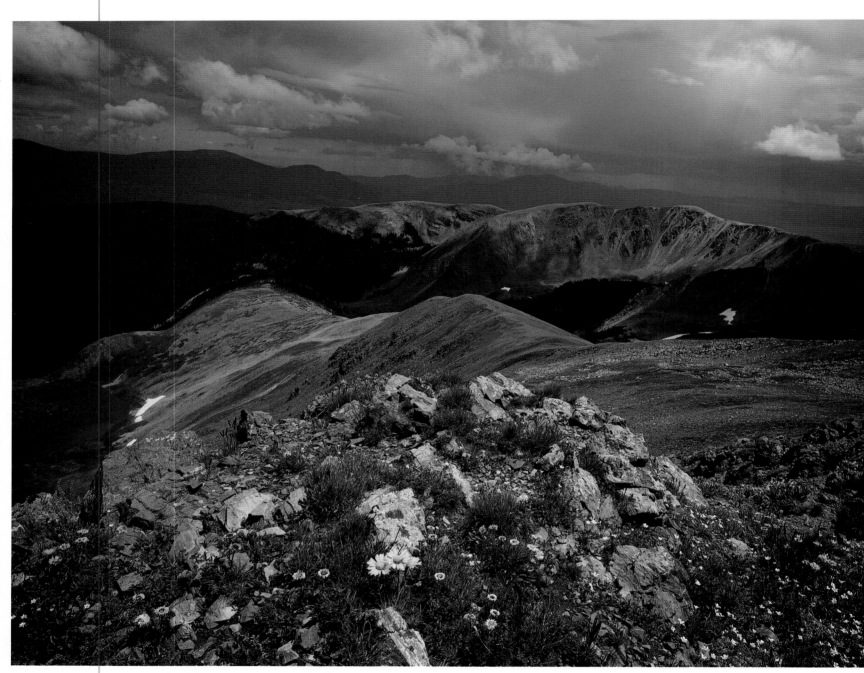

BELOW: A LIGHT OCTOBER SNOW

ETCHES WHITE ON ASPEN ABOVE RED RIVER CANYON,

SANGRE DE CRISTO MOUNTAINS.

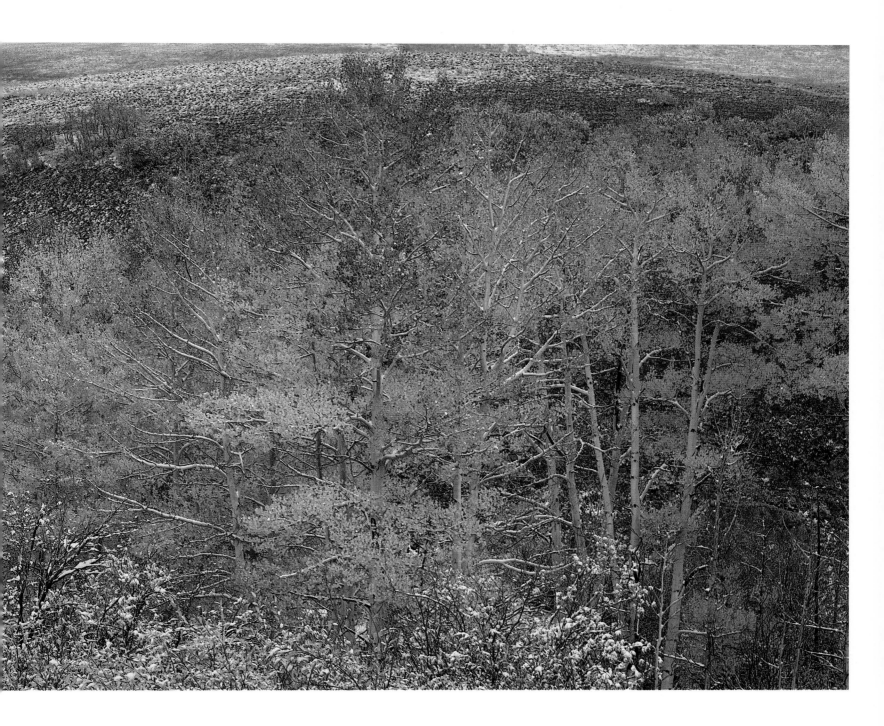

UPPER LEFT: AUGUST VIEW EAST IS FROM 13,161-FOOT

WHEELER PEAK, SANGRE DE CRISTO MOUNTAINS.

LOWER LEFT: ASTERS ARE COMMON IN MOUNTAIN MEADOWS.

*BELOW: HIGH IN THE PECOS WILDERNESS, TRAMPAS CREEK*

*CASCADES THROUGH SEPTEMBER FOREST GREENS OF*

*THE TRUCHAS PEAKS REGION, SANGRE DE CRISTO MOUNTAINS.*

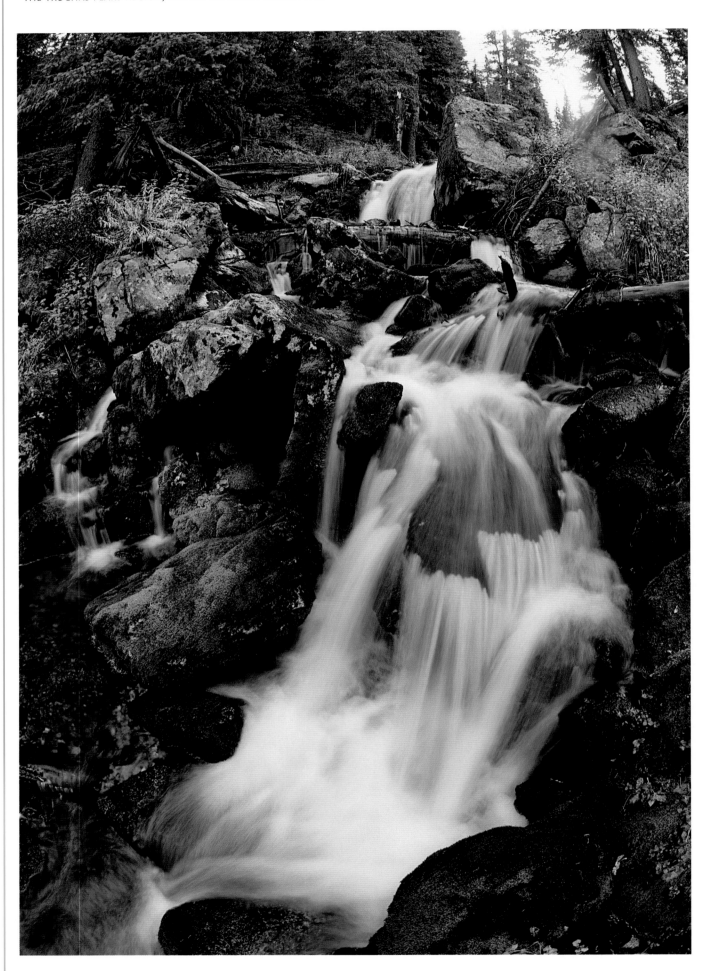

BELOW: TRAMPAS LAKE REFLECTS A SUMMER SKY

IN THIS GLACIALLY CARVED CIRQUE OF TRUCHAS PEAKS

REGION, PECOS WILDERNESS, SANGRE DE CRISTO MOUNTAINS.

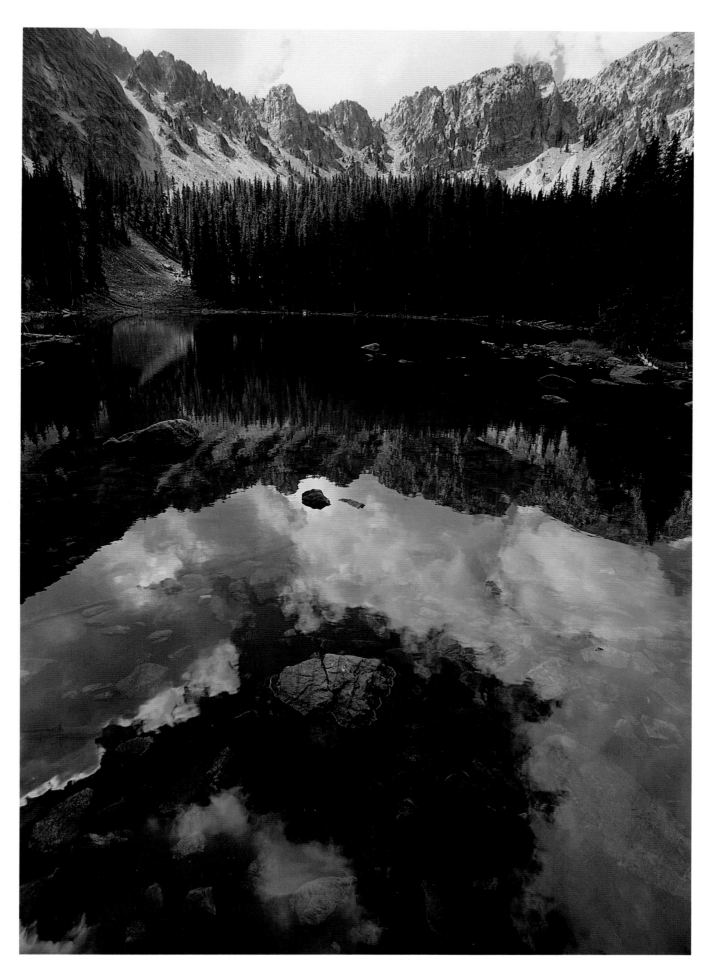

BELOW: ASPEN AND SPRUCE CATCH

THE EARLY MORNING SUNLIGHT ALONG

THE TRAMPAS CANYON TRAIL, PECOS WILDERNESS.

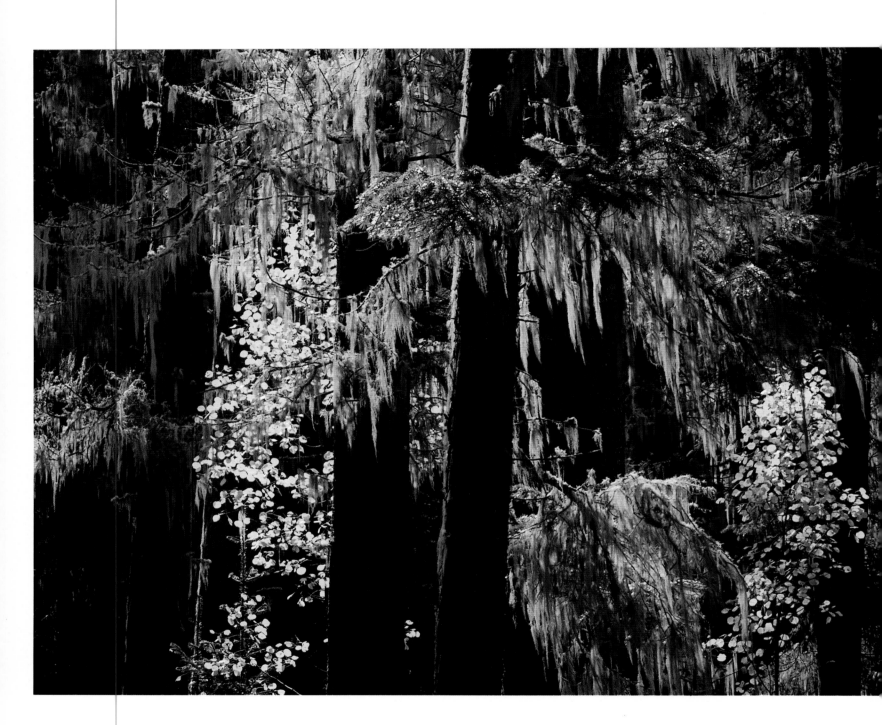

RIGHT: TALL AUGUST SUNFLOWERS ON DISPLAY DEEP IN THE

UPPER CIMARRON RIVER CANYON ON THE

EASTERN SLOPE OF THE SANGRE DE CRISTO MOUNTAINS.

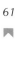
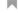
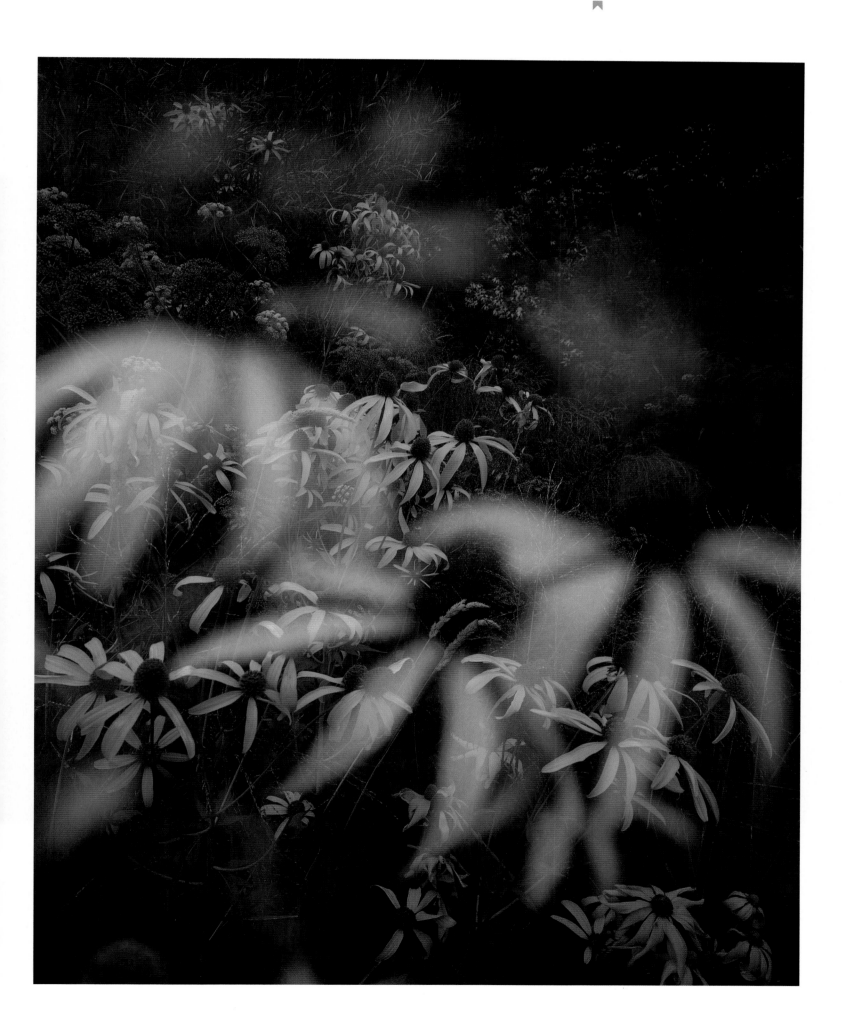

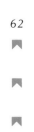

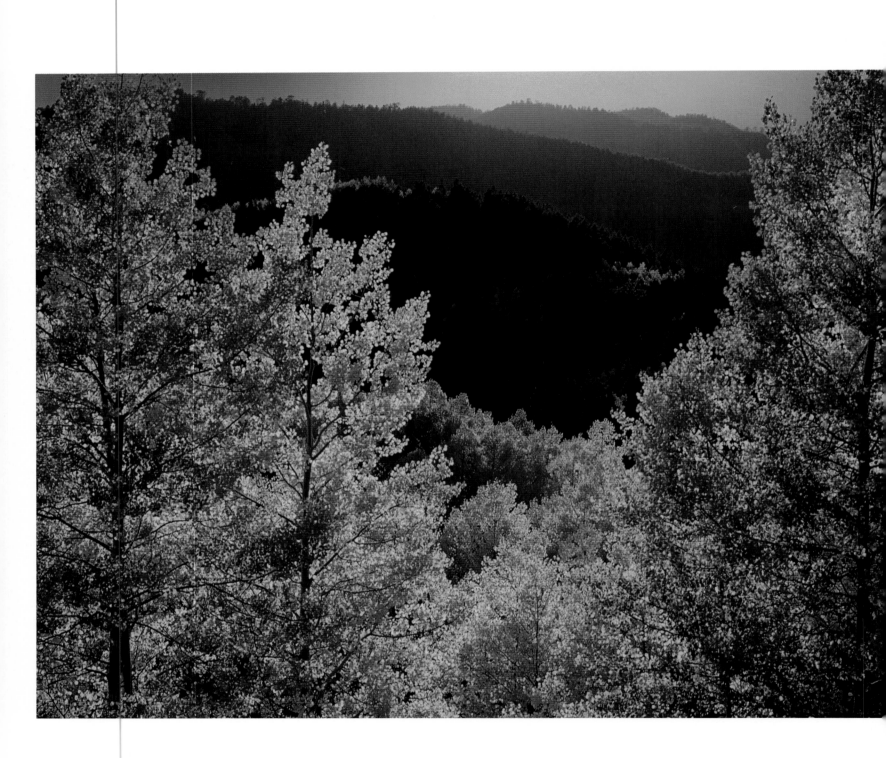

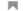

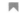
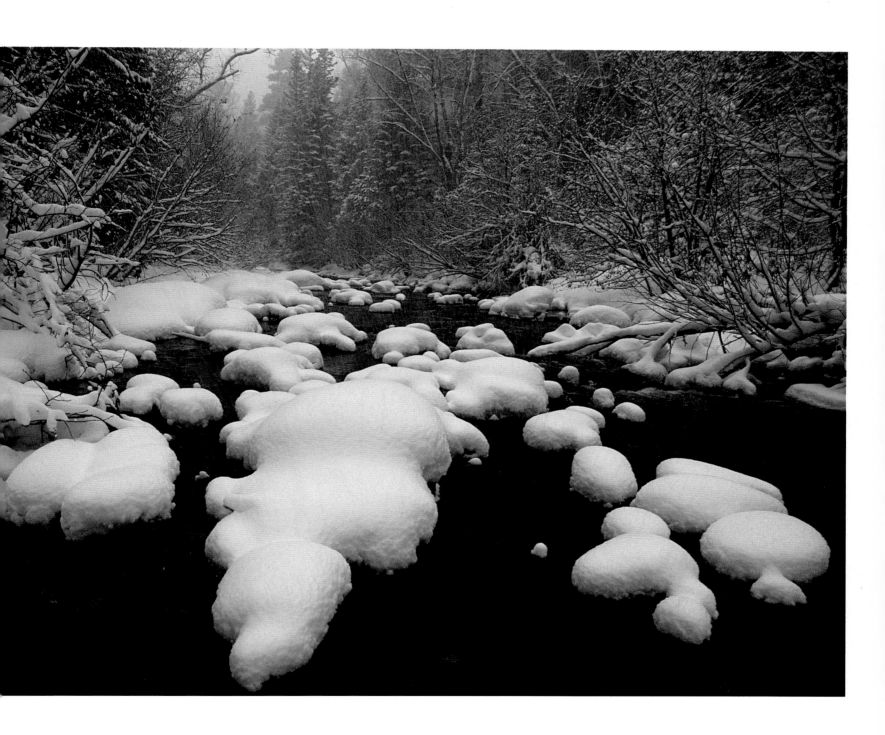

*LEFT: STRIKING AUTUMN COLORS COME*

*TO THE SLOPES OF ASPEN BASIN ABOVE SANTA FE,*

*IN THE SANGRE DE CRISTO MOUNTAINS.*

BELOW: A SKIER DESCENDS KACHINA PEAK

IN THE JANUARY POWDER OF TAOS SKI VALLEY,

SANGRE DE CRISTO MOUNTAINS.

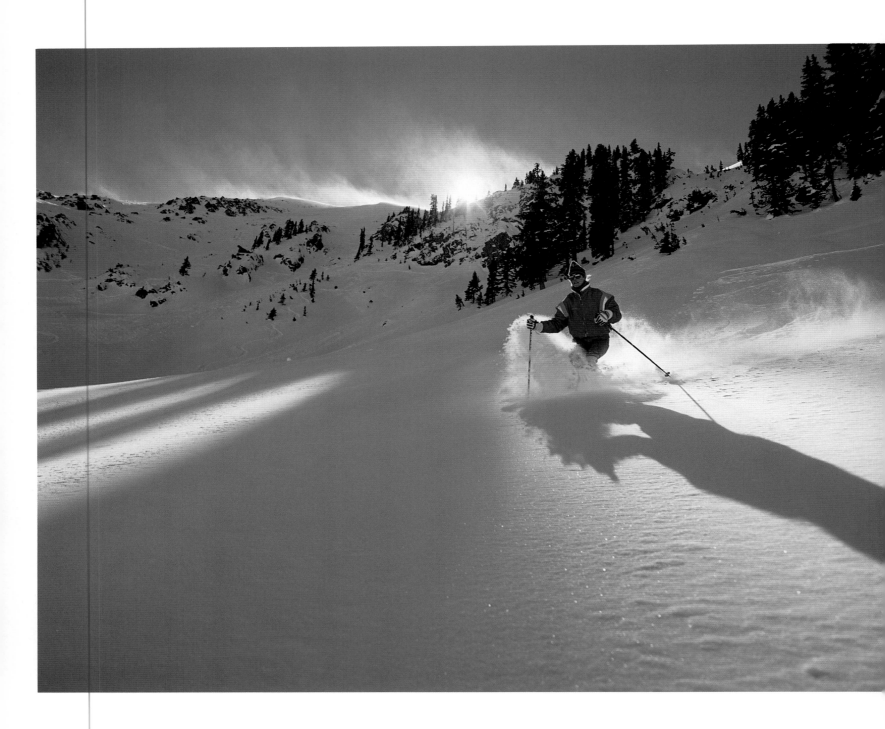

RIGHT: THE SHADOWS OF ASPEN TREES

LENGTHEN INTO PATTERNS DURING SUNSET'S GLOW IN

ASPEN HEIGHTS, SANTA FE SKI BASIN.

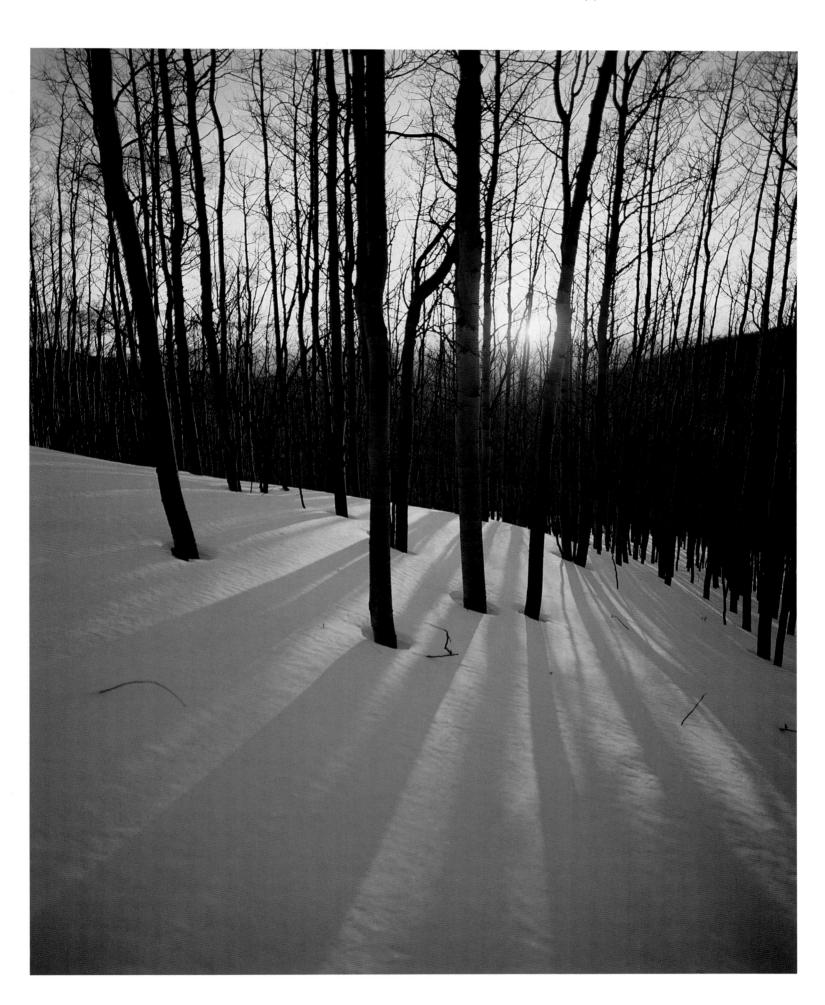

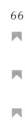

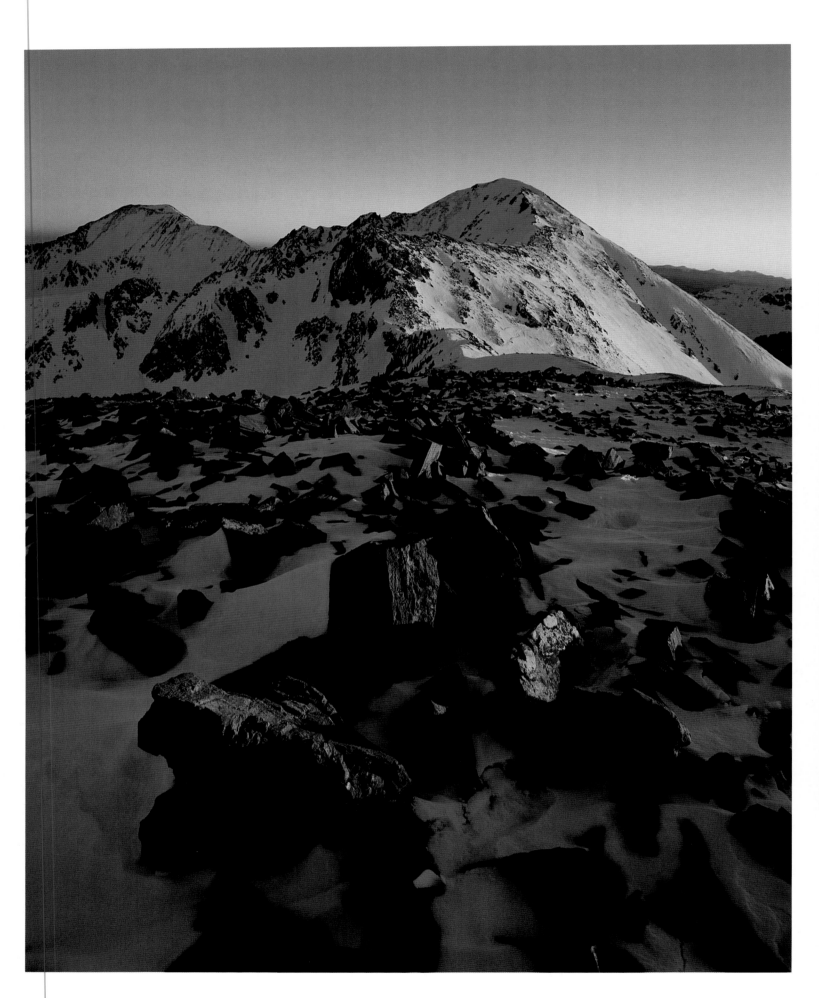

BELOW: A SKIER HIKES ALONG THE WIND-BLOWN

CREST OF KACHINA PEAK AT SUNSET,

WHEELER PEAK WILDERNESS.

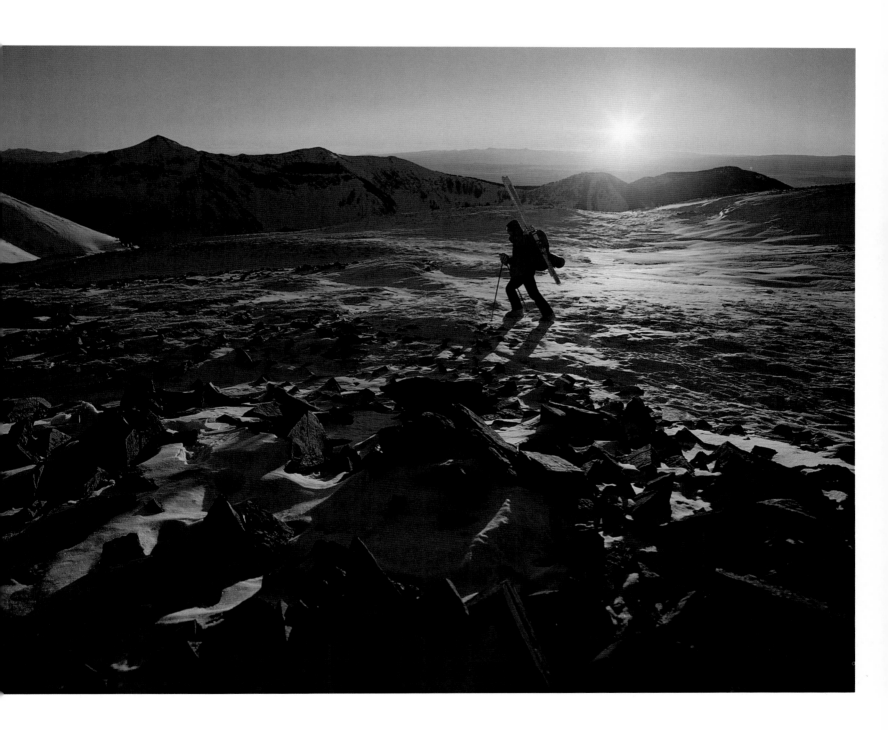

LEFT: A JANUARY EVENING GLOW HIGHLIGHTS

LAKE FORK PEAK ALONG THE TOP

OF THE SANGRE DE CRISTO MOUNTAINS,

WHEELER PEAK WILDERNESS.

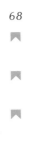

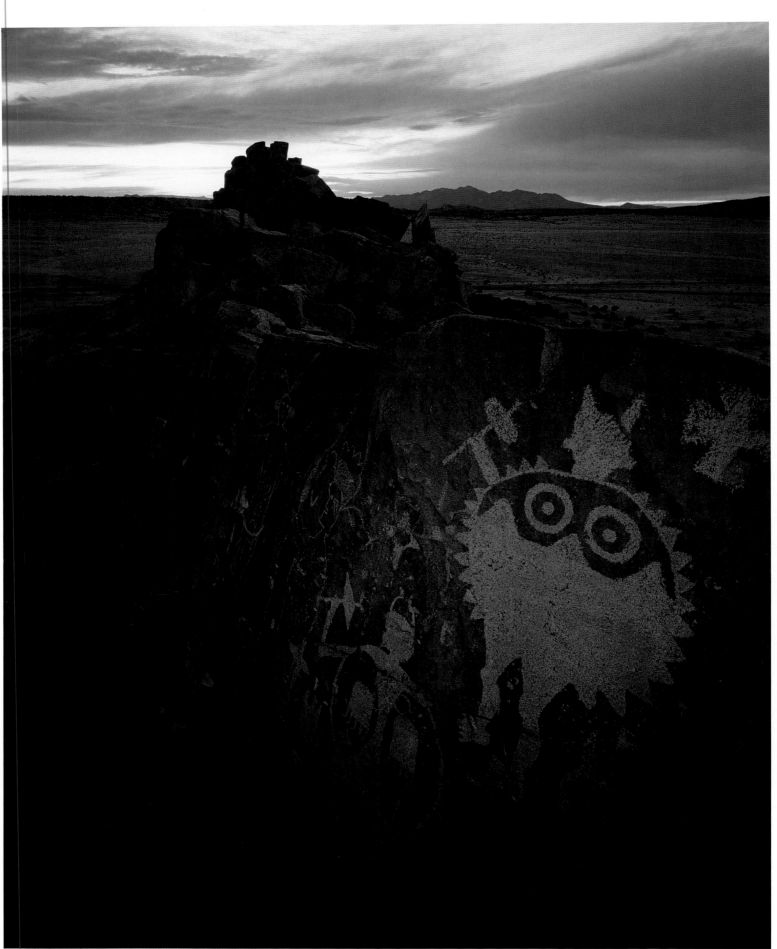

BELOW: THE SYMBOLS OF TWO CULTURES.

AN ANASAZI KIVA IN THE FOREGROUND AND

PUEBLO RUINS SURROUND SPANISH MISSION RUINS,

PECOS NATIONAL HISTORIC PARK.

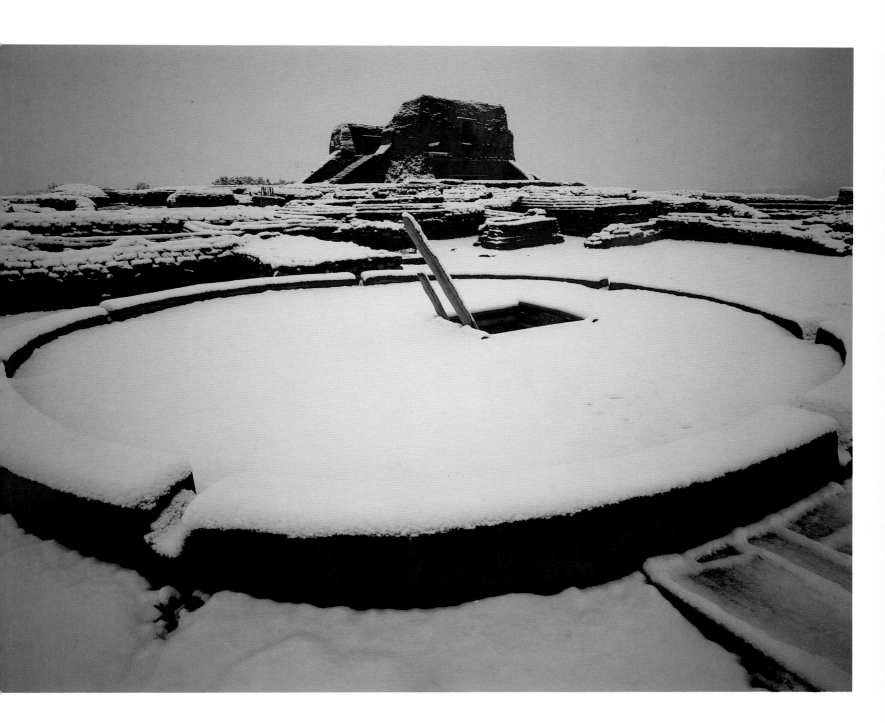

LEFT: SHIELD FIGURES APPEAR TO DEFEND A VOLCANIC

RIDGE AT COMANCHE GAP IN THE GALISTEO BASIN.

THE PETROGLYPHS ARE THOUGHT TO BE

OF A LATER ANASAZI GROUP.

*BELOW: A FEBRUARY SNOW ISOLATES A SMALL CROSS*

*FROM A CHURCH IN THE VILLAGE OF LAS TRAMPAS, AT THE*

*FOOT OF THE SANGRE DE CRISTO MOUNTAINS.*

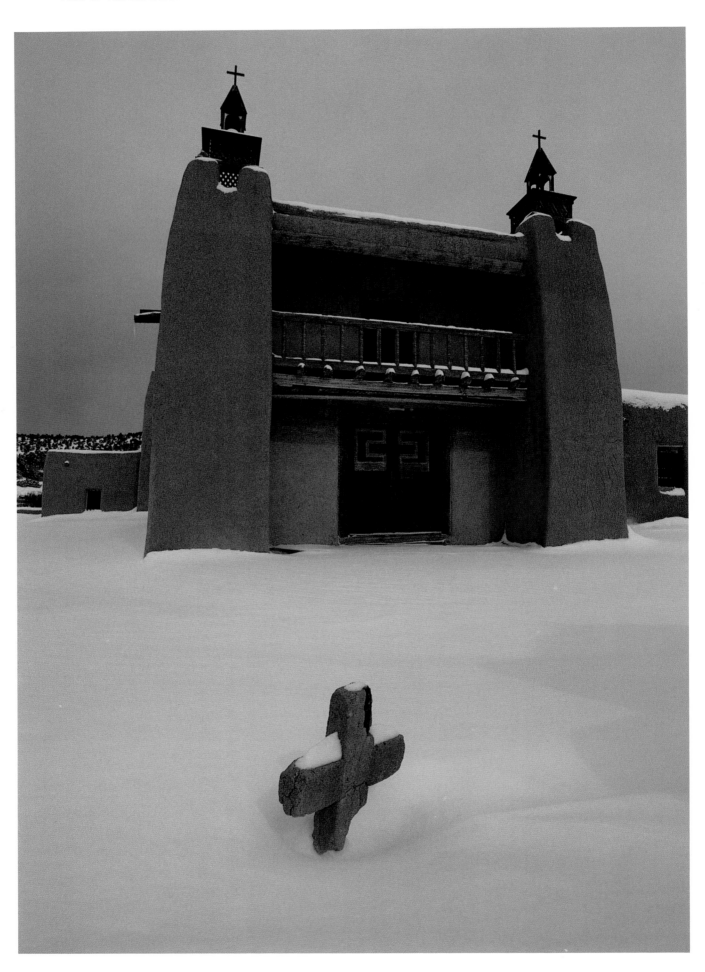

BELOW: A CLOSE VIEW OF THE BELL TOWERS AND

ENTRANCEWAY AT SANTUARIO DE CHIMAYO,

IN THE VILLAGE OF CHIMAYO.

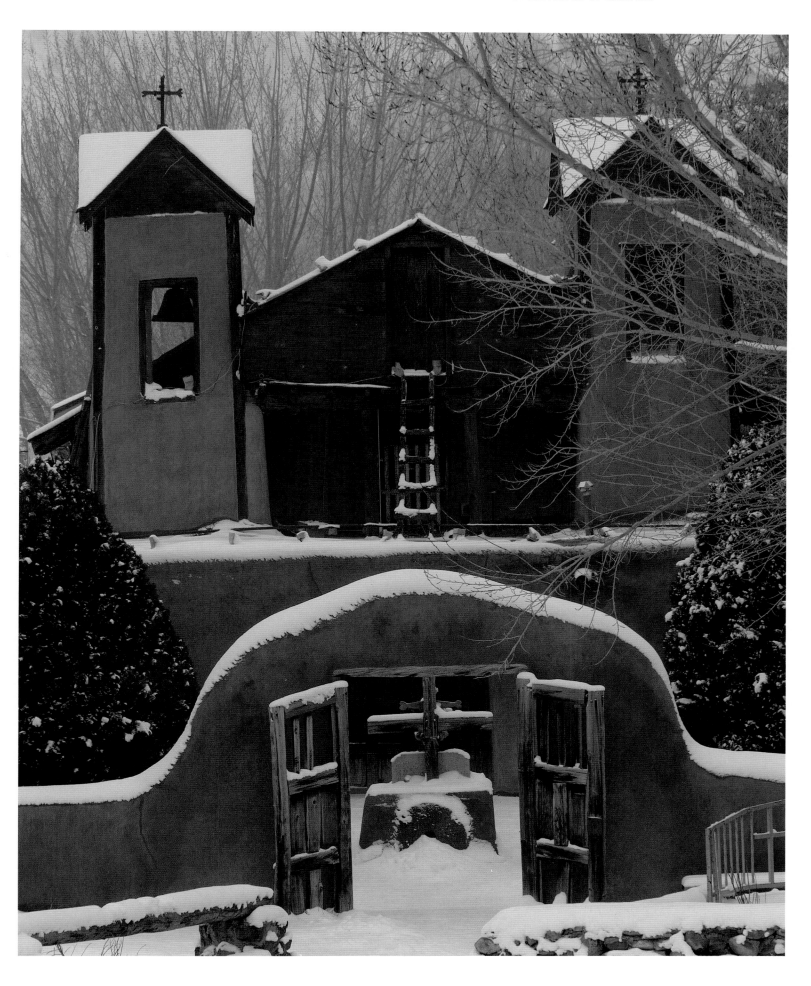

BELOW: A DELICATE DESIGN OF WINTER LACE

CREATES PATTERNS IN THE WILLOWS ALONG

THE RIO GRANDE DEL RANCHO, SOUTH OF TAOS.

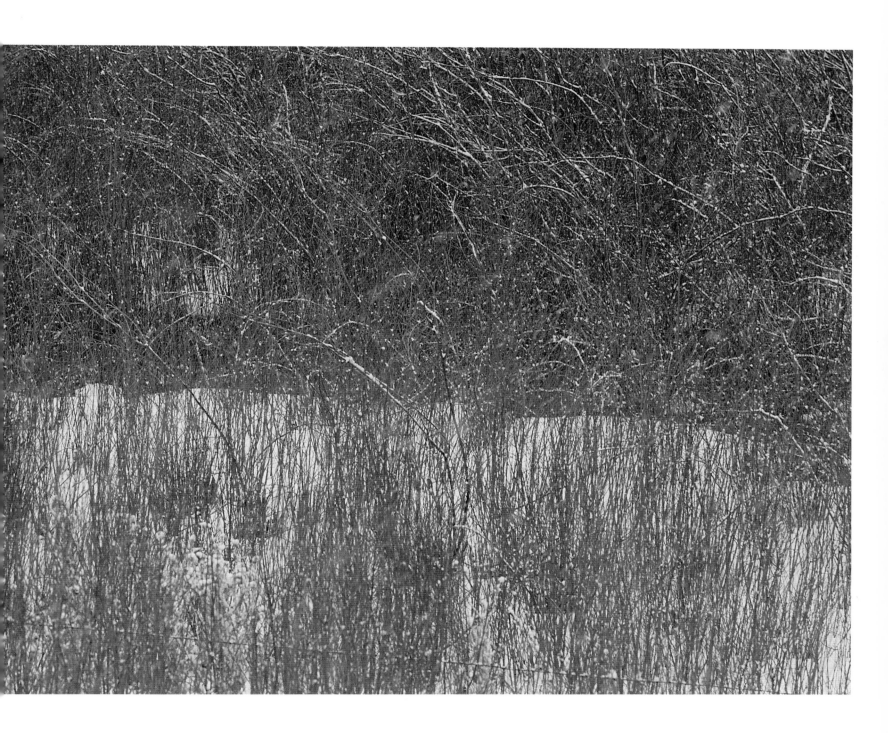

LEFT: SUNLIGHT, FILTERING THROUGH TREE BRANCHES IN A

PATTERN OF LIGHT AND SHADOWS, GIVES A

TRANSPARENT QUALITY TO AN ADOBE WALL, SANTA FE.

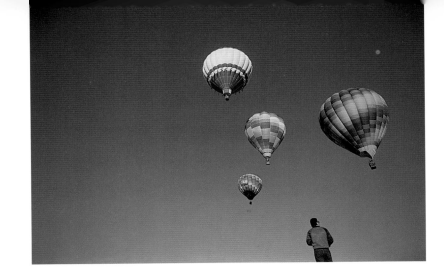

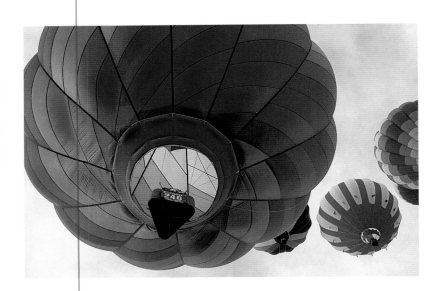

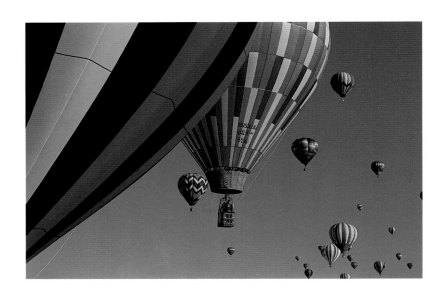

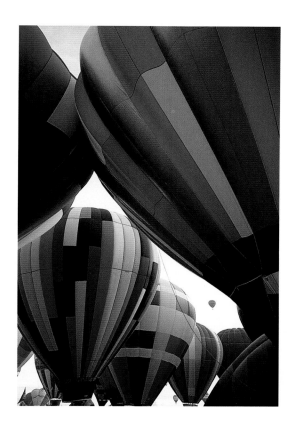

HOT AIR BALLOONING

AT THE ALBUQUERQUE

INTERNATIONAL BALLOON FIESTA.

APPROXIMATELY SIX HUNDRED

BALLOONS LIFT OFF

IN WAVES IN THE CRISP,

CLEAR, OCTOBER SKIES.

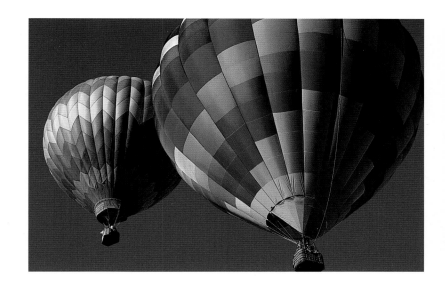

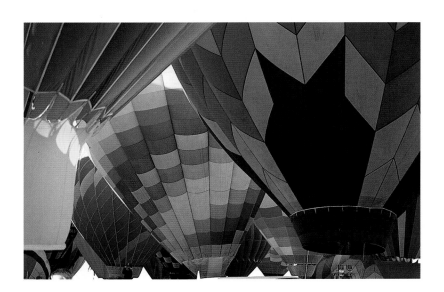

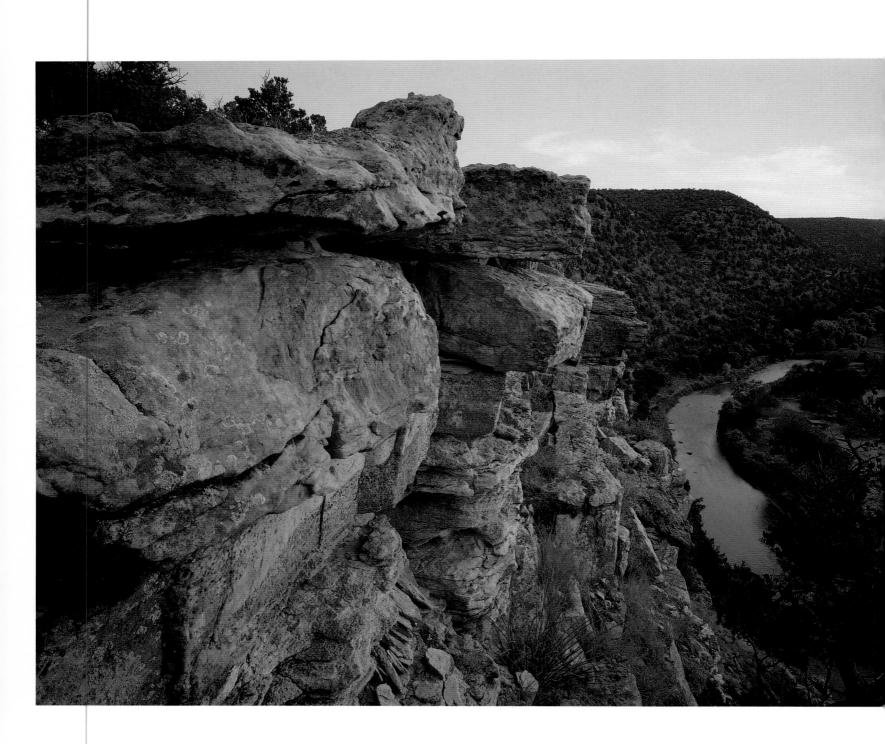

BELOW: FROM SANDIA HEIGHTS, LIGHTS BEGIN

TO SPARKLE BELOW, ALONG THE BANKS

OF THE RIO GRANDE IN ALBUQUERQUE.

MOUNT TAYLOR IS IN SILHOUETTE TO THE WEST.

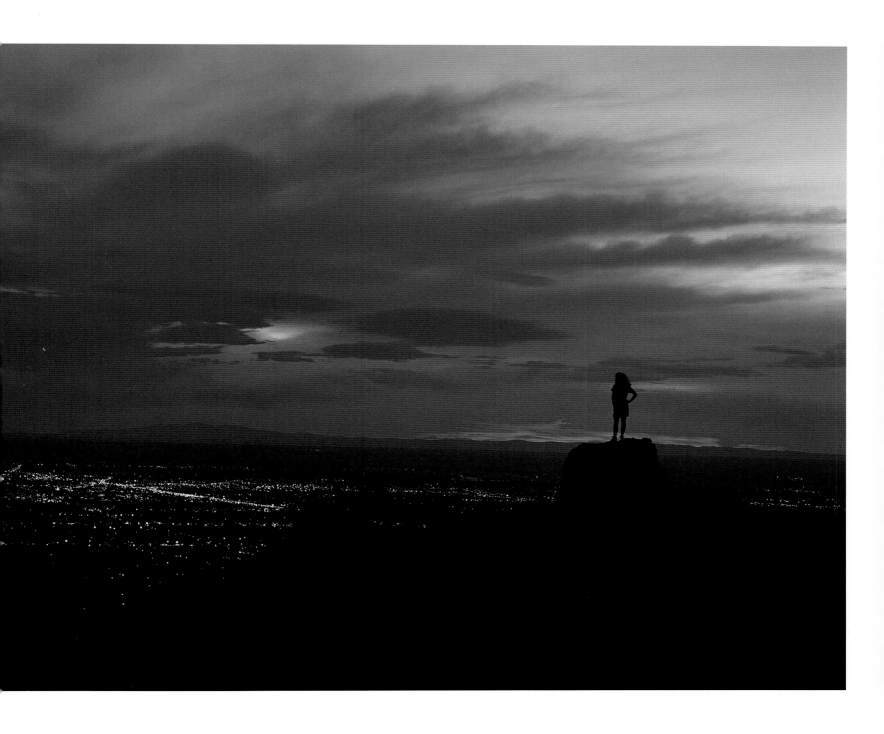

LEFT: THE PECOS RIVER WINDS ITS WAY OUT OF THE SANGRE

DE CRISTO MOUNTAINS AND THROUGH SANDSTONE CANYONS

BEFORE JOINING THE RIO GRANDE

ON THE TEXAS/MEXICO BORDER, VILLANUEVA STATE PARK.

BELOW: A HEAVY AUGUST RAIN HAS BROUGHT

THE FREQUENTLY DRY CANADIAN RIVER TO FLOOD STAGE,

KIOWA NATIONAL GRASSLANDS.

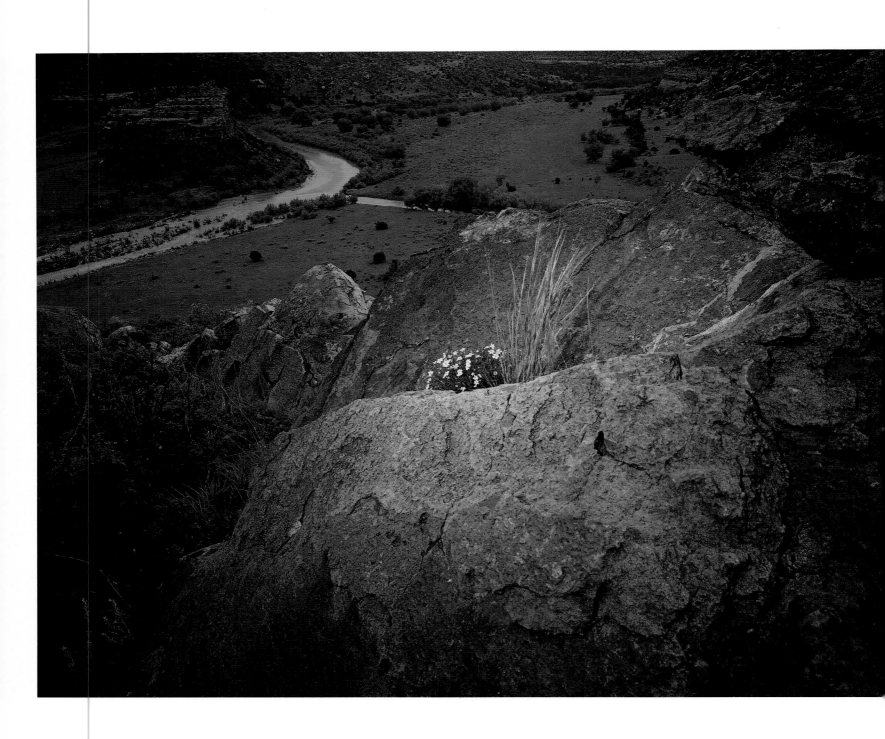

RIGHT: JULY RAINS HAVE GIVEN THESE HIGH PLAINS

AN ABUNDANT DISPLAY OF GROWTH. INDIAN PAINTBRUSH,

SAGE, AND SUNFLOWERS PREDOMINATE IN THIS

EVENING SCENE, CAPULIN VOLCANO NATIONAL MONUMENT.

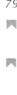
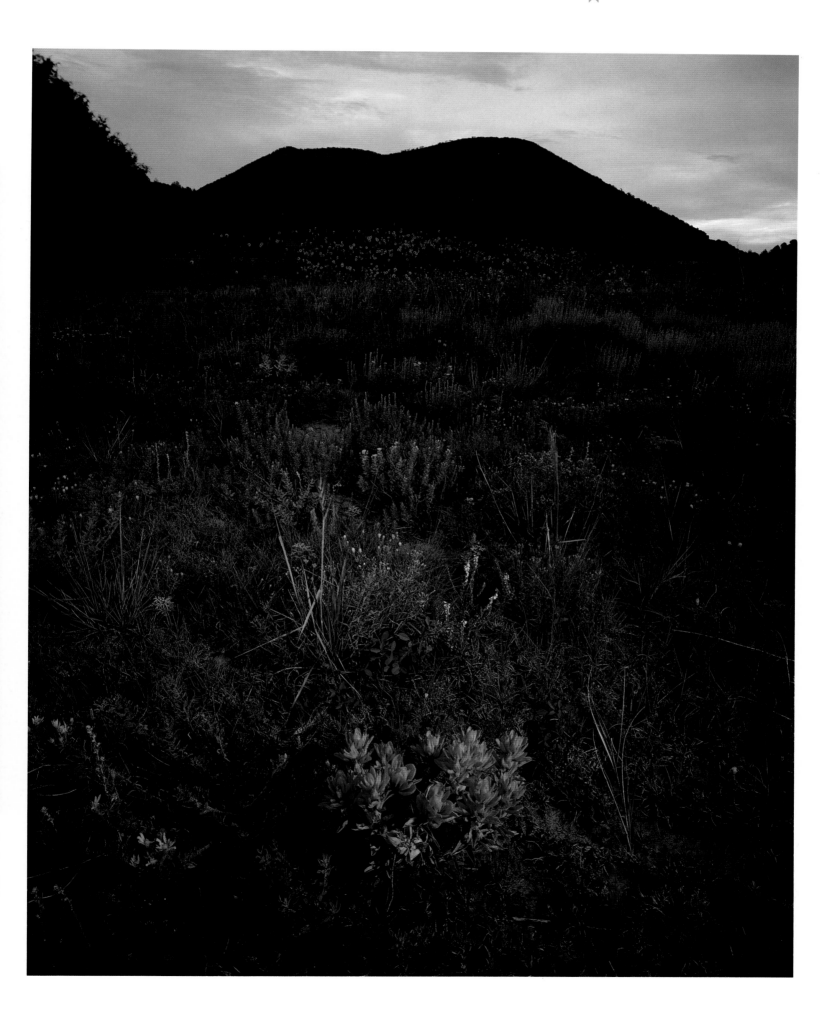

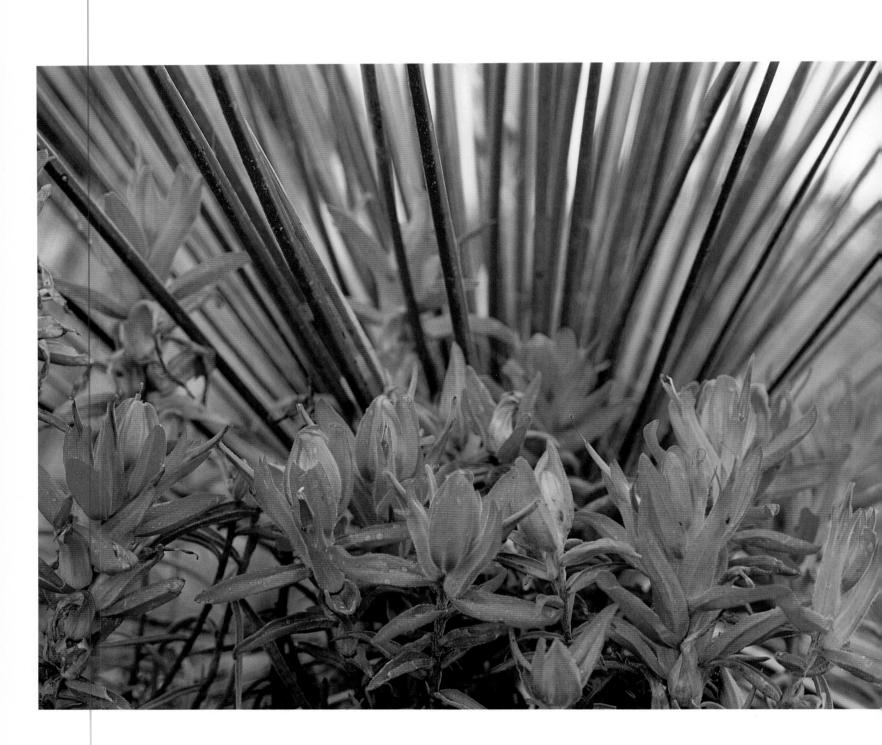

BELOW: A CLUSTER OF PRICKLY POPPY BLOSSOMS

ADORNS AN ALLUVIAL SLOPE OF THE

VOLCANIC SIERRA GRANDE, UNION COUNTY.

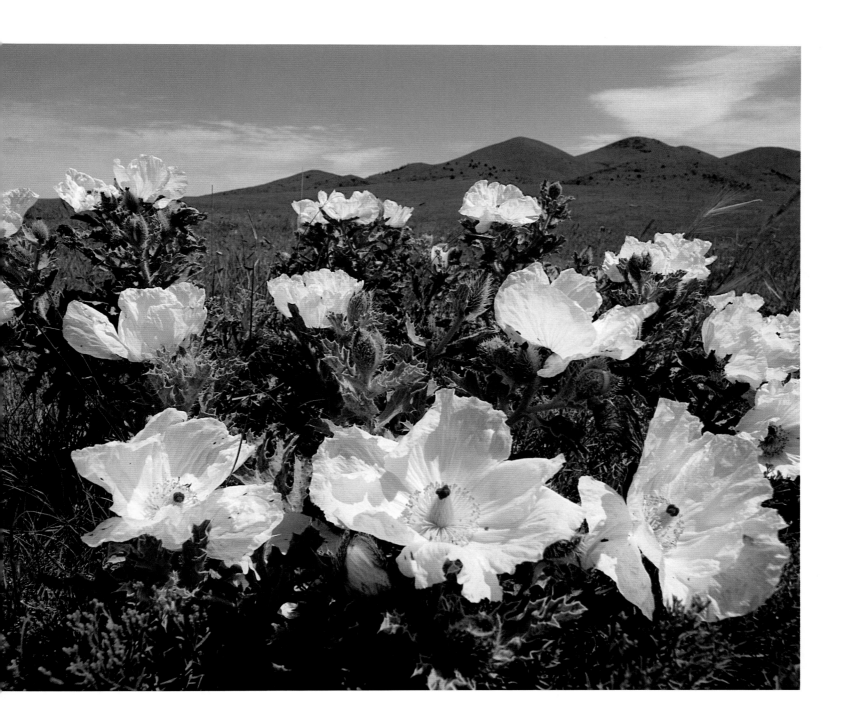

LEFT: A LIZARD'S VIEW OF RED INDIAN PAINTBRUSH

AND YUCCA PLANT IN THE

KIOWA NATIONAL GRASSLANDS, NEAR CLAYTON.

82

RIGHT: A WALL RUIN

OF THE OLD BANK

IN ELIZABETH TOWN,

WITH BALDY MOUNTAIN

IN THE BACKGROUND.

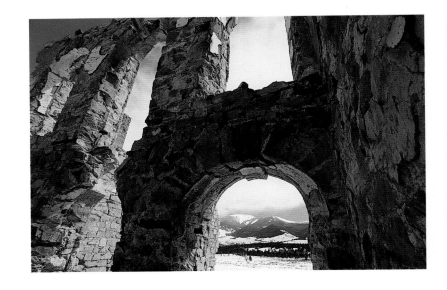

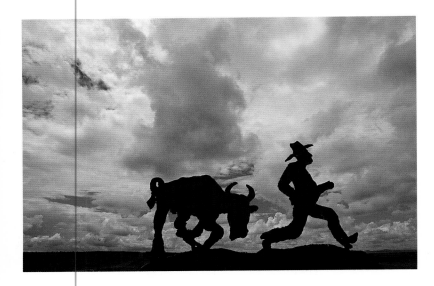

LEFT: AN IRON SCULPTURE

ANNOUNCES A RANCH ENTRANCE

IN LINCOLN COUNTY.

BELOW: RELICS OF ABANDONMENT

AT THE TOWN OF FOLSOM,

UNION COUNTY.

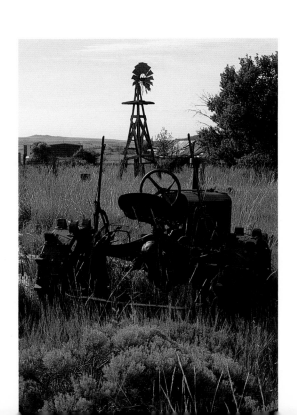

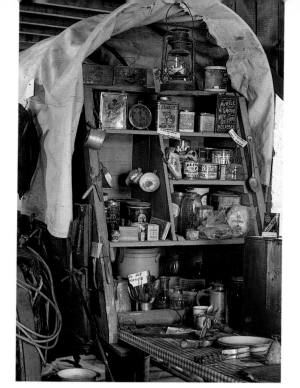

*LEFT: A COOK'S WAGON*

*DISPLAY IN AZTEC*

*MILL MUSEUM, CIMARRON.*

*BELOW RIGHT: A HORSE FEEDS*

*BY A PAINTED WINDOW*

*NEAR GALISTEO.*

*BELOW LEFT: LIGHT SNOW*

*INTEGRATES SCATTERED RELICS*

*OF ABANDONMENT IN NAMBE.*

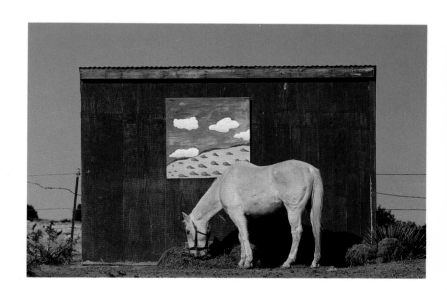

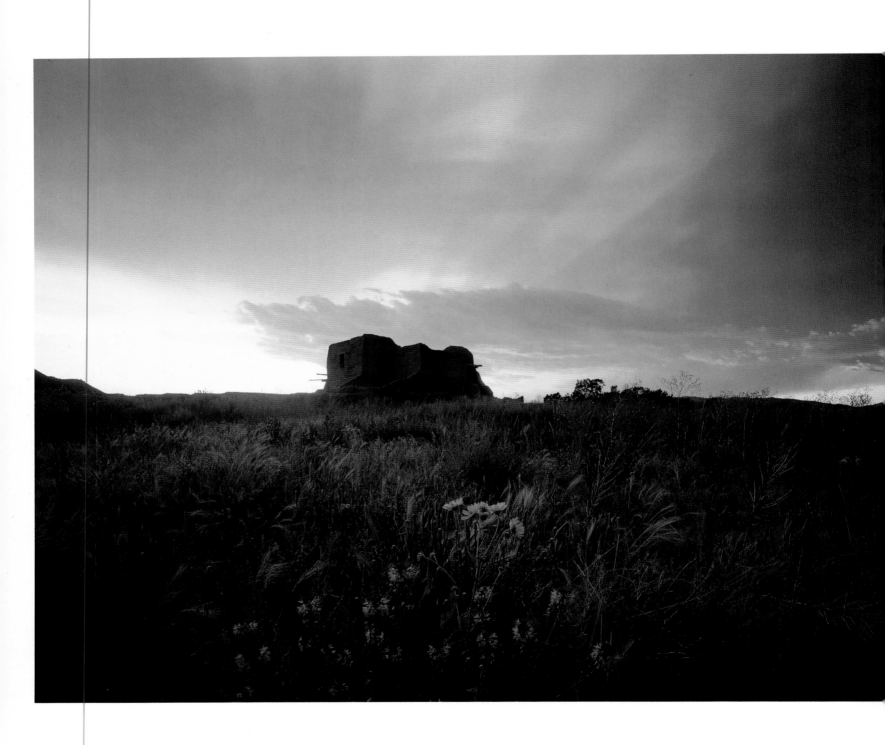

BELOW: THE PETROGLYPH OF FOUR MASKS,

ETCHED IN ROCK, IS THOUGHT TO BE

OF A CEREMONIAL NATURE, GALISTEO BASIN.

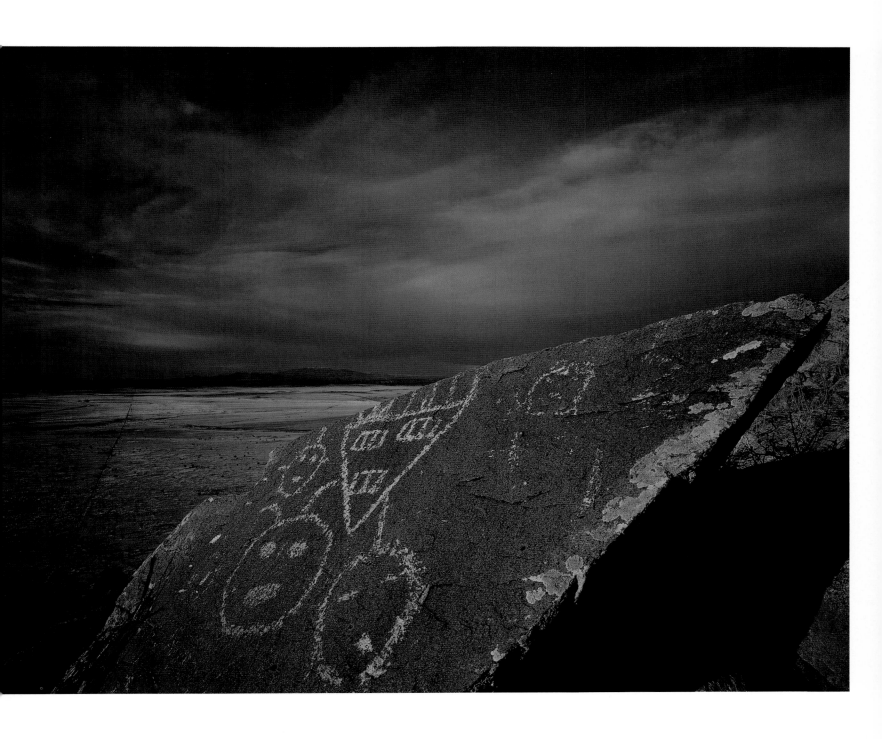

LEFT: THE RUINS OF A SEVENTEENTH-CENTURY SPANISH

MISSION/CHURCH ARE SILHOUETTED AGAINST

AN EVENING SKY, PECOS NATIONAL HISTORICAL PARK.

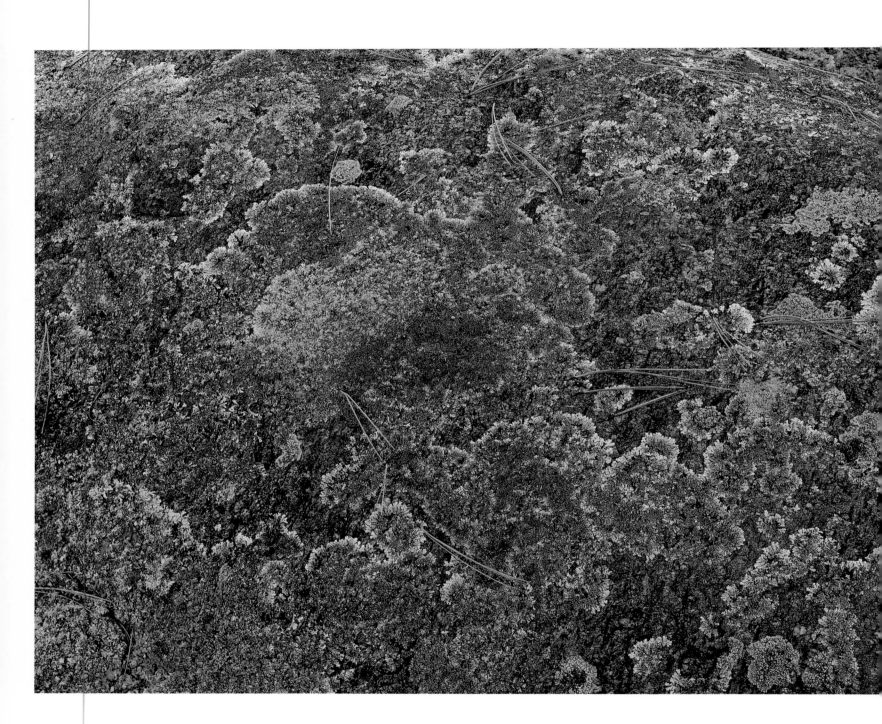

*BELOW: THE SYMBOL OF THE ANCIENT FLUTE PLAYER*

*IS ETCHED OUT OF VOLCANIC PATINA IN THE*

*GALISTEO BASIN, COMANCHE GAP.*

*LEFT: LICHEN PLANTS FORM AN ABSTRACTION*

*ON THE SURFACE OF PINK*

*GRANITE, IN THE CIMARRON RIVER CANYON.*

BELOW: A MAY STORM BROODS OVER MISSION/CHURCH RUINS

IN THE CENTER OF A TWELFTH-CENTURY

PUEBLO, PECOS NATIONAL HISTORICAL PARK.

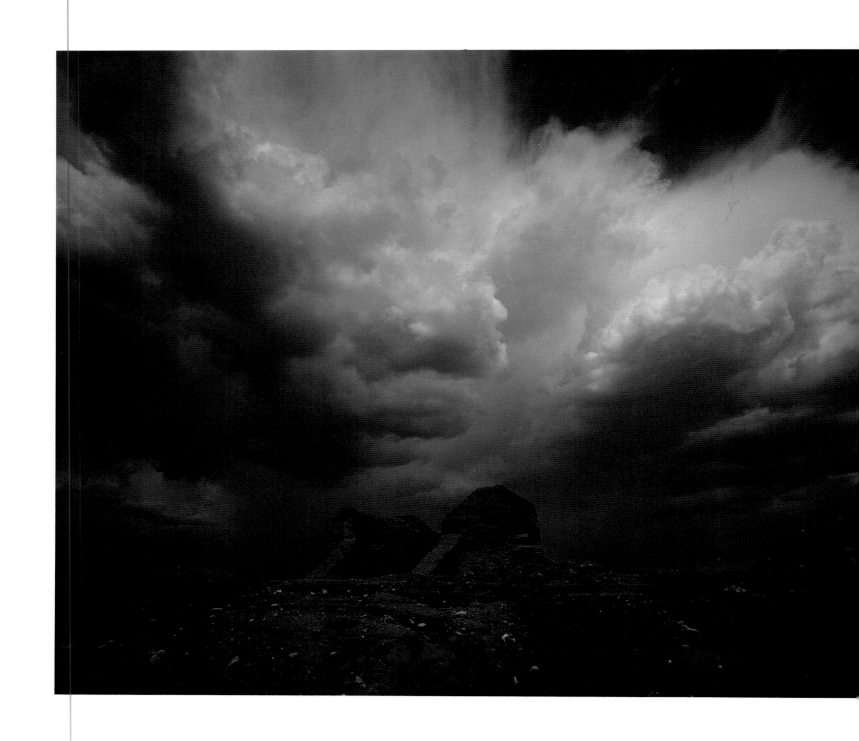

UPPER RIGHT: SPANISH MISSION RUINS ARE SILHOUETTED

AGAINST AN EVENING SKY AT ABO, A UNIT OF

SALINAS PUEBLO MISSIONS NATIONAL MONUMENT.

LOWER RIGHT: TRUCHAS PEAKS AT EVENING THROUGH A

WOODEN CROSS, SANGRE DE CRISTO MOUNTAINS.

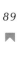
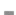
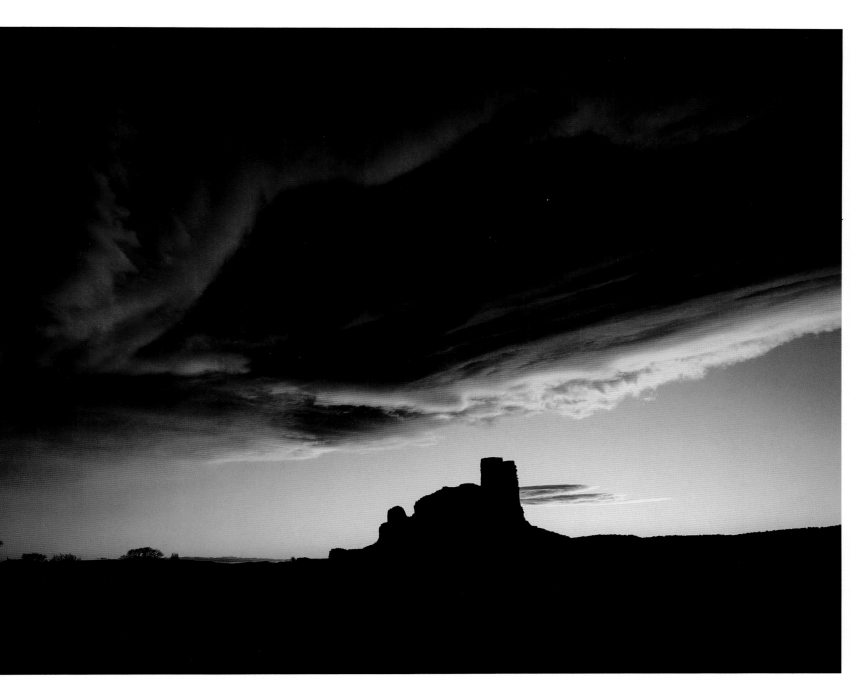
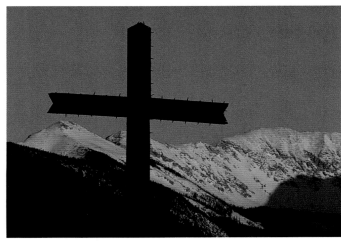

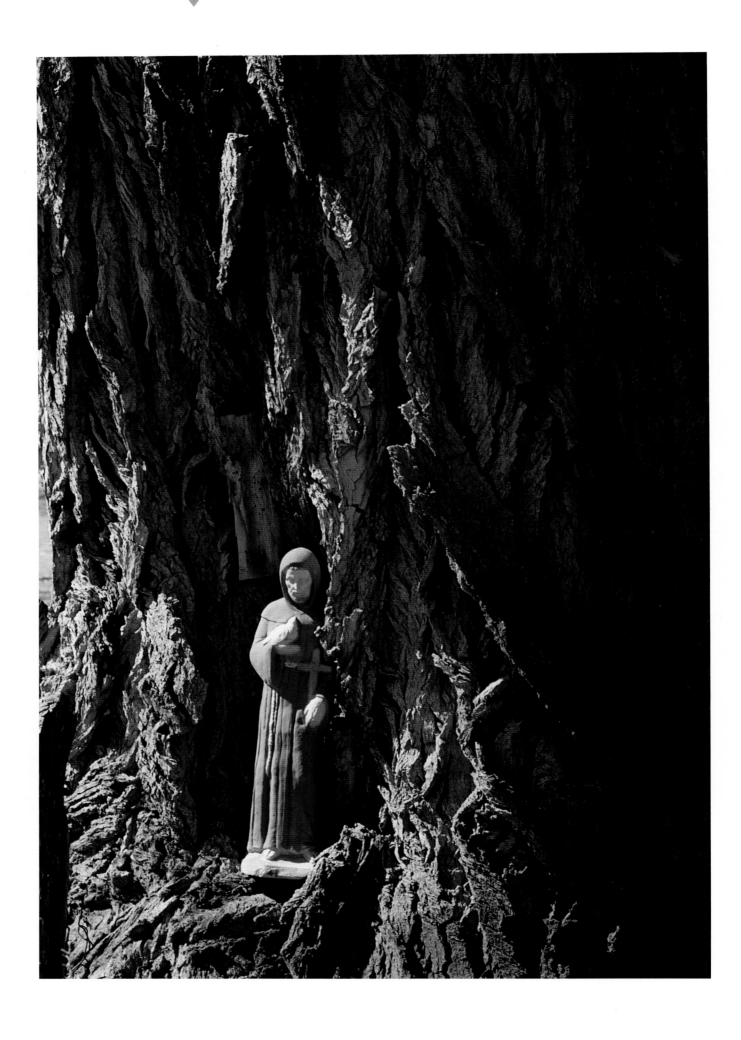

◆

◆

SPANISH RUINS, QUARAI. THE FURROWED BARK

◆

OF AN ANCIENT COTTONWOOD INDICATES THINGS

ARE SLOW TO CHANGE ON THE HIGH PLAINS,

SALINAS PUEBLO MISSIONS NATIONAL MONUMENT.

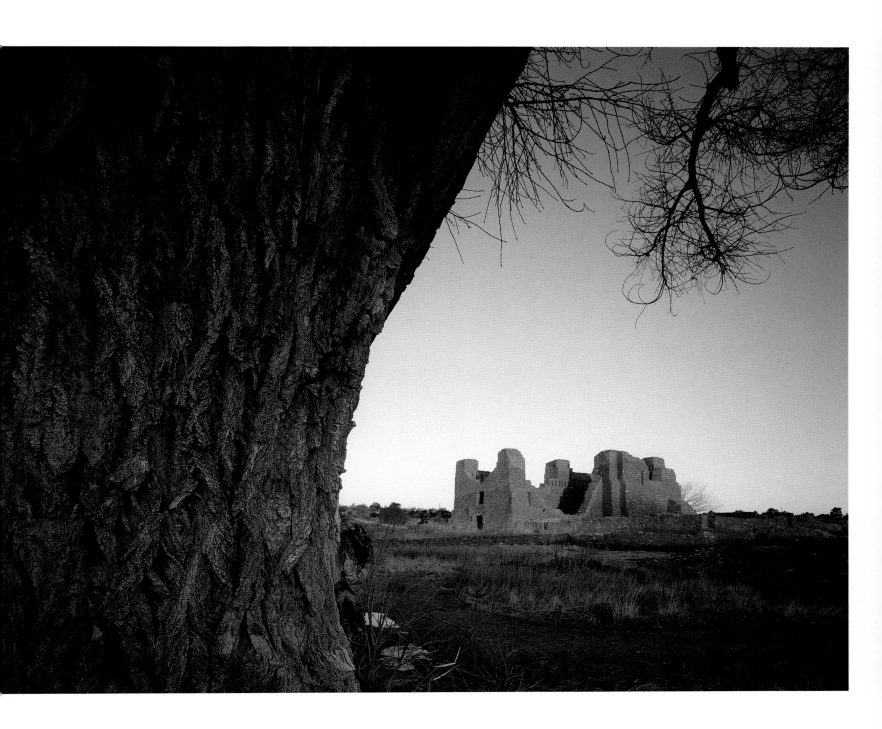

◆

LEFT: A STATUE OF SAINT FRANCIS DE ASSISI LOOKS

OUT FROM A NICHE IN A LARGE, OLD

COTTONWOOD IN A BOSQUE

ALONG THE BANKS OF THE RIO GRANDE, SOCORRO.

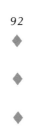

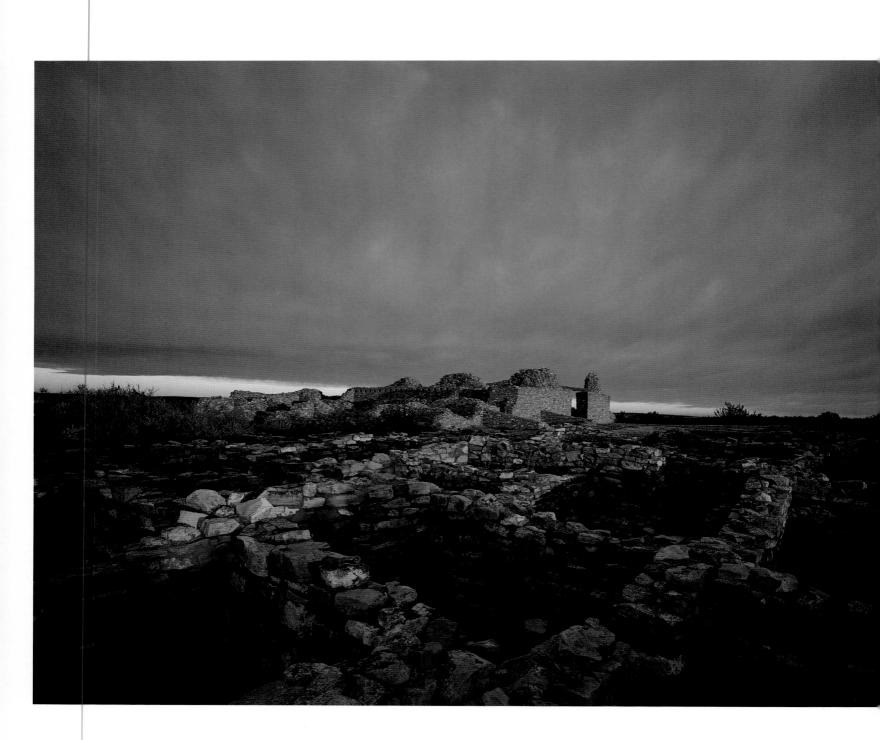

♦

BELOW: PAINTED MASK FIGURES SUGGEST

♦

CEREMONIAL DEITIES OF THE

♦

SIXTEENTH AND SEVENTEENTH CENTURIES

ON A PICTOGRAPH PANEL, THE ABO PASS REGION.

♦

LEFT: RUIN STRUCTURES OF A TWELFTH-CENTURY

INDIAN PUEBLO AND MISSION/CHURCH ARE

HIGHLIGHTED BY THE RISING SUN AT GRAN QUIVIRA,

SALINAS PUEBLO MISSIONS NATIONAL MONUMENT.

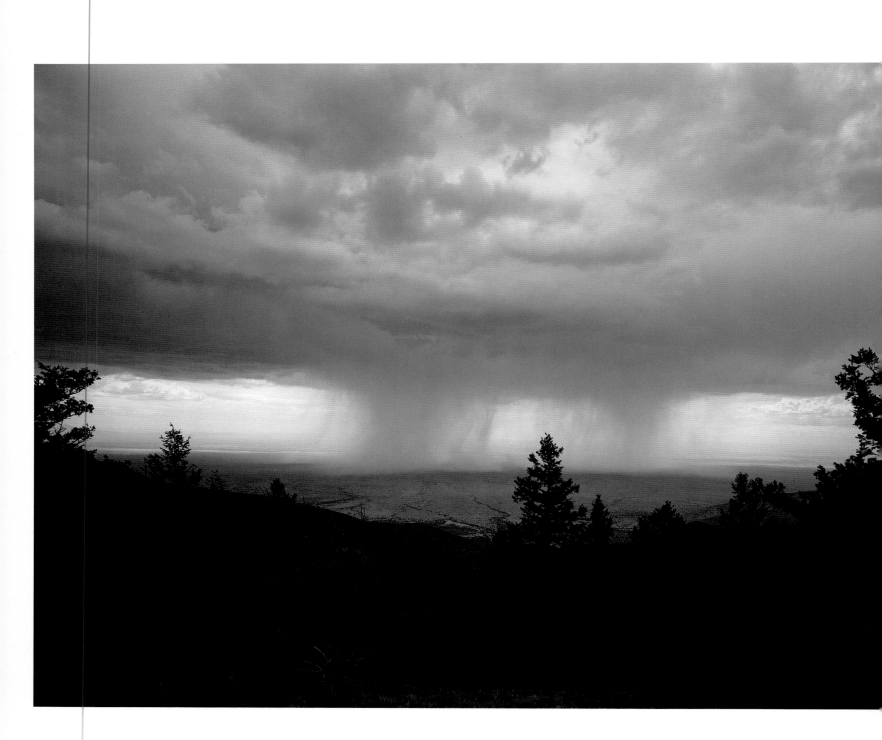

◆

*BELOW: THE TWIN FEATHERED SERPENTS PETROGLYPH WATCHES*

◆

*OVER A TIMELESS ARROYO IN THE ABO PASS REGION.*

◆

*THE AREA SERVES AS AN IMPORTANT PASSAGE BETWEEN THE*

*HIGH PLAINS AND THE RIO GRANDE RIVER VALLEY.*

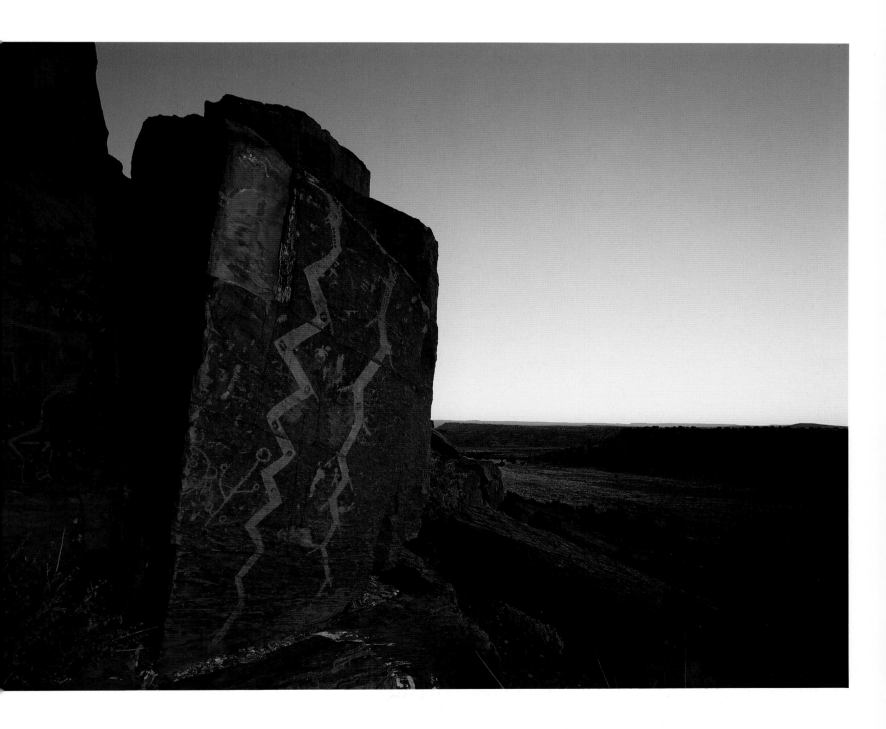

◆

*LEFT: FROM CAPILLA PEAK, A MAY RAIN SHOWER BEGINS*

*TO FALL ON AN ALLUVIAL PLAIN IN THE RIO GRANDE*

*RIVER VALLEY, MANZANO MOUNTAIN WILDERNESS.*

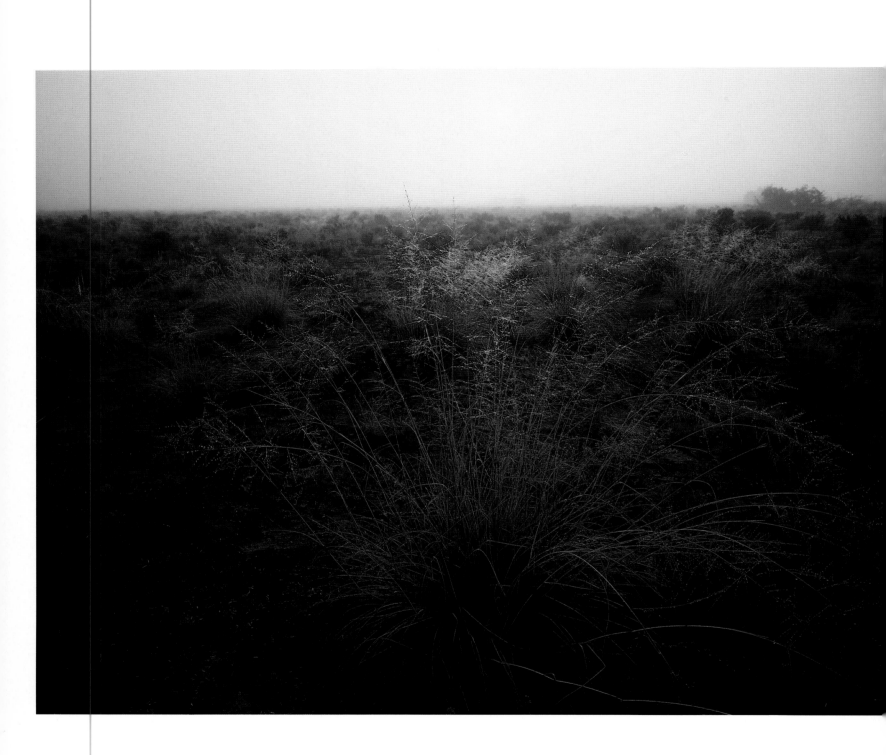

BELOW: A LONE YUCCA LINKS THE EVENING SKY

◆

WITH RIPPLED GYPSUM SANDS,

◆

WHITE SANDS NATIONAL MONUMENT.

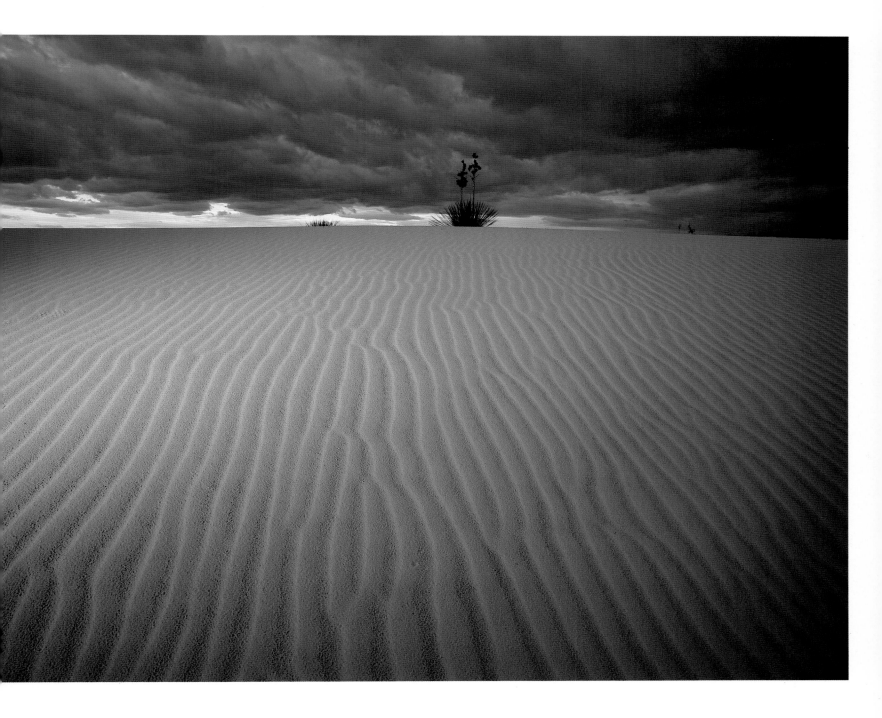

◆

LEFT: MORNING DEWDROPS HIGHLIGHT

SWITCH GRASS IN THE

QUERECHO PLAINS, NEAR HOBBS.

◆

◆

◆

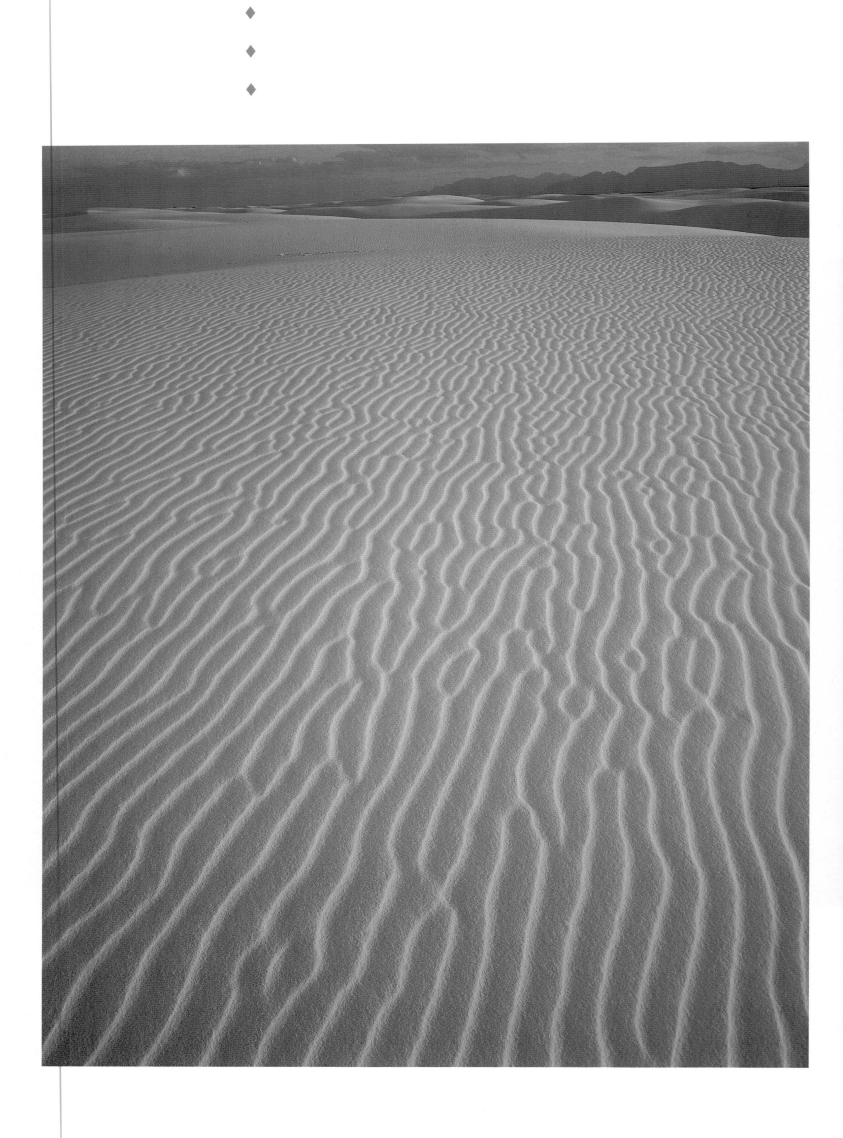

♦

BELOW: A HEDGEHOG CACTUS DISPLAYS ITS FLOWERING

♦

RADIANCE IN MAY ON PAHOEHOE LAVA,

♦

VALLEY OF FIRES STATE PARK, TULAROSA VALLEY NEAR CARRIZOZO.

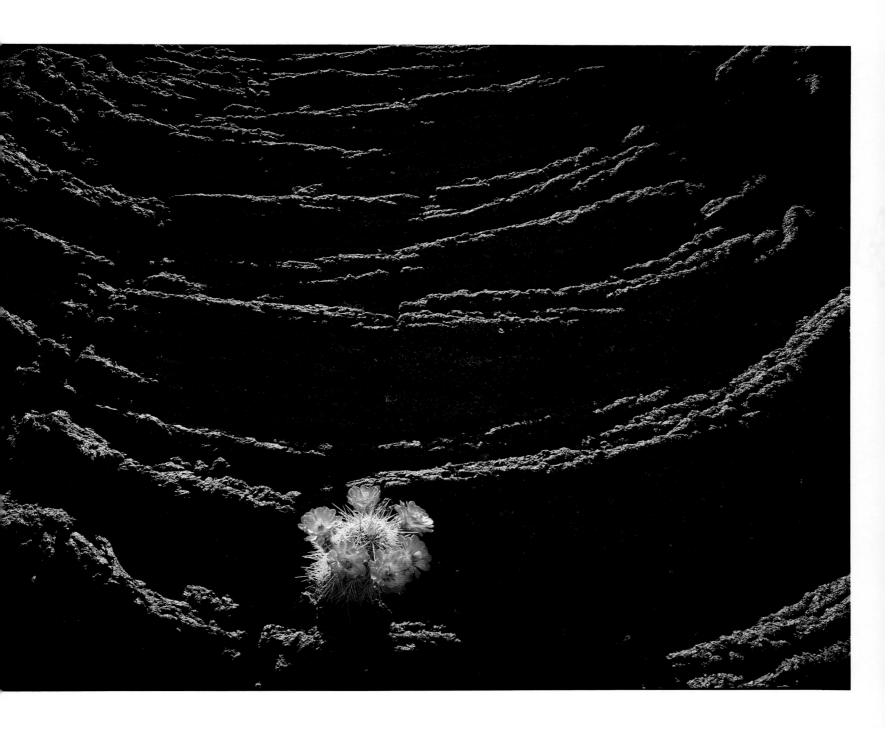

♦

LEFT: WESTERLY WINDS HAVE GENTLY ETCHED

THESE GYPSUM DUNES IN EVENING MOOD,

WHITE SANDS NATIONAL MONUMENT.

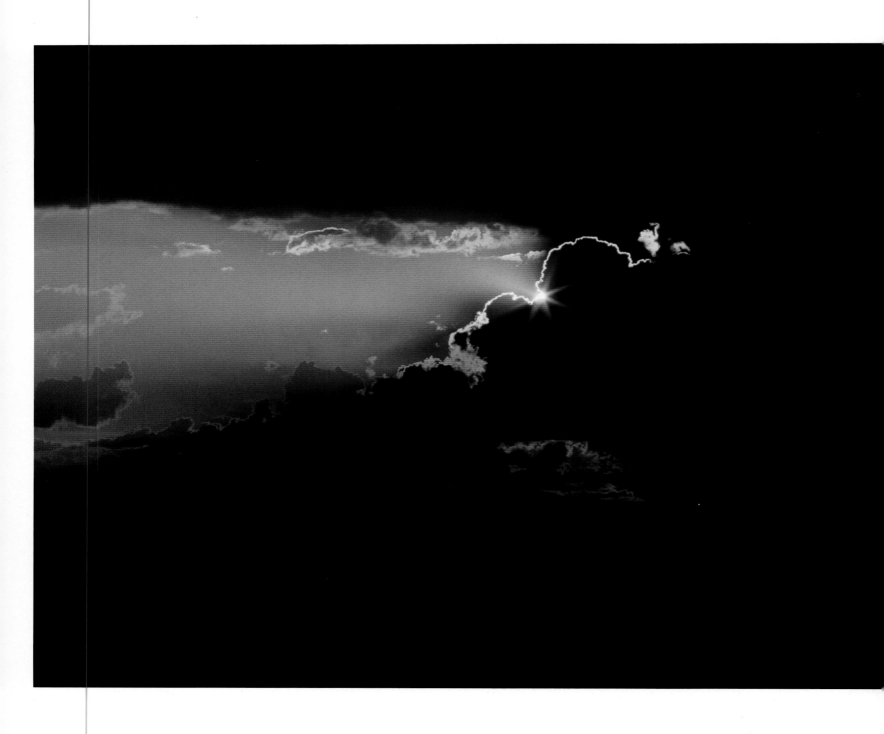

◆

*BELOW: AN AUGUST STORM DARKENS AN EVENING SKY*

◆

*ABOVE A FLOWERING MESQUITE PLANT*

◆

*AND THE ORGAN MOUNTAINS, NEAR LAS CRUCES.*

*CAN BE DRAMATIC, EVEN VIOLENT, AT TIMES.*

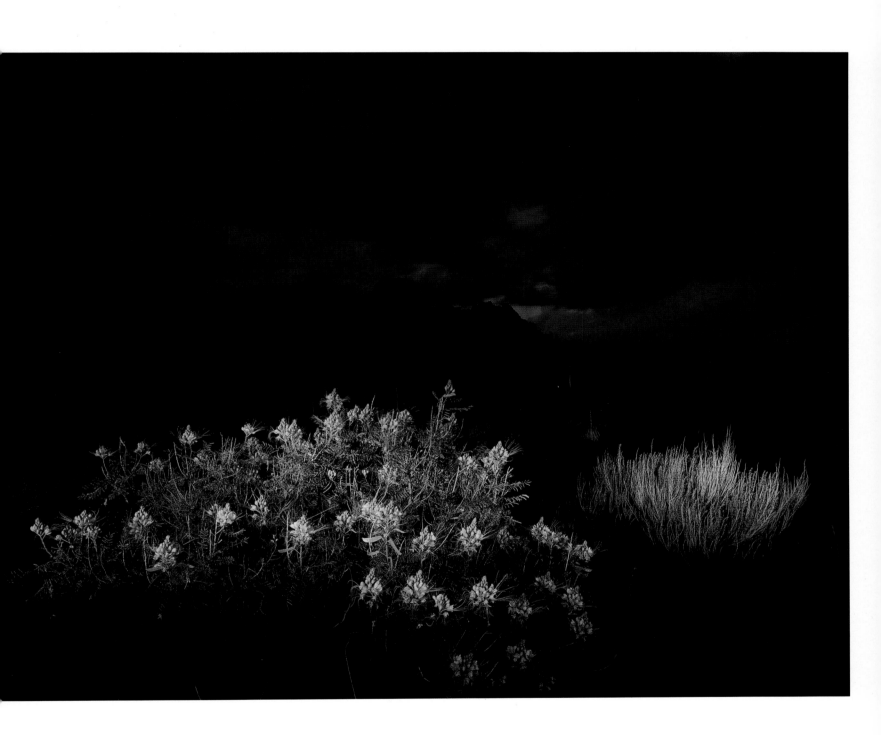

◆

*LEFT: THE SUN HIGHLIGHTS A THUNDERHEAD*

*IN THE SAME EVENING STORM AS THE PHOTOGRAPH ABOVE.*

*SUMMER STORMS IN THIS AREA*

*CAN BE DRAMATIC, EVEN VIOLENT, AT TIMES.*

◆

*BELOW: APRIL BLOOMS OF CLARET CUP CACTUS AND*

◆

*BANANA YUCCA ADORN A DESERT ALLUVIAL PLAIN BELOW*

◆

*SERRATED GRANITES OF THE ORGAN MOUNTAINS.*

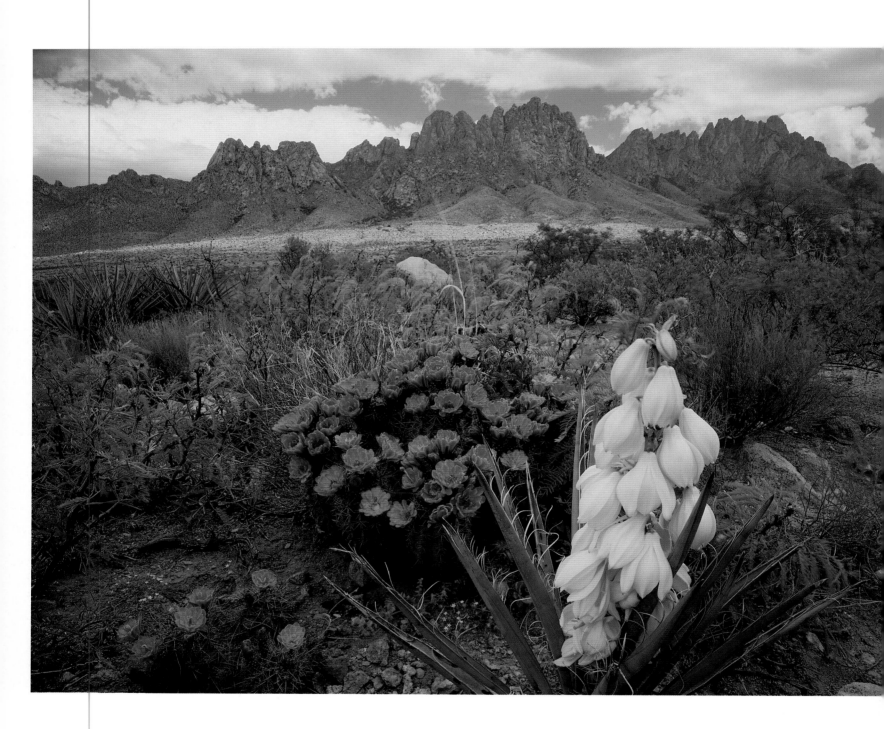

◆

*UPPER RIGHT: A WINTER-DESICCATED PRICKLY PEAR CACTUS*

*CLINGS TO A VOLCANIC WALL NEAR DRIPPING SPRINGS IN THE*

*ORGAN MOUNTAINS, NEAR LAS CRUCES.*

*LOWER RIGHT: SACRED DATURA AND*

*GRASSES SHARE A DESERT ARROYO, AGUIRRE SPRING.*

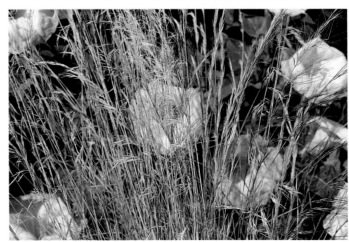

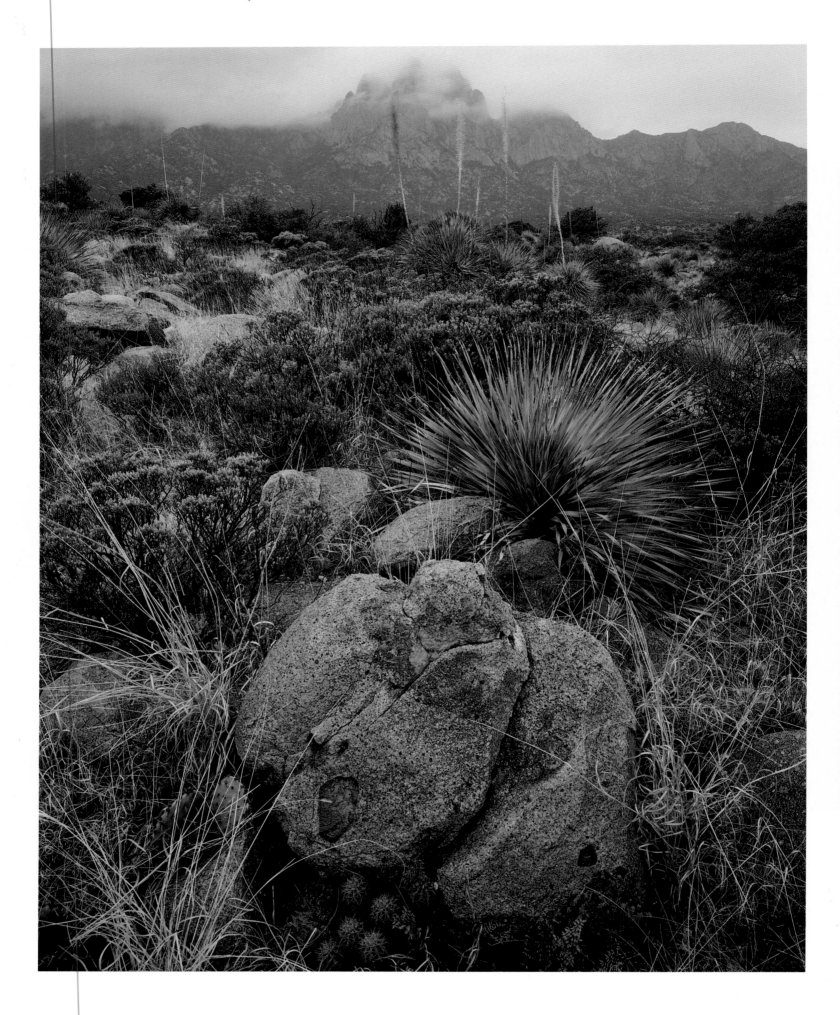

◆

*BELOW: IN MAY, GRANITE SPIRES OF THE*

◆

*ORGAN MOUNTAINS CONTRAST WITH YUCCA BLOSSOMS*

◆

*IN THE CHIHUAHUAN DESERT, AGUIRRE SPRING.*

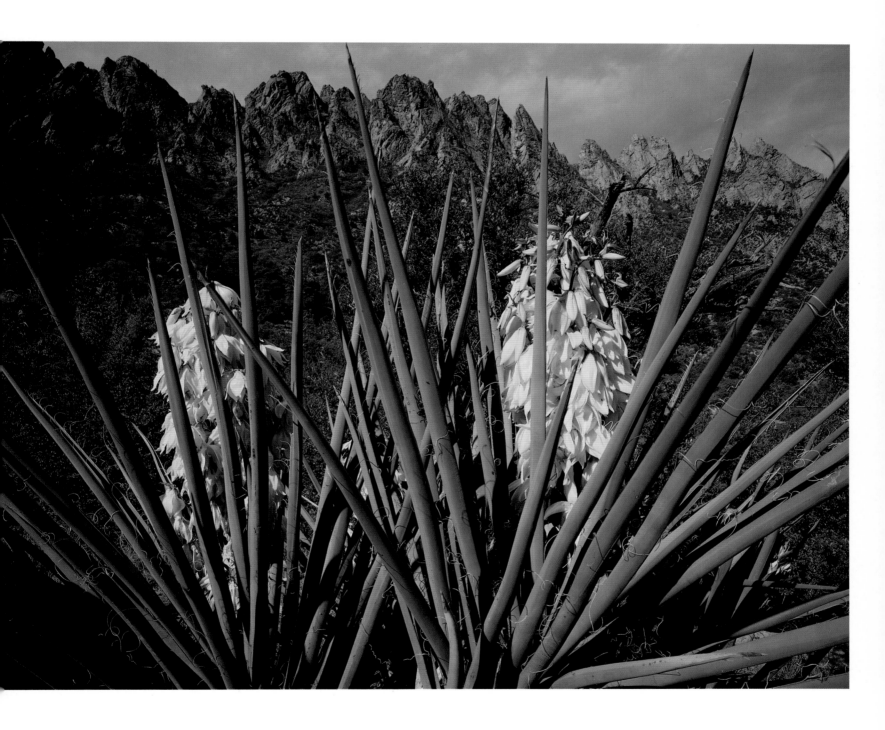

◆

*LEFT: AN UPPER SONORAN DESERT PLANT COMMUNITY*

*OF GRASSES, HEDGEHOG CACTUS, SOTOL, MAHOGANY, AND*

*OAK SURROUNDS AN OUTCROP OF GRANITE*

*BELOW RABBIT EARS PEAK, ORGAN MOUNTAINS.*

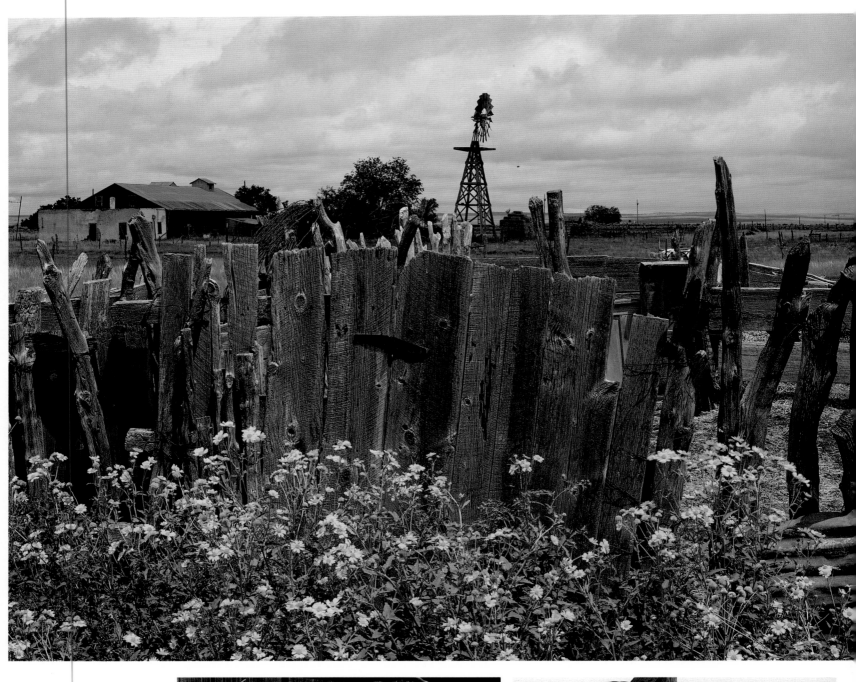

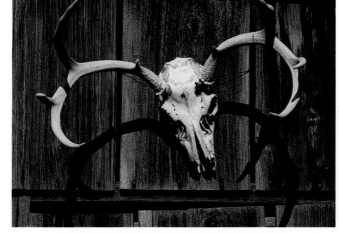

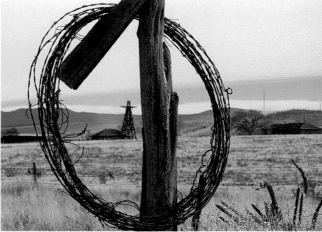

◆

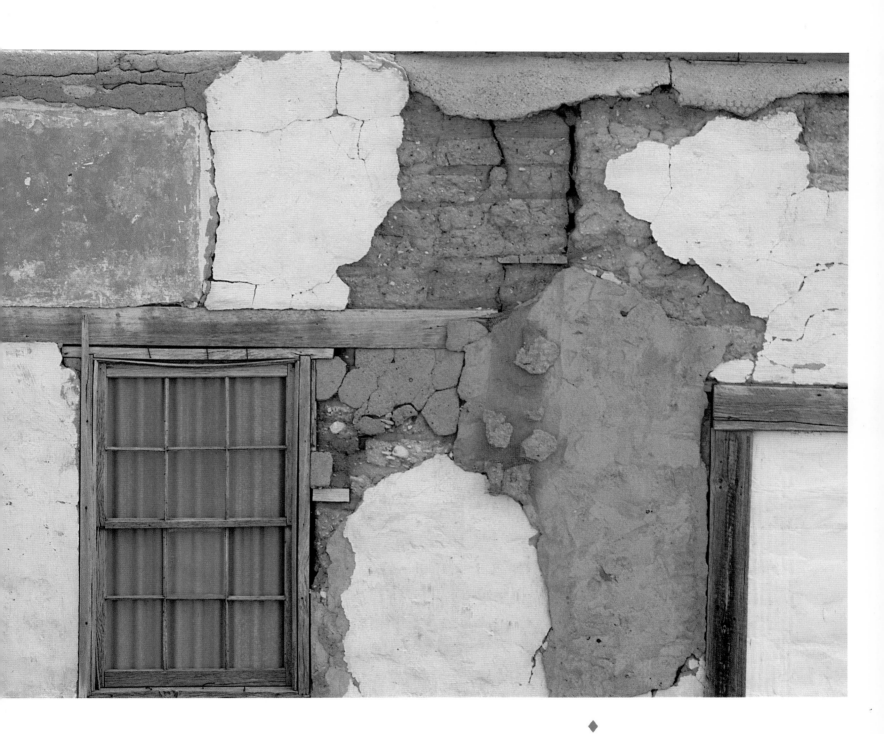

◆

*UPPER LEFT: A HOMEMADE CORRAL FENCE LENDS A WEATHERED*

*NOTE TO SURVIVAL ON AN ABANDONED RANCH IN CLAUNCH.*

*FAR LEFT: AN ELK SKULL ON A PINE WALL*

*OF A RANCH BARN IN CLAUNCH.*

*CLOSE LEFT: A CIRCLE OF SPARE FENCING WIRE ISOLATES*

*AN ABANDONED HOMESTEAD IN CLAUNCH, SOCORRO COUNTY.*

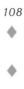
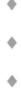

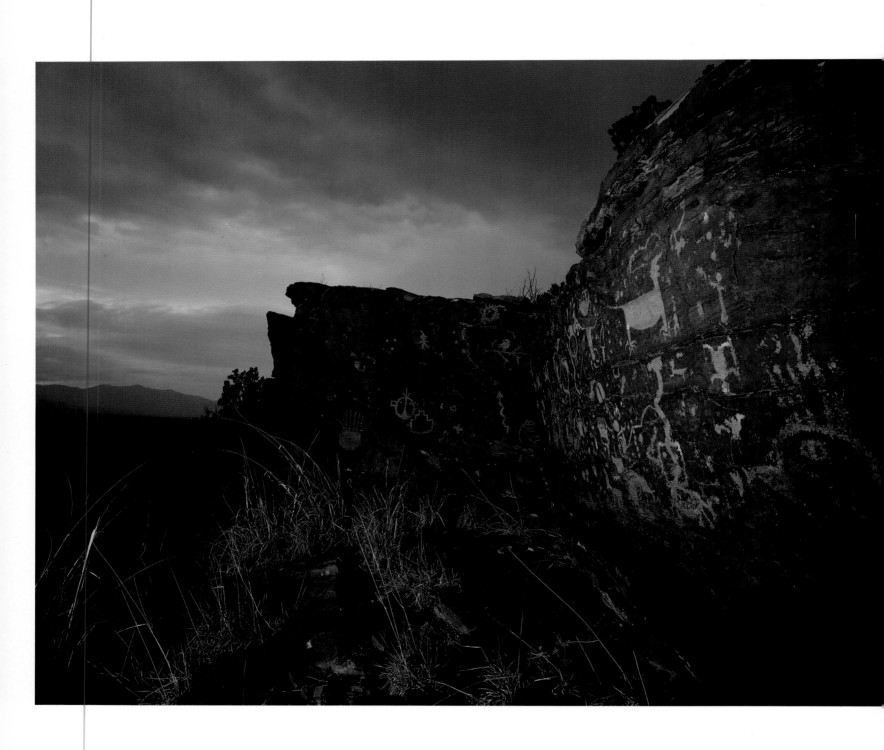

◆

*BELOW: AN ETCHED FACE AT THREE RIVERS SITE*

◆

*STARES UP INTO ANOTHER TIME ON THE*

◆

*DESERT FLOOR BEFORE THE DISTANT SIERRA BLANCA.*

*THE PEOPLE WHO CREATED THESE PETROGLYPHS*

*ARE REFERRED TO AS DESERT JORNADA.*

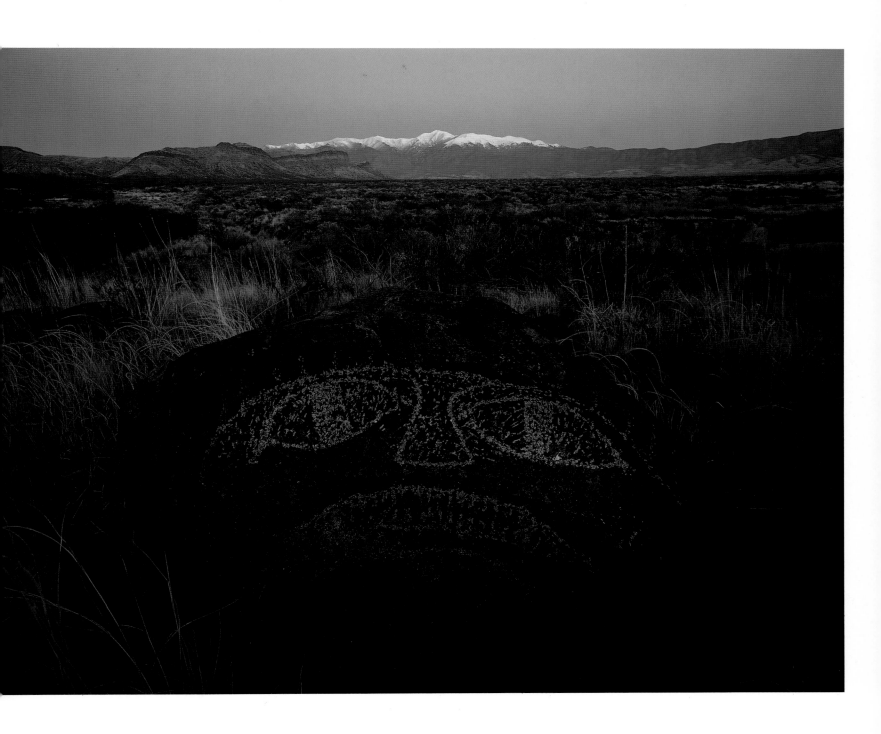

◆

*LEFT: ANIMAL AND MASK FIGURES HAUNT*

*A PETROGLYPH PANEL*

*ON A SANDSTONE PATINA, THE ABO PASS REGION.*

♦

*BELOW: MAIDENHAIR FERNS GROW ALONG THE WALL*

♦

*BESIDE A GENTLE CASCADE, MINERALIZED BY*

♦

*SPRINGS AT SITTING BULL FALLS, GUADALUPE MOUNTAINS.*

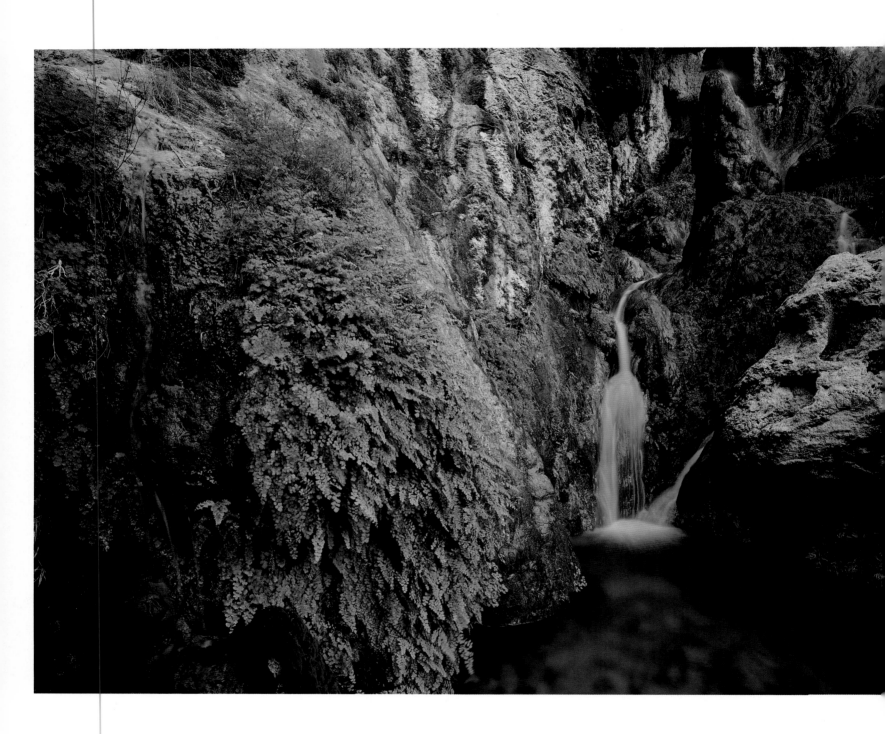

♦

*RIGHT: CARDINAL FLOWER AND GOLDENROD ARE*

*WELL WATERED ALONG POOLS*

*IN SITTING BULL CANYON, GUADALUPE MOUNTAINS.*

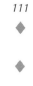

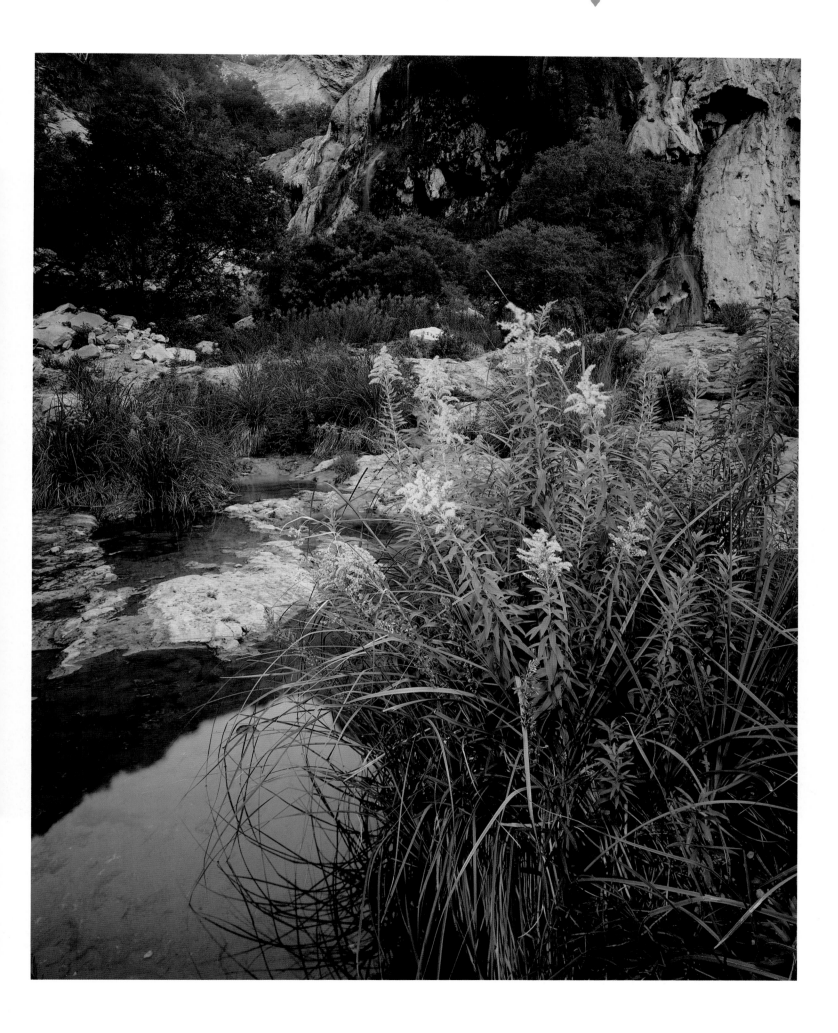

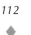

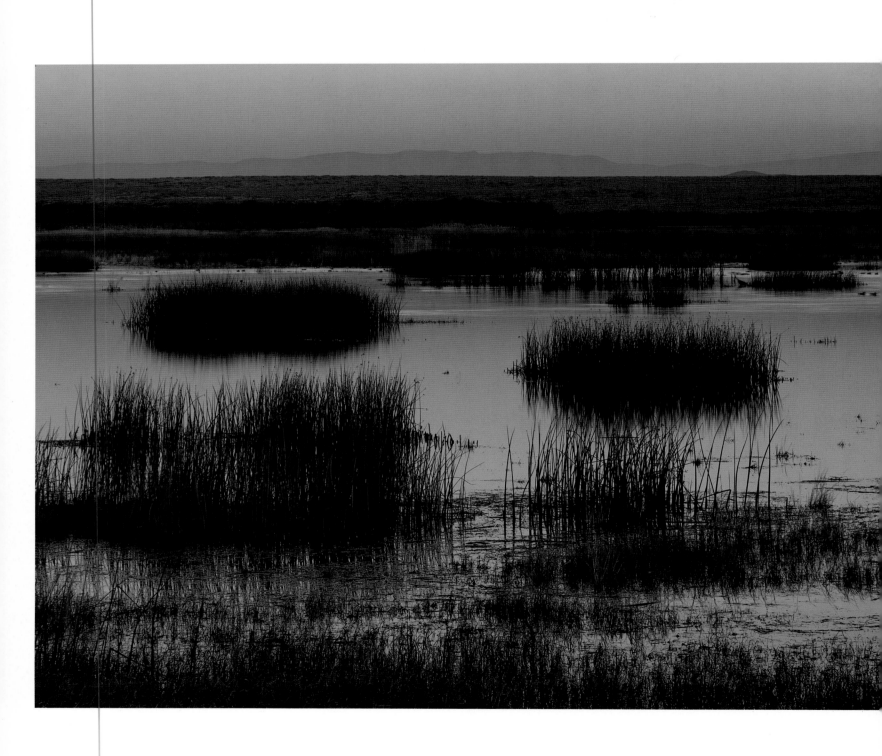

◆

*BELOW: SANDHILL CRANES FEED IN THE MARSHES*

◆

*WHILE SNOW GEESE FLY ABOVE,*

◆

*BETWEEN THE GRAIN FIELDS AND POOLS OF*

*BOSQUE DEL APACHE NATIONAL WILDLIFE REFUGE.*

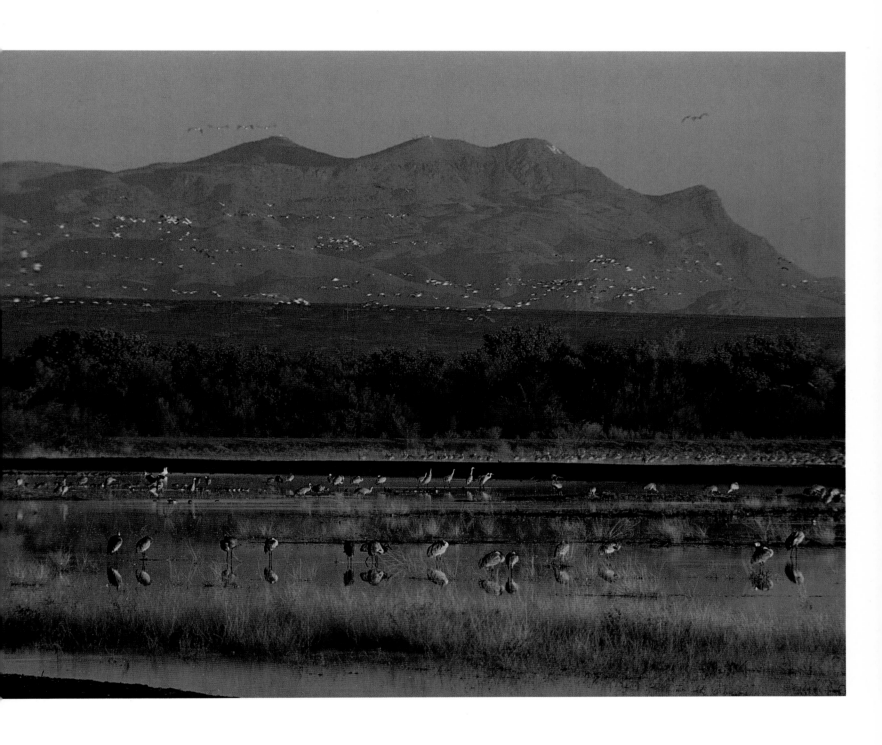

◆

*LEFT: EVENING DESCENDS ON THE MARSHES ALONG THE*

*RIO GRANDE AT BOSQUE DEL APACHE*

*NATIONAL WILDLIFE REFUGE, NEAR SOCORRO.*

◆

*BELOW: A VOLCANIC RIDGE AT THREE RIVERS DISCLOSES*

◆

*FIGURE PETROGLYPHS MADE BY*

◆

*PEOPLE OF THE DESERT JORNADA TRADITION.*

*THE SNOW-COVERED SIERRA BLANCA IS TO THE EAST.*

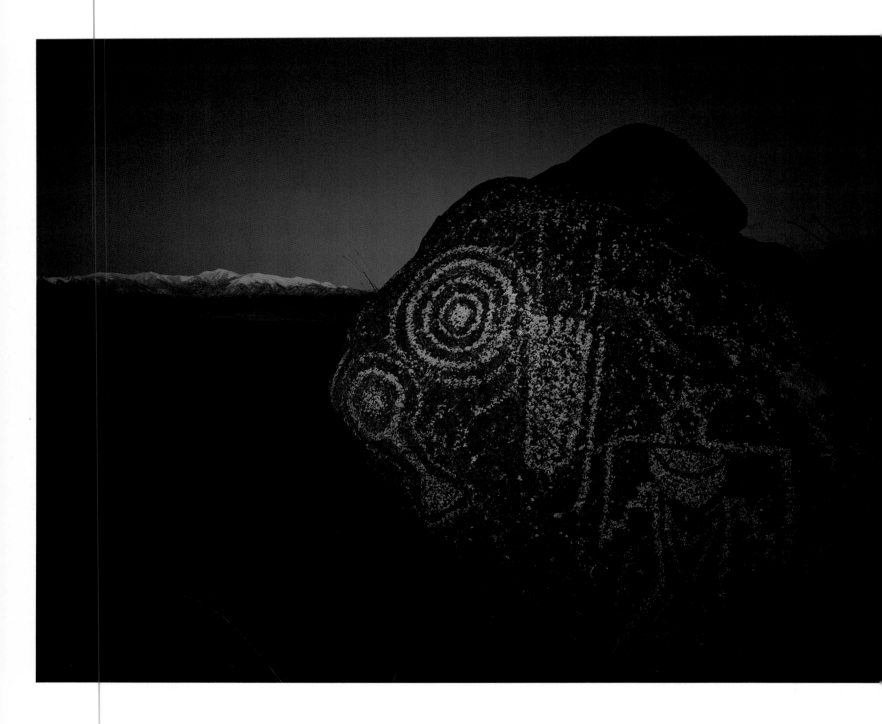

◆

*RIGHT: PAINTED FIGURES AND DESIGNS*

*OF AN ARCHAIC DESERT CULTURE*

*STRETCH ACROSS THE BACK OF PAINTED GROTTO,*

*CARLSBAD CAVERNS NATIONAL PARK.*

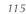

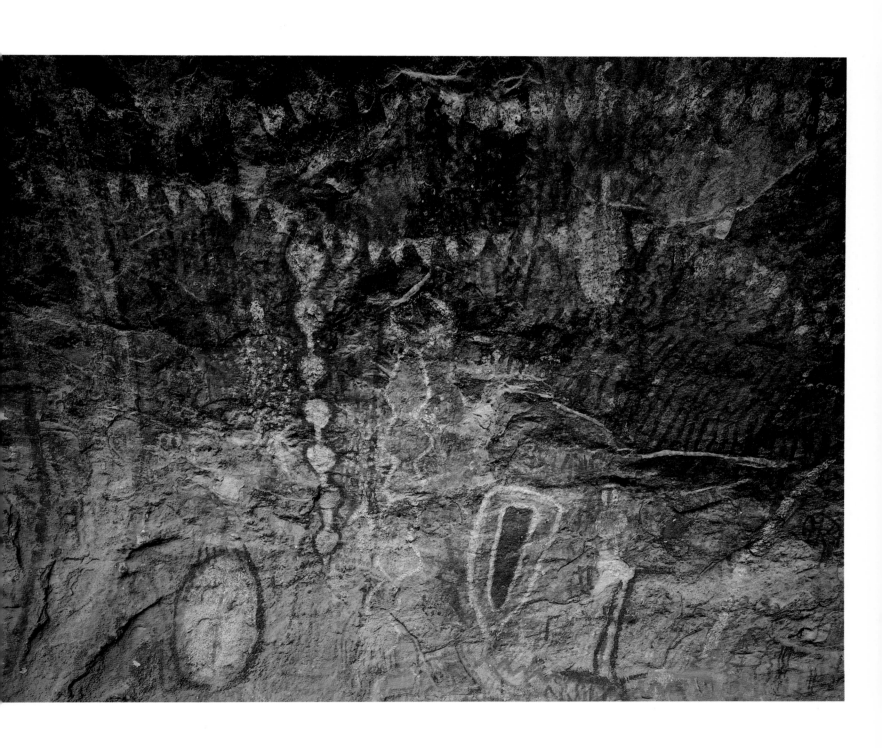

◆

*BELOW: WALL*

◆

*STALACTITES FORM*

◆

*PATTERNS IN*

*NEW CAVE, CARLSBAD*

*CAVERNS NATIONAL PARK.*

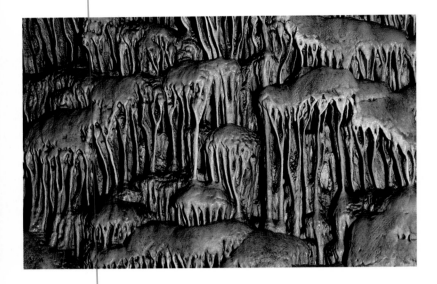

*RIGHT: VARIOUS HUES*

*ILLUMINATE ROCK OF AGES*

*IN THE BIG ROOM,*

*CARLSBAD CAVERNS.*

*BELOW: THIS FORMATION IN*

*NEW CAVE IS NAMED*

*THE CHRISTMAS TREE.*

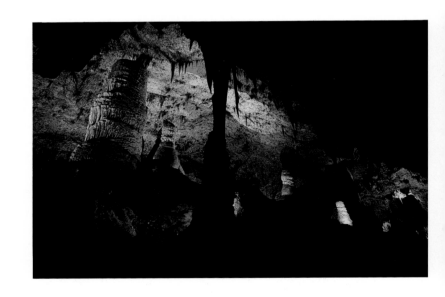

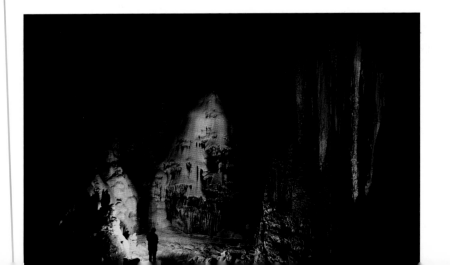

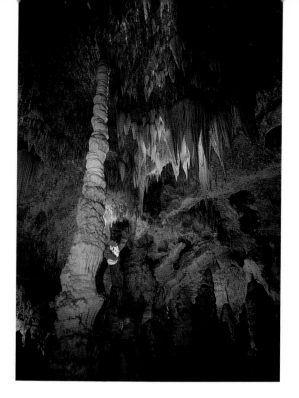

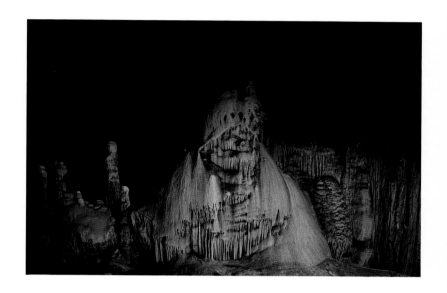

*RIGHT: A LARGE STALAGMITE*

*FORMATION, THE CLANSMAN,*

*IN NEW CAVE, CARLSBAD CAVERNS.*

*BELOW: COOL HUES OF A POOL*

*MINGLE WITH WARM TONES OF*

*SURROUNDING FORMATIONS*

*IN THE GREEN LAKE ROOM,*

*CARLSBAD CAVERNS NATIONAL PARK.*

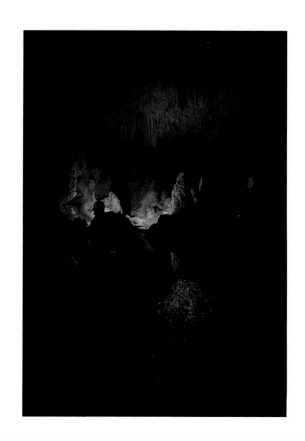

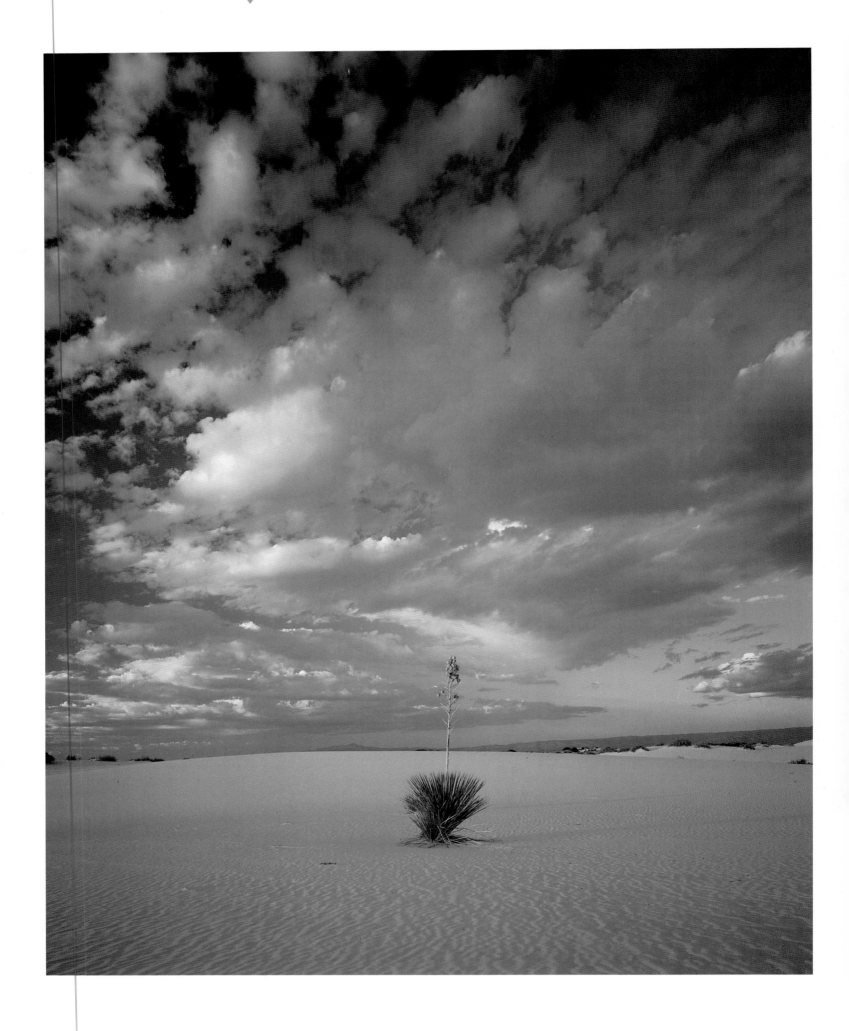

◆

BELOW: SUMMER THUNDERSTORMS OVER THE

◆

HACHITA VALLEY BREAK UP INTO LOFTY

◆

SCULPTURES AT SUNSET BEHIND A YUCCA PLANT IN

THE BOOT HEEL OF NEW MEXICO.

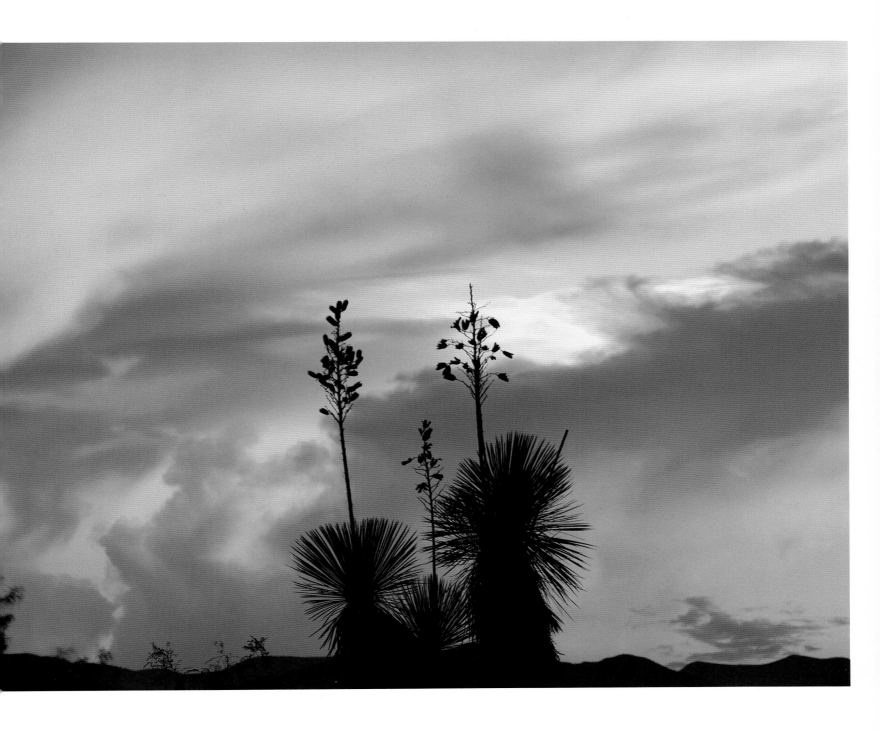

◆

LEFT: EVENING SKY AND A LONE YUCCA PLANT SUGGEST

INTENSE SOLITUDE, WHITE SANDS NATIONAL MONUMENT.

FOLLOWING PAGES: MOUNTAIN RIDGES AND FORESTS

OF GILA AND ALDO LEOPOLD WILDERNESSES.

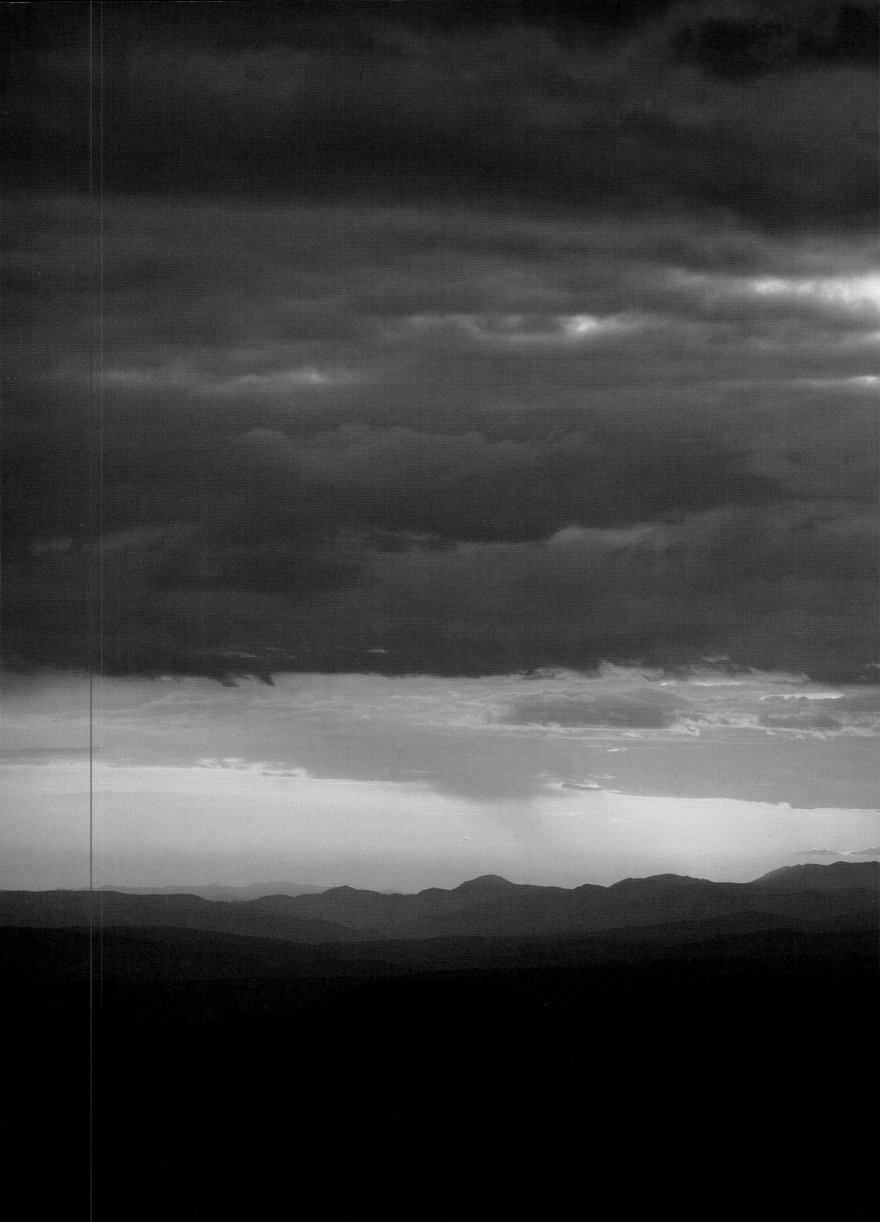

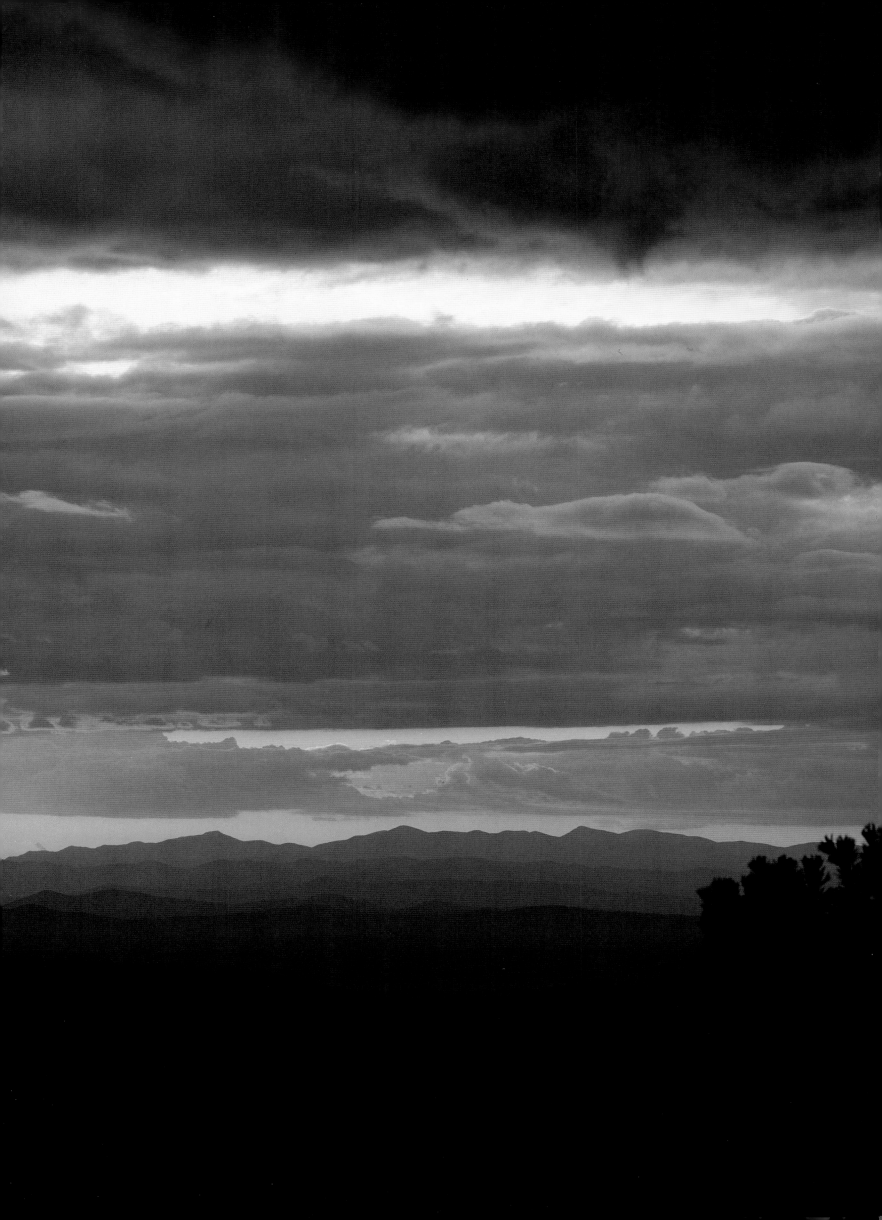

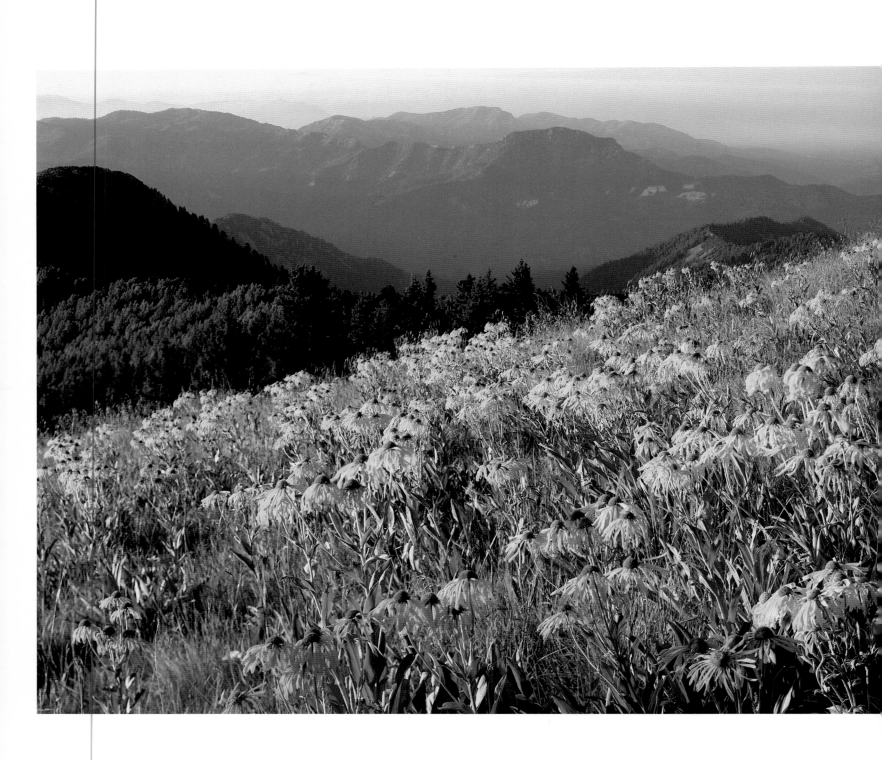

BELOW: A SLOPING FOREST FLOOR IN JULY

WITH LOGS AND FERNS AT

LITTLE HOBO SPRING, GILA WILDERNESS.

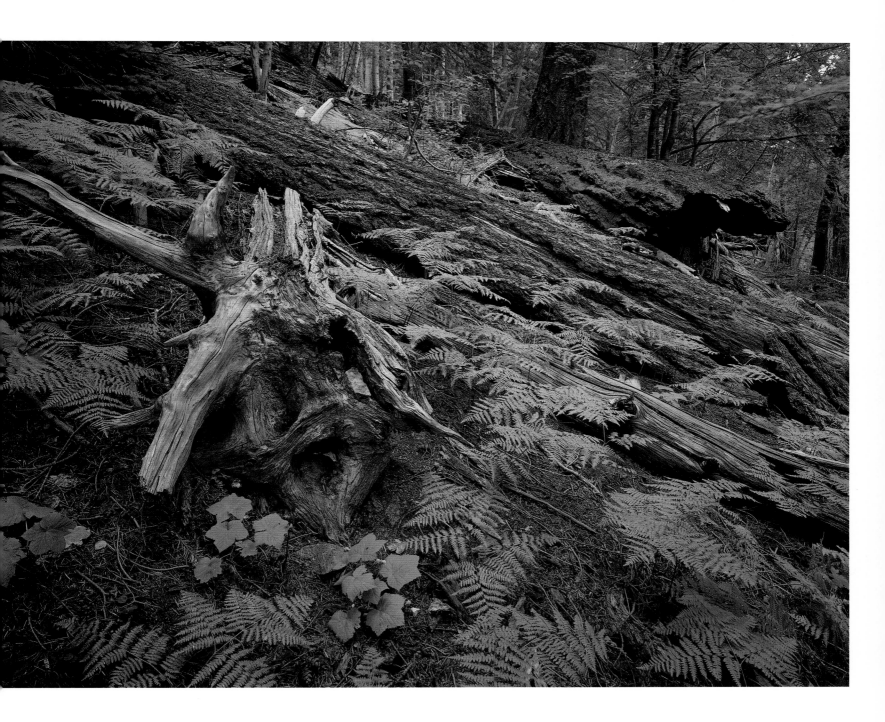

LEFT: SNEEZEWEED APPEARS SUSPENDED

IN A HANGING MEADOW ON

MOGOLLON BALDY PEAK, GILA WILDERNESS.

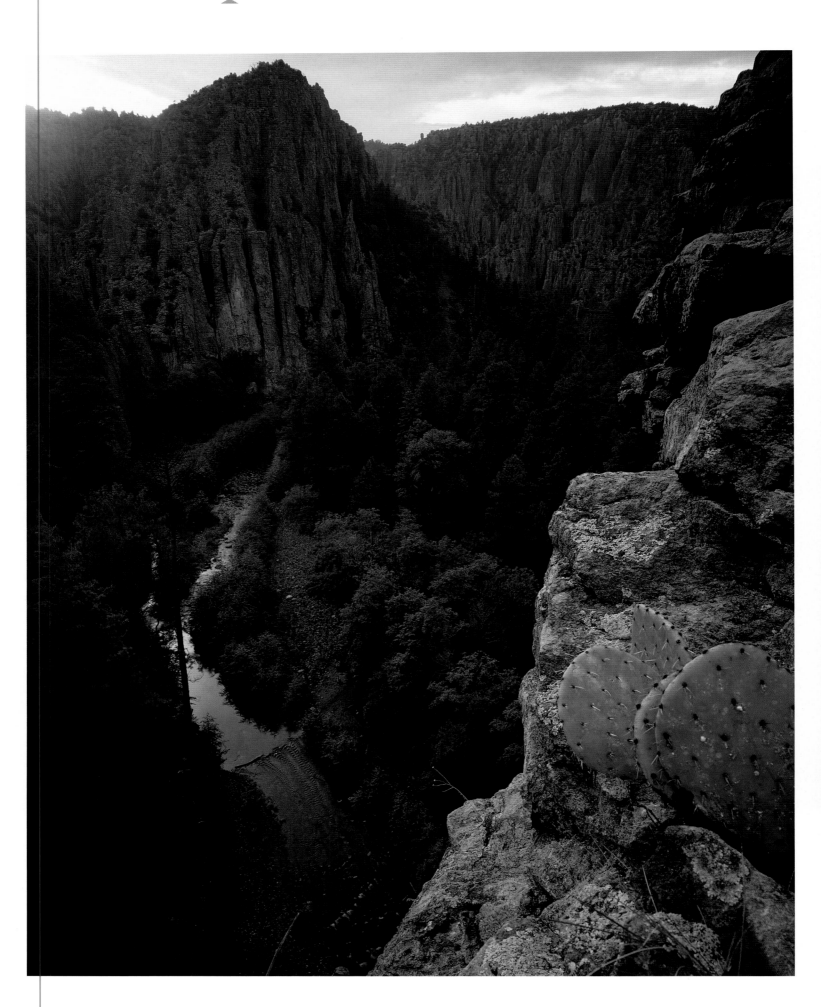

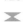
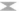

BELOW: A SUMMER AFTERNOON THUNDERSHOWER

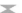

DEVELOPS OVER PLAYA VALLEY FROM THE VOLCANIC SPIRES OF

ANIMAS MOUNTAINS. THE NATURE CONSERVANCY'S

GRAY RANCH PRESERVE, THE BOOT HEEL OF NEW MEXICO.

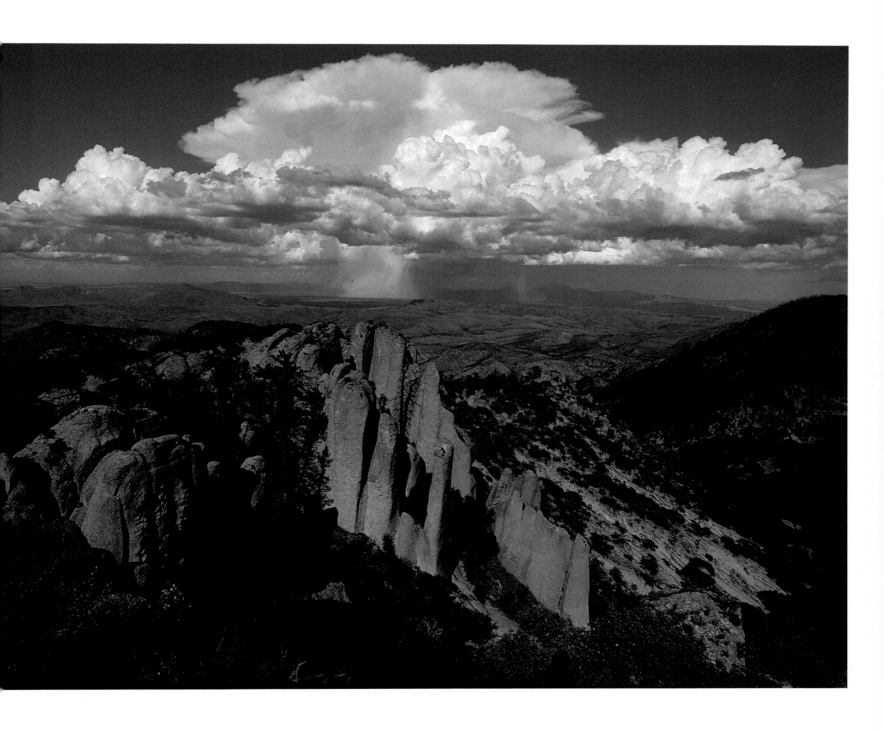

LEFT: THE WEST FORK OF THE GILA RIVER

WINDS THROUGH A CANYON OF VOLCANIC SPIRES IN

THE HEART OF THE GILA WILDERNESS.

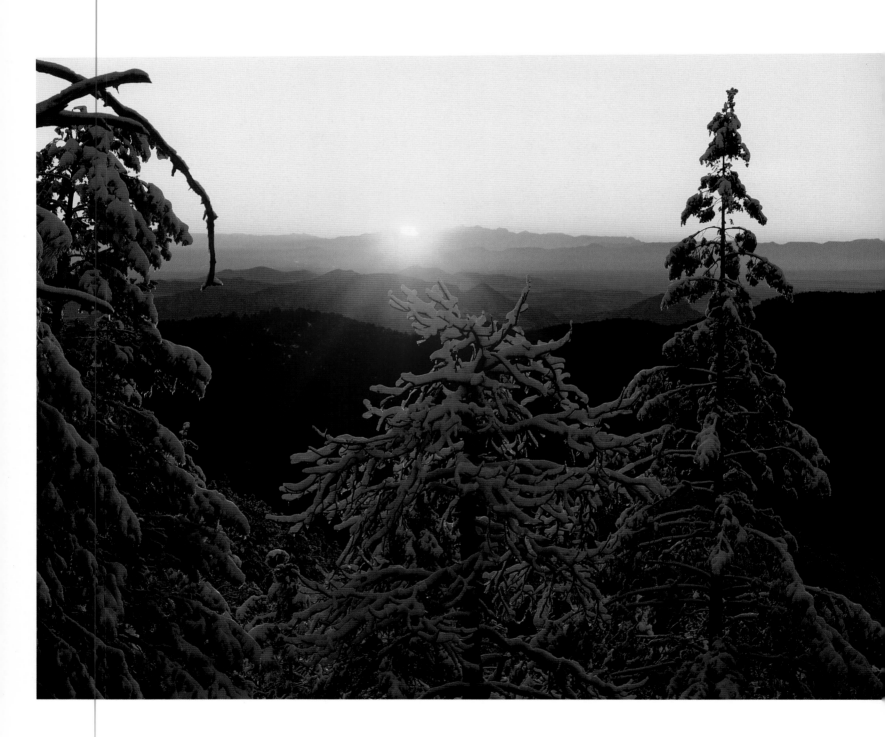

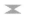
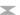
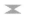
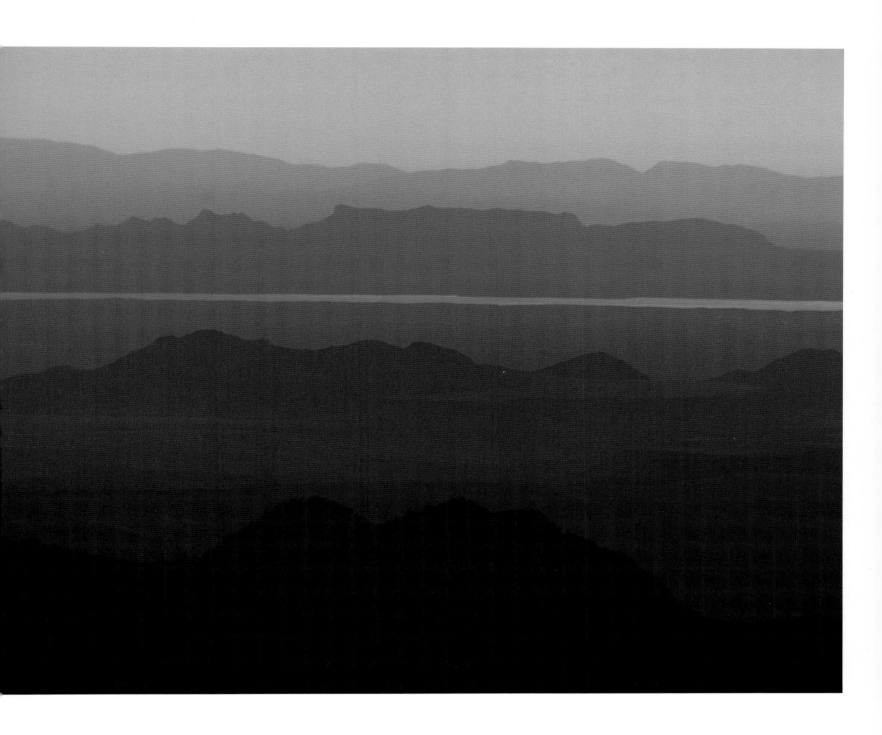

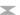

*LEFT: THE DISTANT ORGAN MOUNTAINS SPLIT A*

*DECEMBER SUN FROM THE FORESTED*

*HEIGHTS OF THE BLACK RANGE, HILLSBORO PEAK.*

✕

*BELOW: A MOGOLLON DWELLING COMPLEMENTS*

✕

*THE ARCHED BUTTRESS IN CAVES,*

✕

*GILA CLIFF DWELLINGS.*

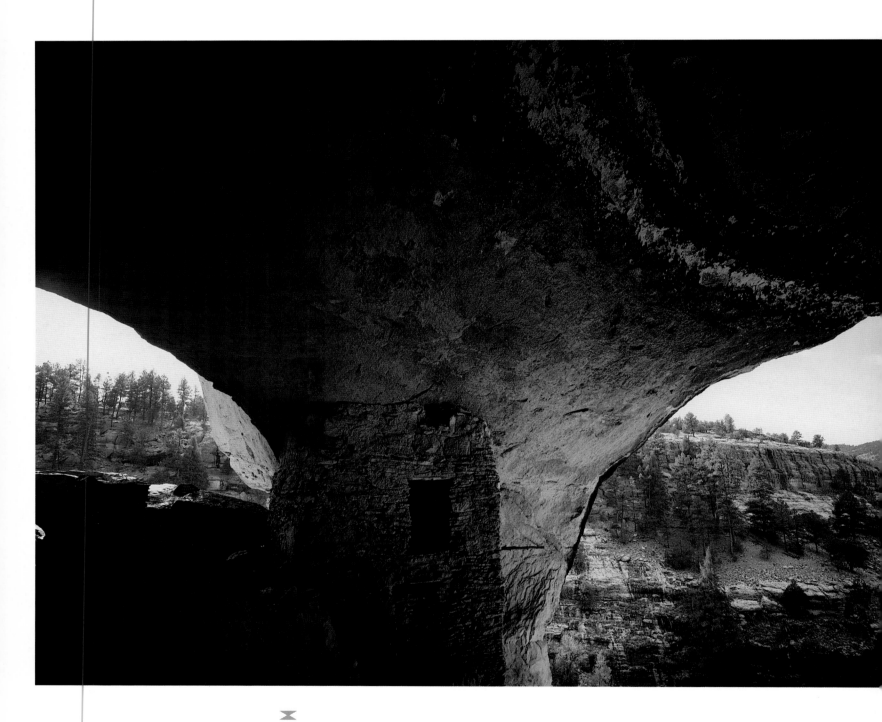

✕

*UPPER RIGHT: PEOPLE OF THE MOGOLLON TRADITION*

*INHABITED NATURAL VOLCANIC CAVES,*

*GILA CLIFF DWELLINGS NATIONAL MONUMENT.*

*LOWER RIGHT: MIMBRES BLACK-ON-WHITE BAT DESIGN*

*WAS MADE BY A THIRTEENTH-CENTURY POTTER*

*LIVING ALONG THE MIMBRES RIVER NEAR SILVER CITY.*

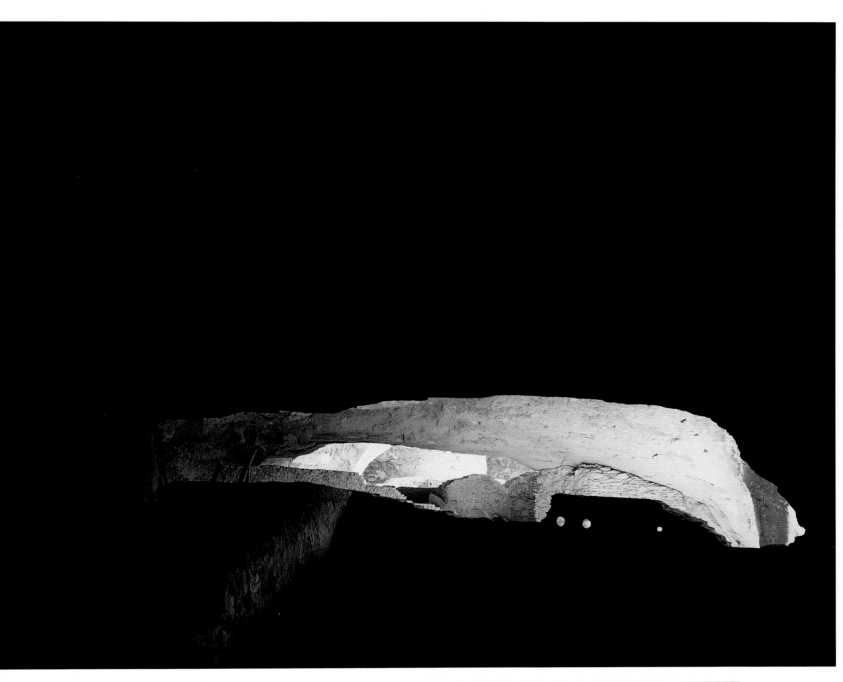

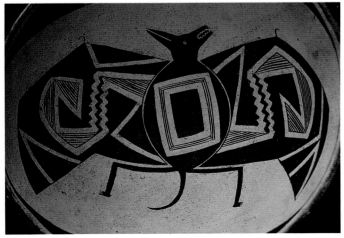

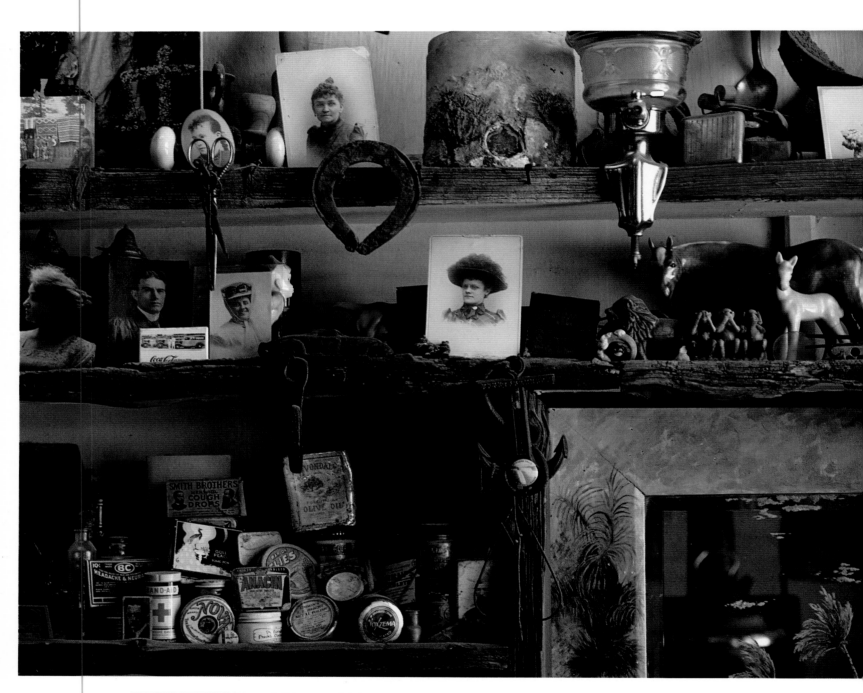

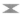
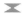
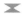
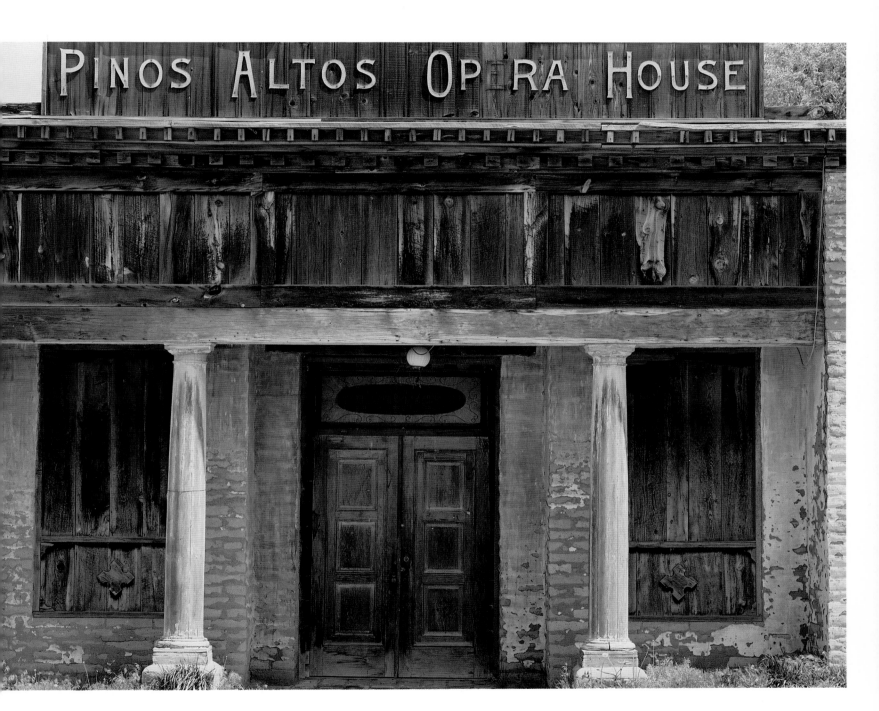

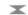

UPPER LEFT: AN 1880S MINING TOWN OF HILLSBORO.

LOWER LEFT: HISTORIC LINCOLN, WHERE

WILLIAM BONNEY, ALIAS BILLY THE KID, PARTICIPATED

IN THE LINCOLN COUNTY WARS.

FOLLOWING PAGES: MARCH SUN SKIPS ACROSS A

SAND DUNE ABOVE THE VALLEY OF THE LOWER RIO GRANDE.

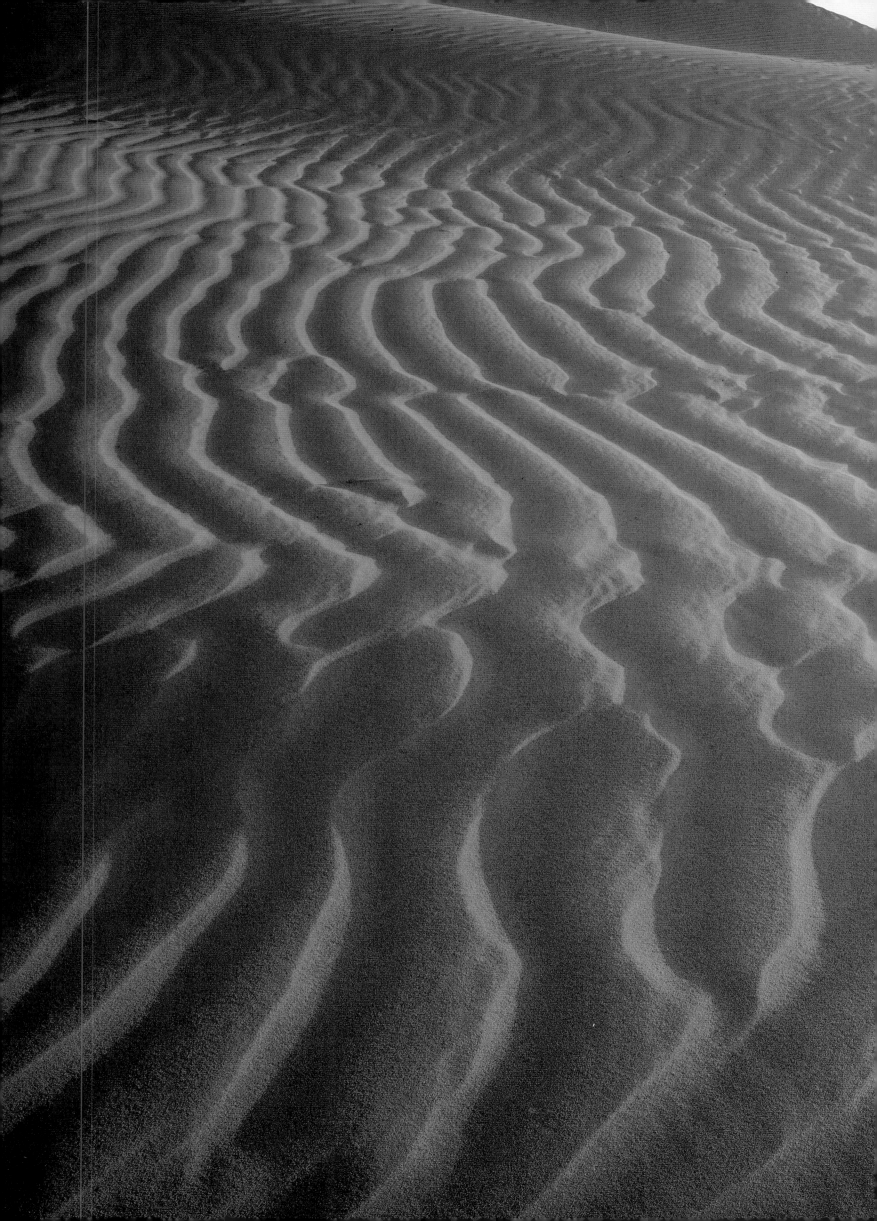

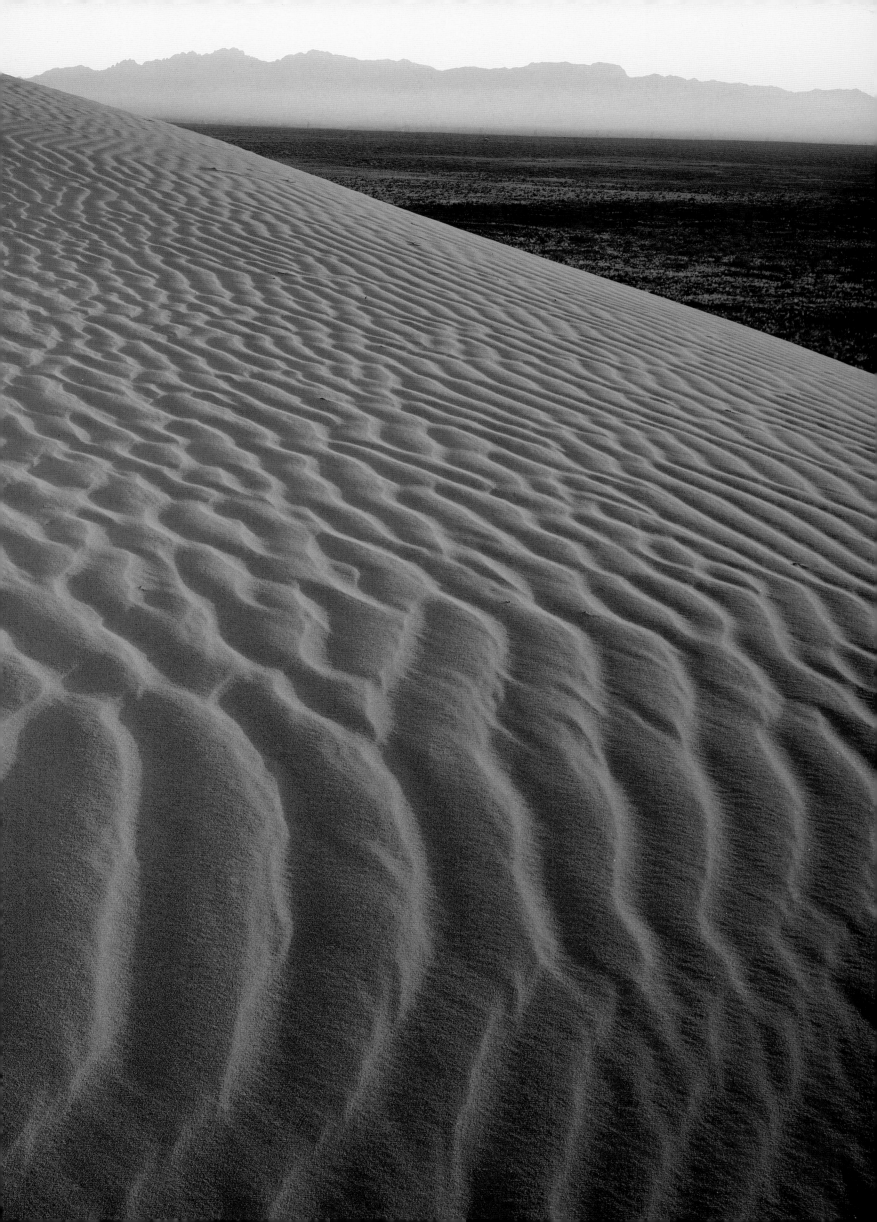

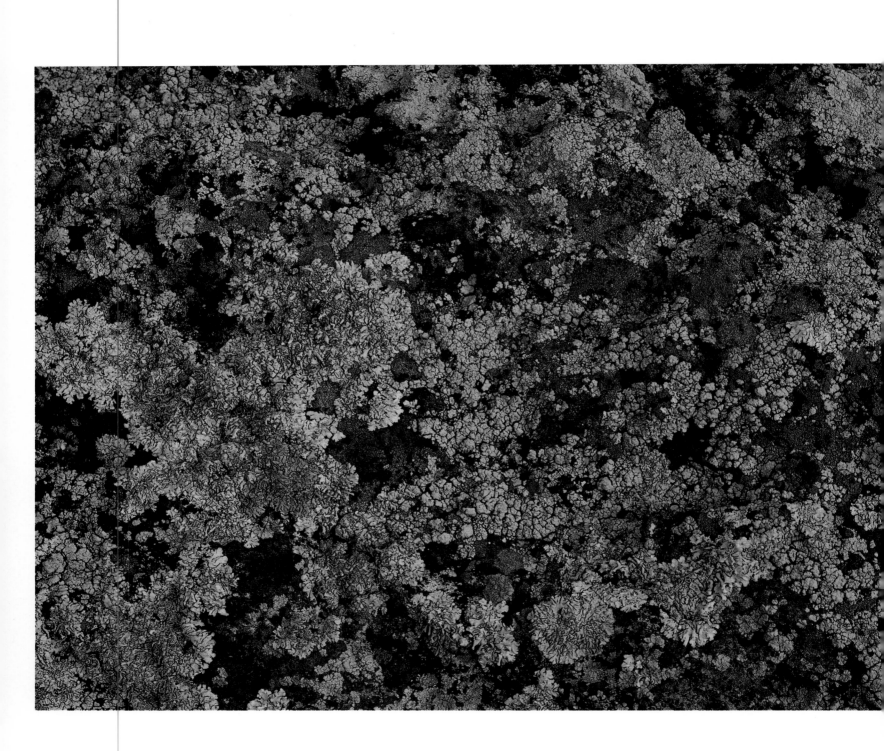

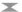

*BELOW: JAGGED VOLCANIC ROCK*

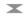

*FORMS THE EAST RIM OF ADON CRATER,*

*DONA ANA COUNTY.*

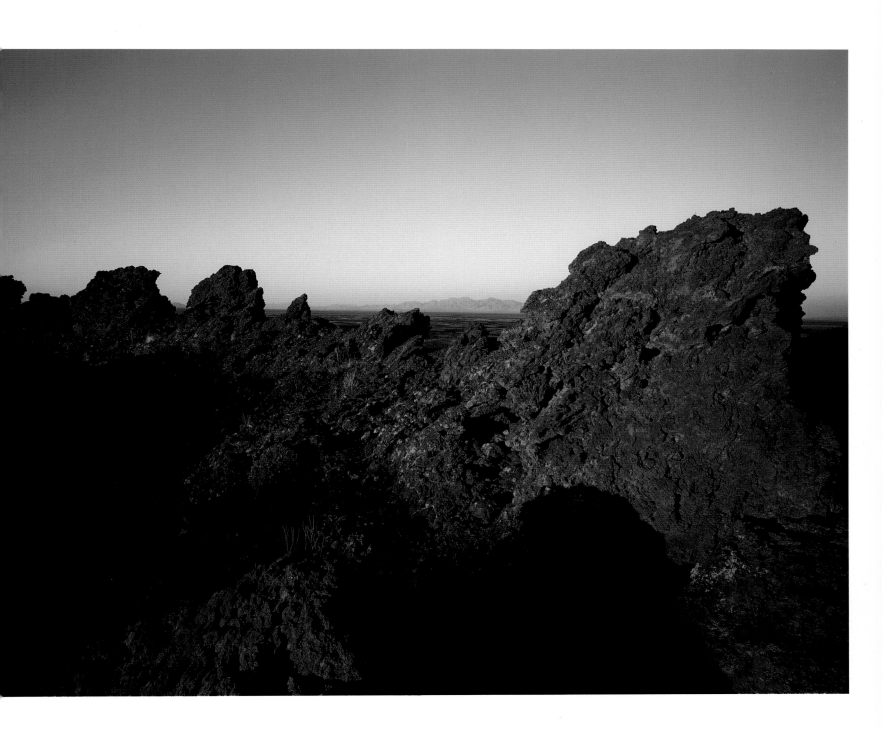

*LEFT: OVERLAPPING LAYERS OF LICHEN COAT*

*THE NORTH EXPOSURE OF VOLCANIC ROCKS,*

*ADON CRATER, DONA ANA COUNTY.*

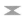

BELOW: A SOTOL PLANT HOLDS ONTO A VOLCANIC WALL

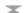

BELOW AN OPENING TO A DISTANT PEAK

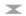

OF THE FLORIDA MOUNTAINS, NEAR DEMING.

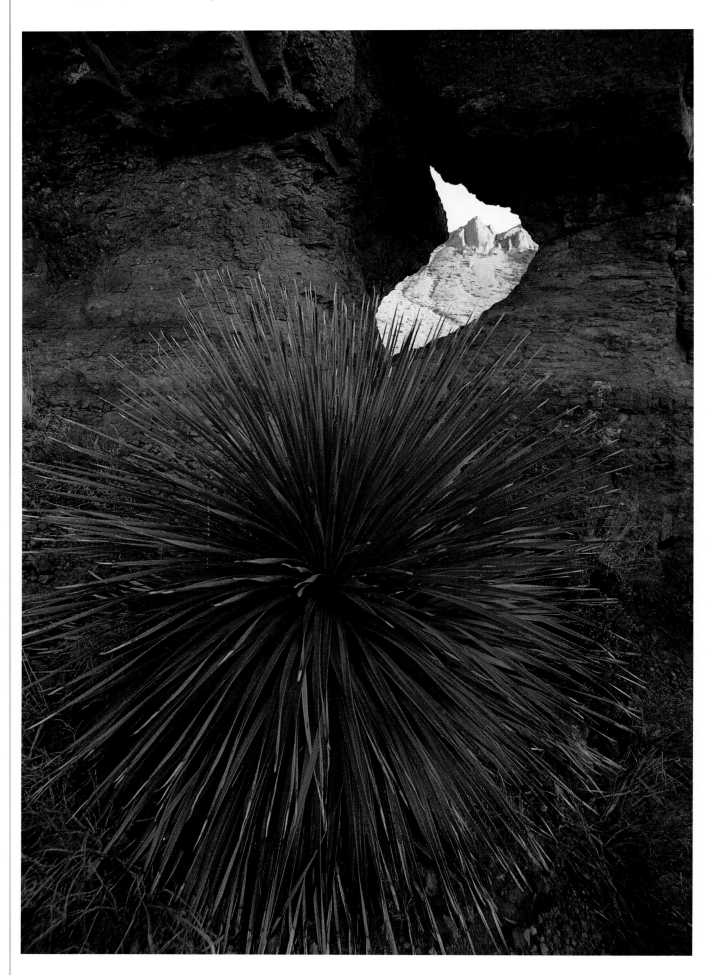

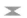

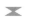
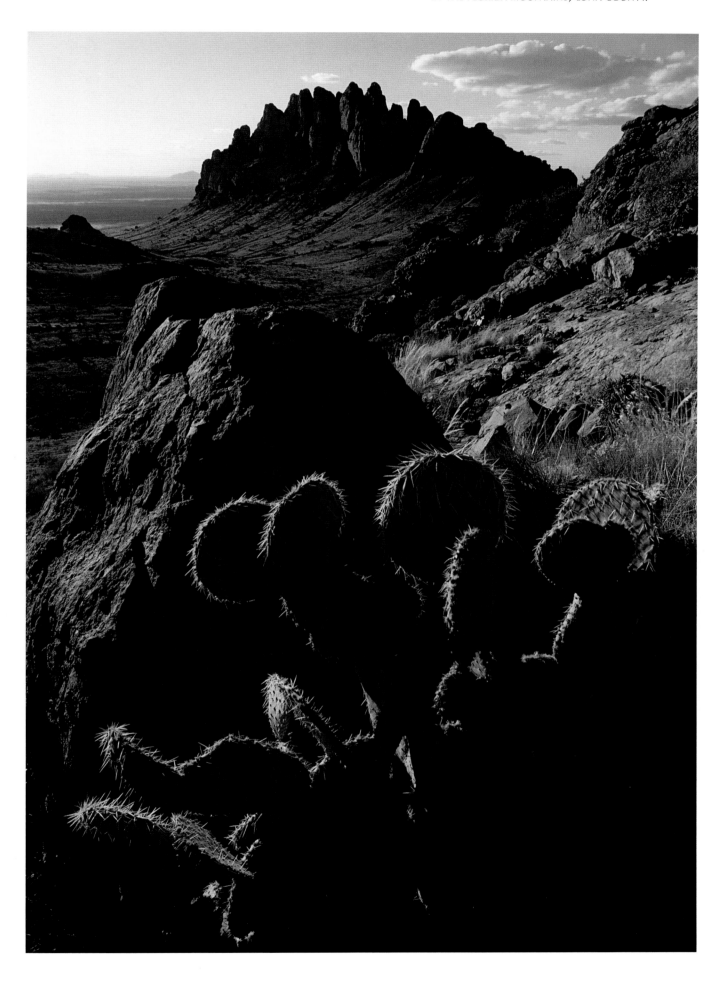

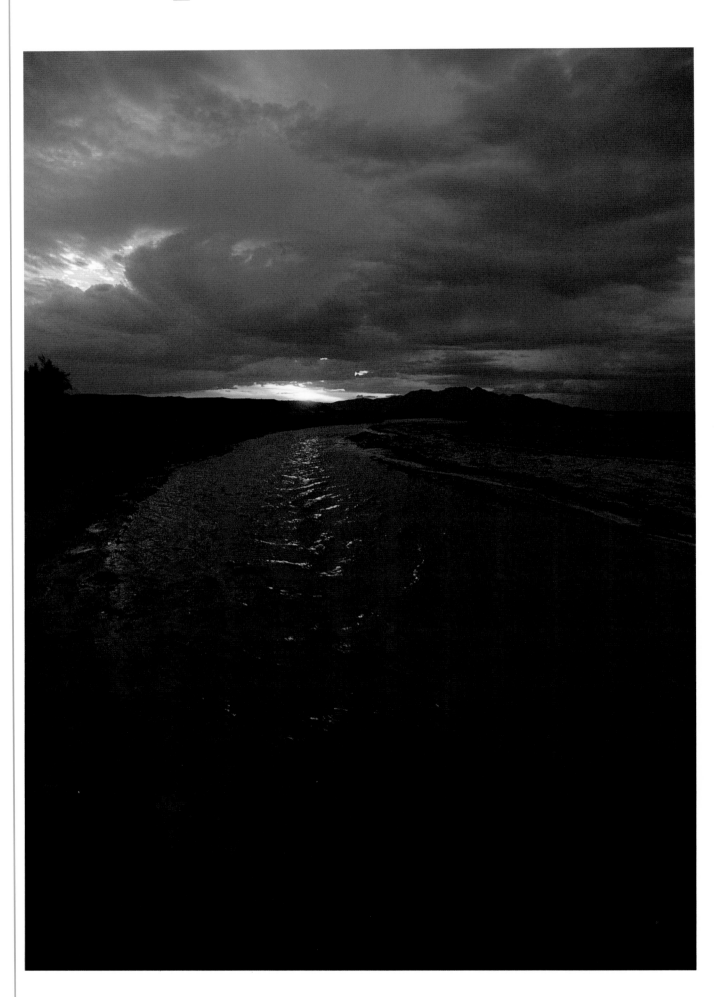

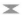

BELOW: A JUMBLE OF ROCKS AND THE SYMMETRICAL

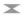

SHAPE OF COOKS PEAK BATHE

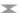

IN A DAWN GLOW, CITY OF ROCKS STATE PARK.

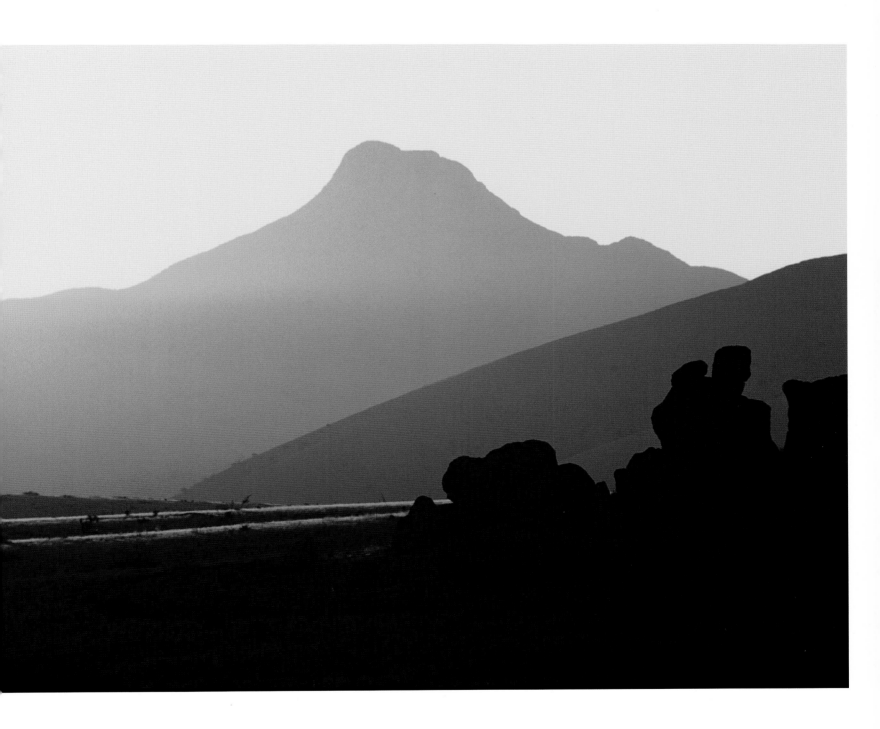

LEFT: A FLASH FLOOD RUMBLES ALONG THROUGH

THE NORMALLY DRY RIO SALADO WASH

ON A SEPTEMBER EVENING, SOCORRO COUNTY.

140

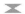

BELOW: AN ANCIENT ROCK FORM

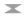

IS SILHOUETTED AGAINST THE MORNING SKY,

CITY OF ROCKS STATE PARK.

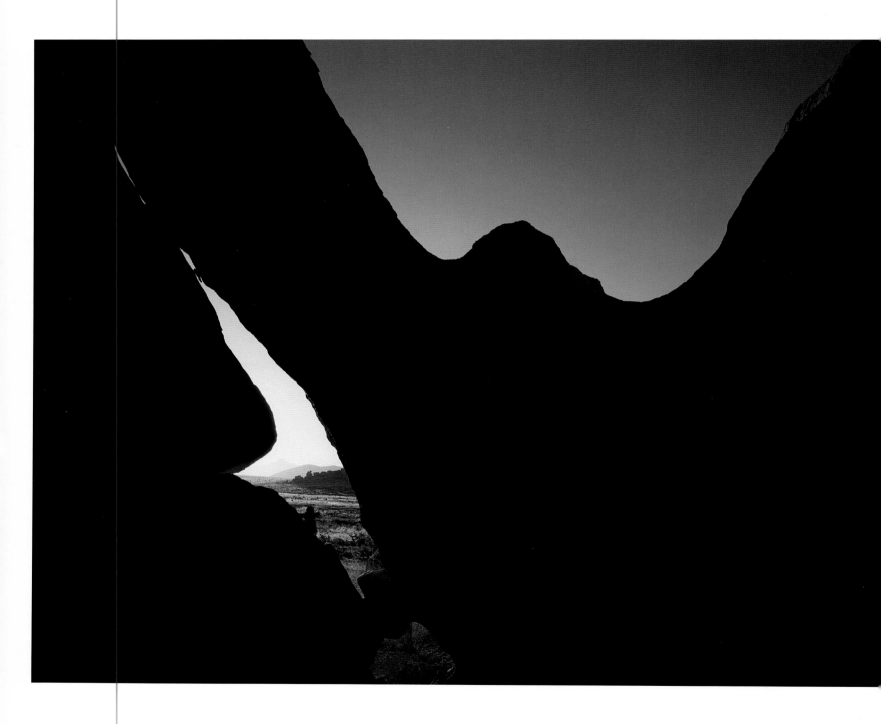

RIGHT: STAR PATHS ENCIRCLE POLARIS,

THE NORTH STAR, ABOVE A SCATTERING OF BOULDERS,

CITY OF ROCKS STATE PARK.

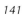
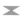
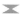

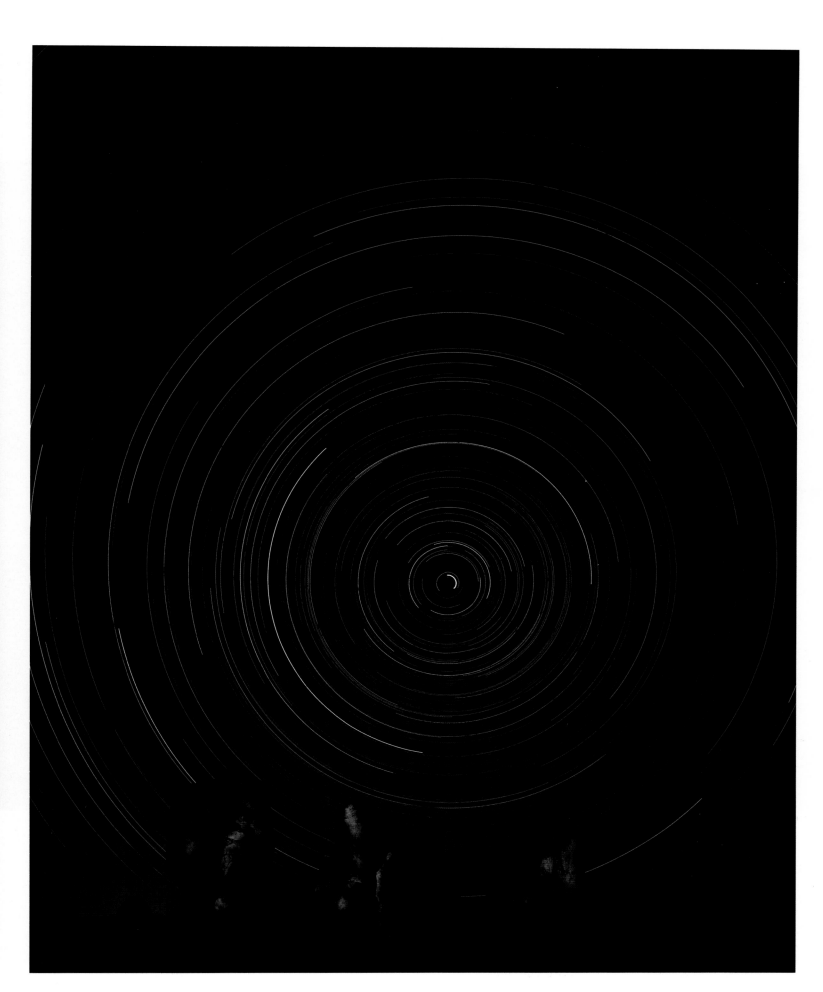

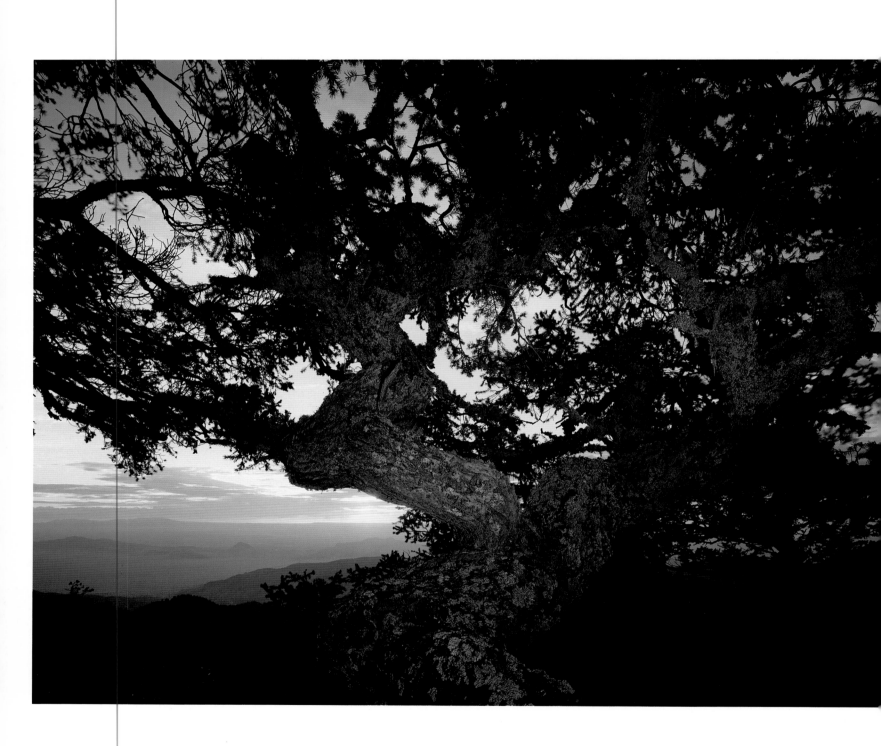

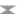

*LEFT: THE LARGE, SPRAWLING TRUNK OF A DOUGLAS FIR*

*HOLDS FIRMLY TO A LEDGE BELOW*

*SOUTH BALDY PEAK, MAGDALENA MOUNTAINS.*

BELOW: A PENSTEMON PLANT RADIATES A

DELICATE HUE ON A SLOPE OF VOLCANIC SCREE

IN UPPER POTATO CANYON, SAN MATEO MOUNTAINS.

THIS WILD MOUNTAIN CANYON COUNTRY

IS PROTECTED IN WITHINGTON WILDERNESS.

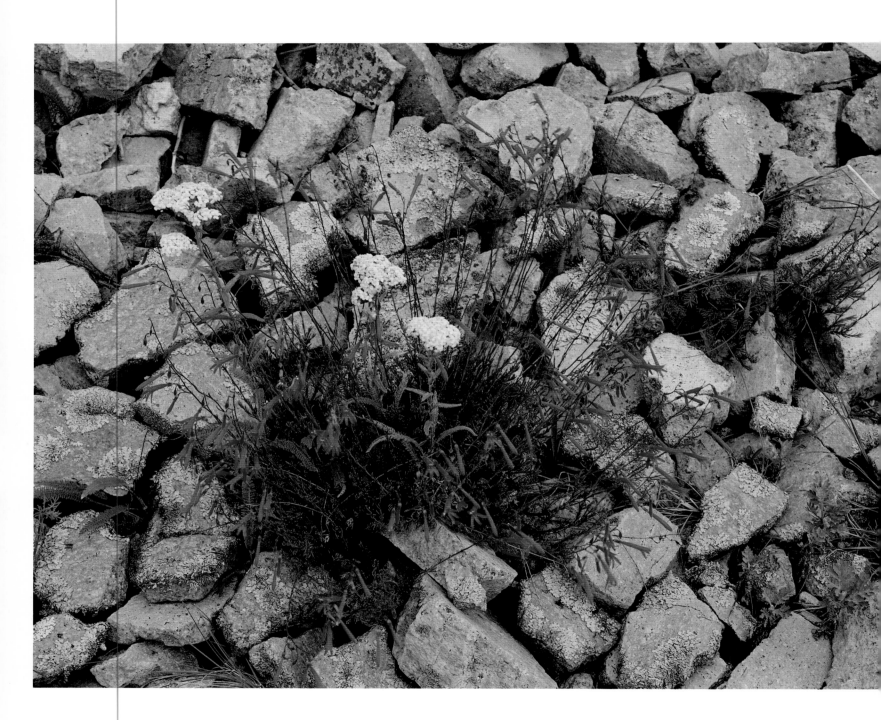

RIGHT: CANE CHOLLA FLOWERS OF LATE MAY

OCCUPY THE DRY SLOPES OF

SHIPMAN CANYON, APACHE KID WILDERNESS.

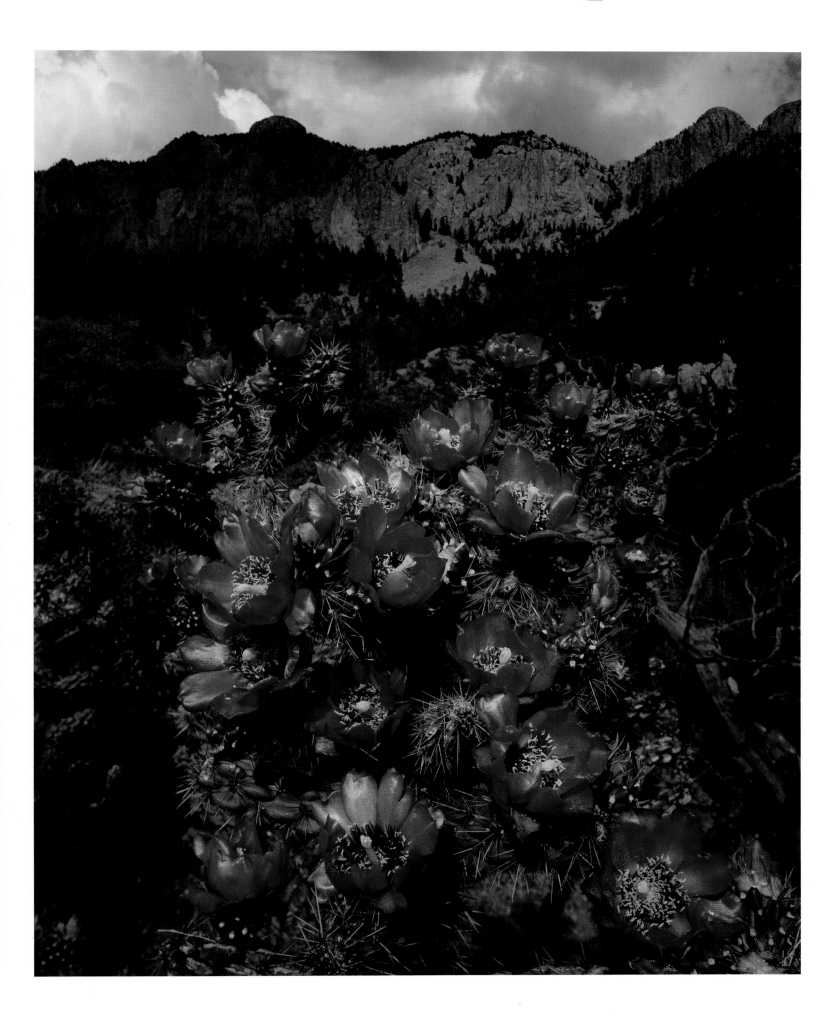

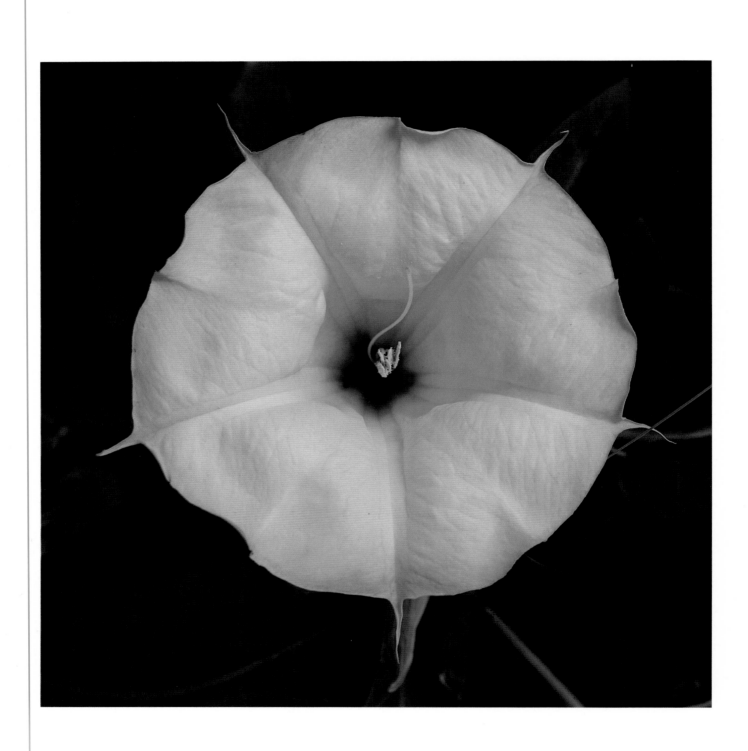

BELOW: YUCCA AND SACATON GRASS CATCH

FIRST LIGHT IN ANIMAS VALLEY, GRAY RANCH PRESERVE.

THIS HISTORIC CATTLE RANCH ON THE MEXICO BORDER

WAS RECENTLY PURCHASED BY THE

NATURE CONSERVANCY TO PROTECT THE GREAT DIVERSITY

OF FLORA AND FAUNA FOUND IN THIS COUNTRY.

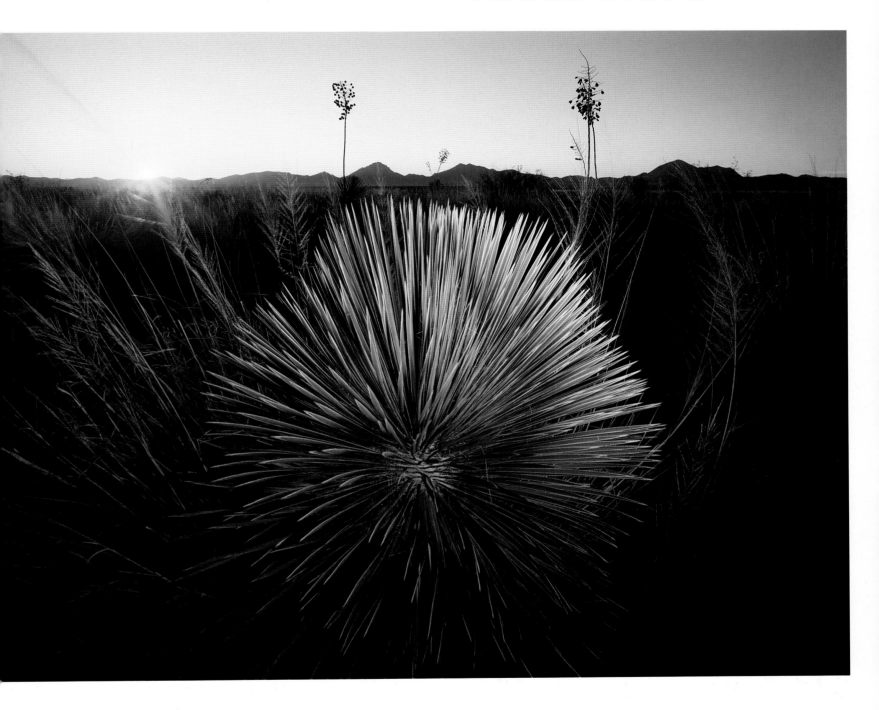

LEFT: A SACRED DATURA FLOWER GRACES THE SHADED

SIDE OF A CORRAL WALL, ON THE GRAY RANCH PRESERVE.

FOLLOWING PAGES: AN AUTUMN SKY AND GRASSLANDS

OF UPPER ANIMAS VALLEY EXPRESS A CLARITY

SPECIAL TO NEW MEXICO, GRAY RANCH PRESERVE.

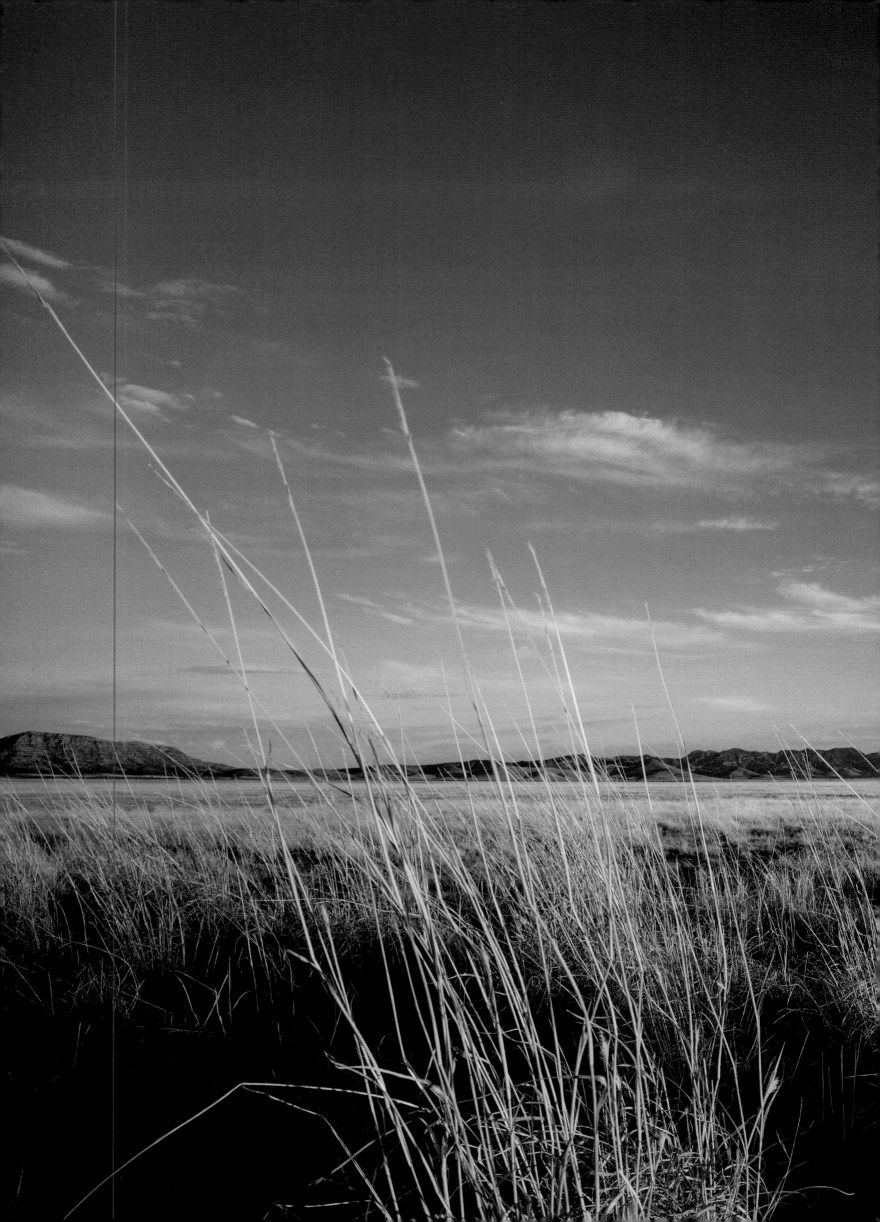

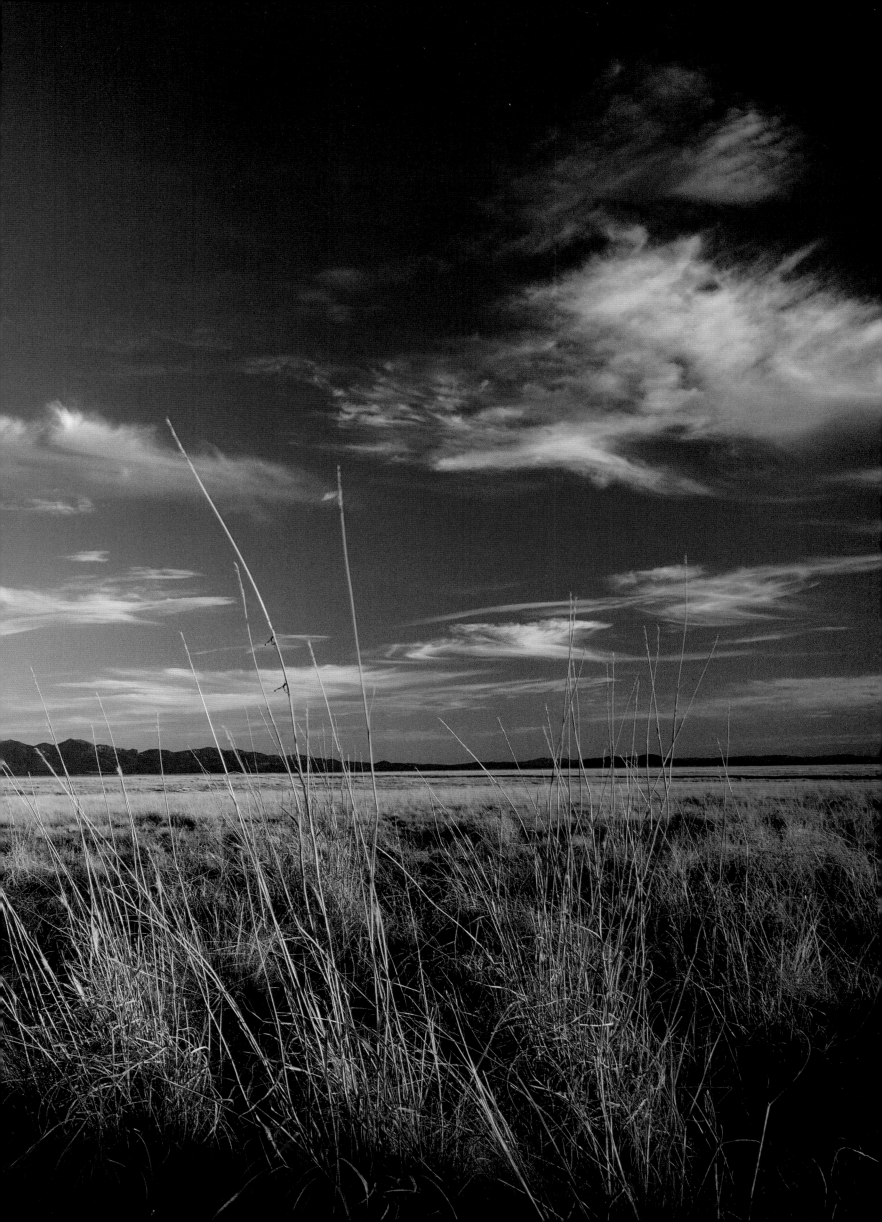

*BELOW: A WESTERLY WIND CREATES A RIPPLED SCULPTURE*

*IN THE LOWER RIO GRANDE VALLEY.*

*THE ORGAN MOUNTAINS ARE TO THE NORTH.*

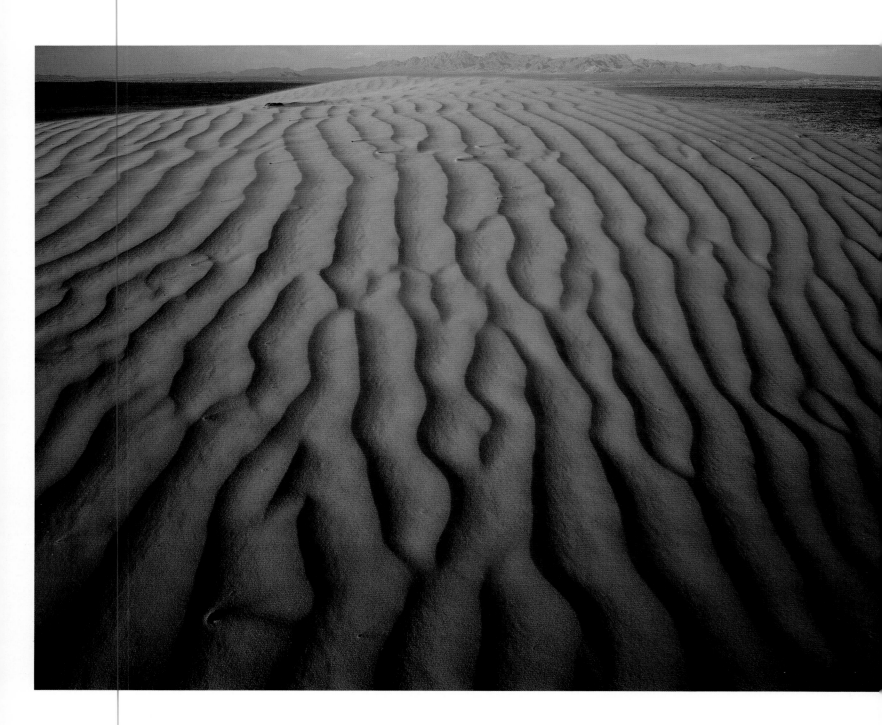

*RIGHT: RUSSIAN THISTLE, OR TUMBLEWEED,*

*GATHERS BEHIND A FENCE OF MESQUITE*

*AND SACATON IN ANIMAS VALLEY, HIDALGO COUNTY.*

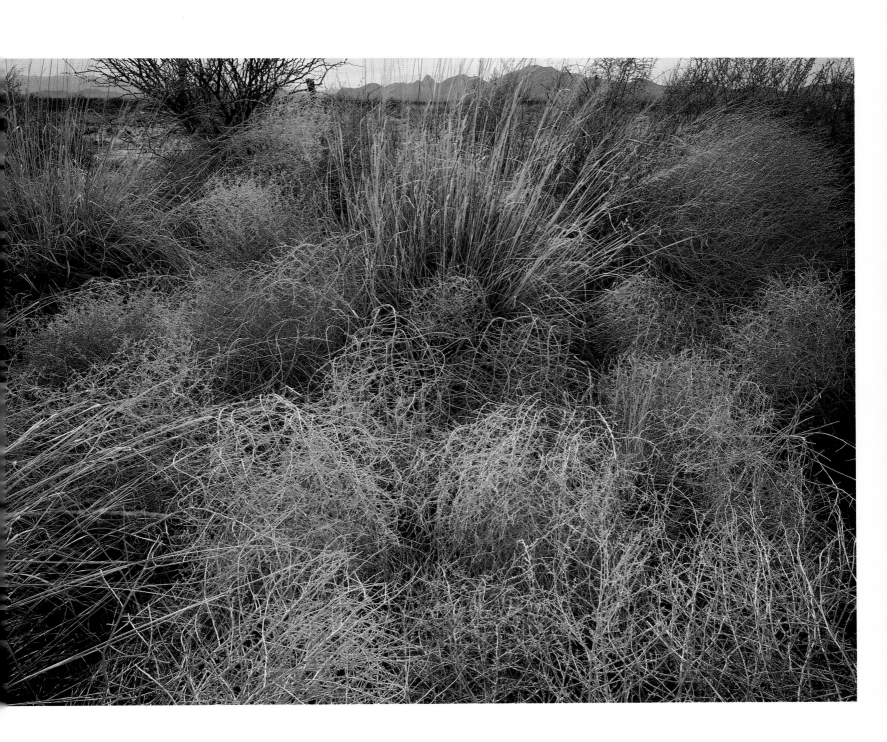

152

BELOW: BONY QUARTZITE AND LIMESTONE LEDGES

CATCH A SUMMER MORNING'S LIGHT ALONG

BIG HATCHET MOUNTAINS IN THE BOOT HEEL.

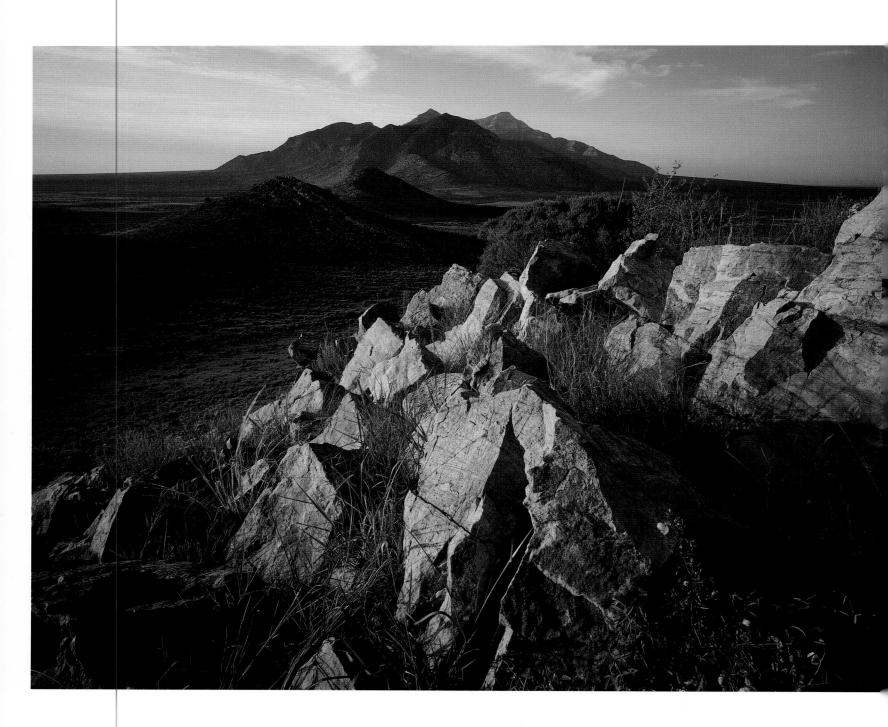

RIGHT: PLACEMENT OF ANIMAS PEAK AND STALKS OF

SACATON GRASS GIVE A SENSE OF SOLITUDE

TO AN AUGUST MORNING, GRAY RANCH PRESERVE.

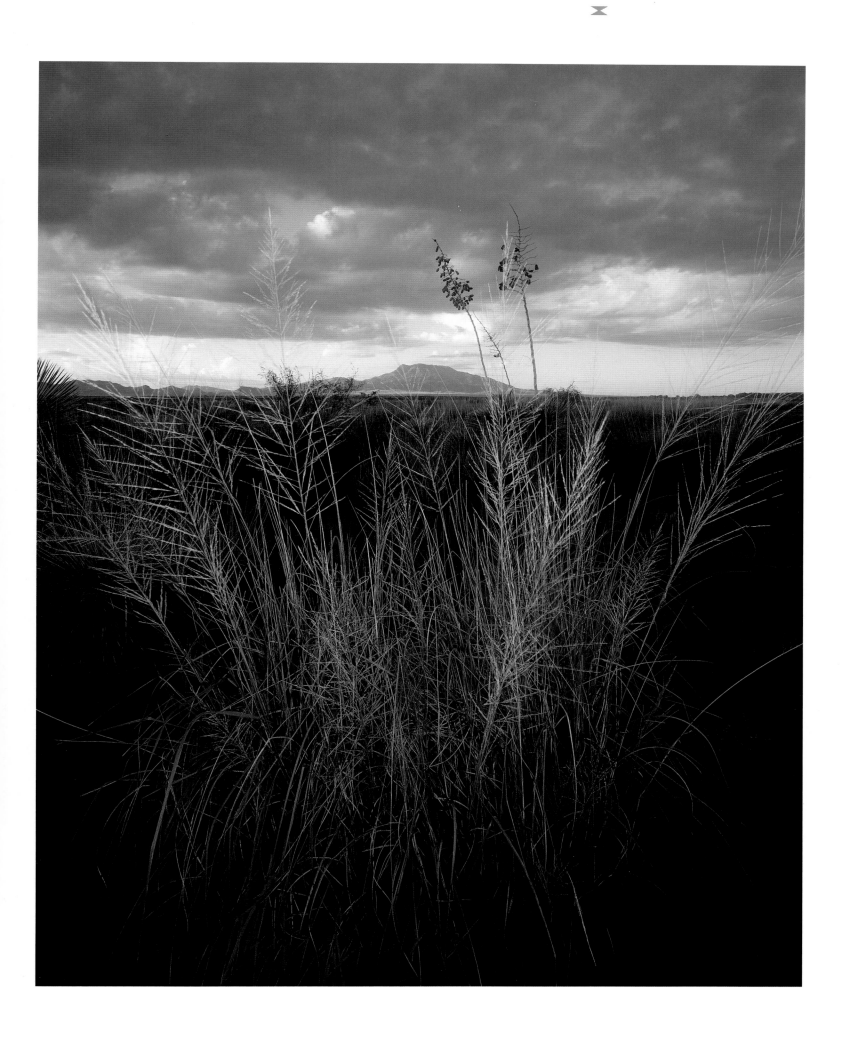

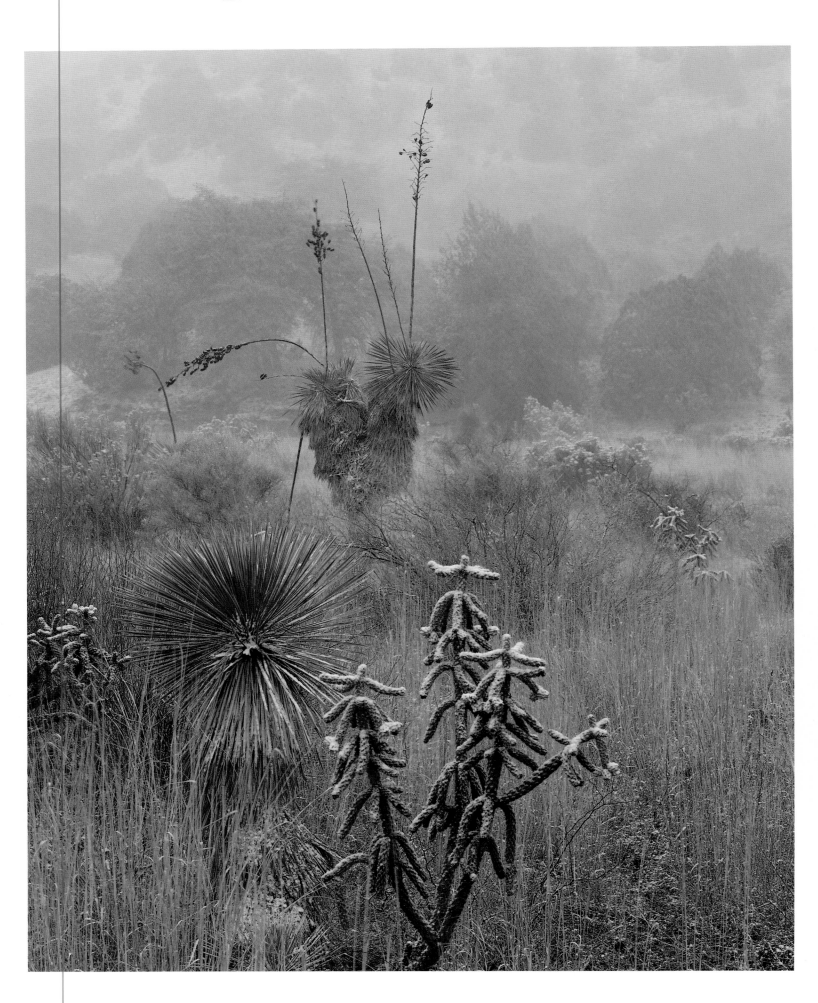

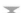

BELOW: EVENING THUNDERHEADS FLOAT PAST

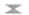

YUCCA BLOSSOMS ON THE WESTERN SLOPE

OF THE ANIMAS MOUNTAINS, GRAY RANCH PRESERVE.

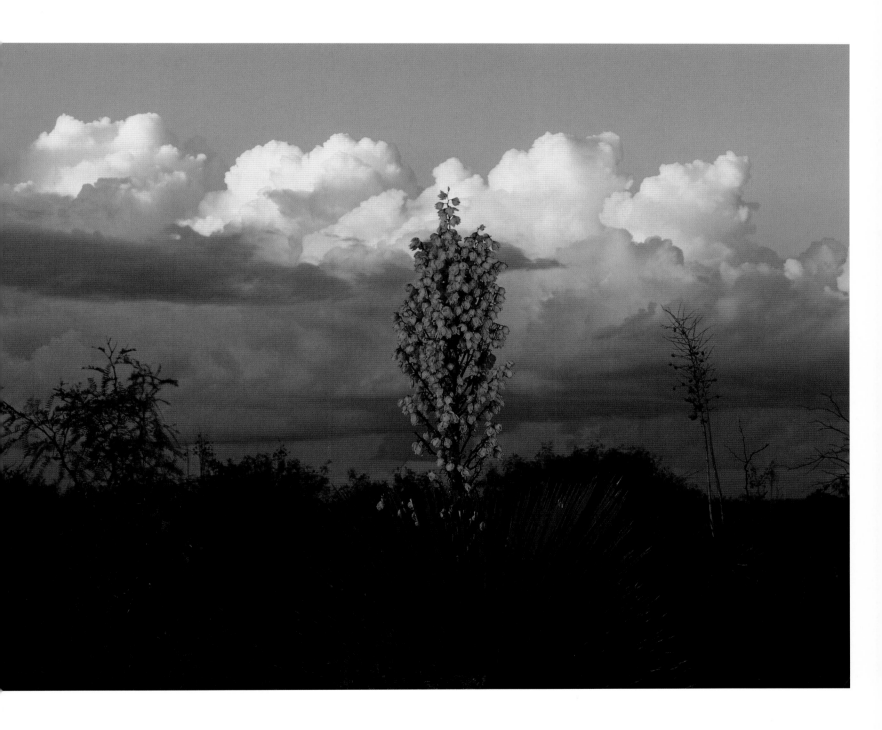

LEFT: A LIGHT NOVEMBER SNOW TRANSFORMS CANE

CHOLLA AND YUCCA PLANTS IN AN ARROYO

OF THE MIMBRES RIVER VALLEY, NEAR SAN LORENZO.

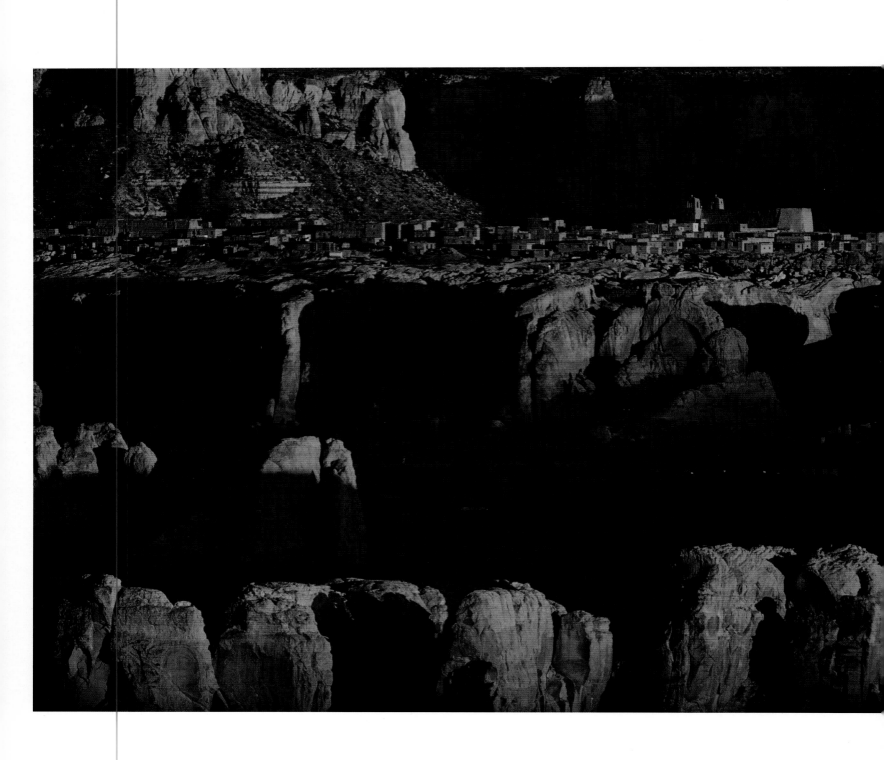

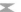
BELOW: A GLOW OF FEBRUARY DAWN MOON-SET HOLDS

THE STRIKING LANDMARK OF EL MORRO IN ITS GRIP,

EL MORRO NATIONAL MONUMENT.

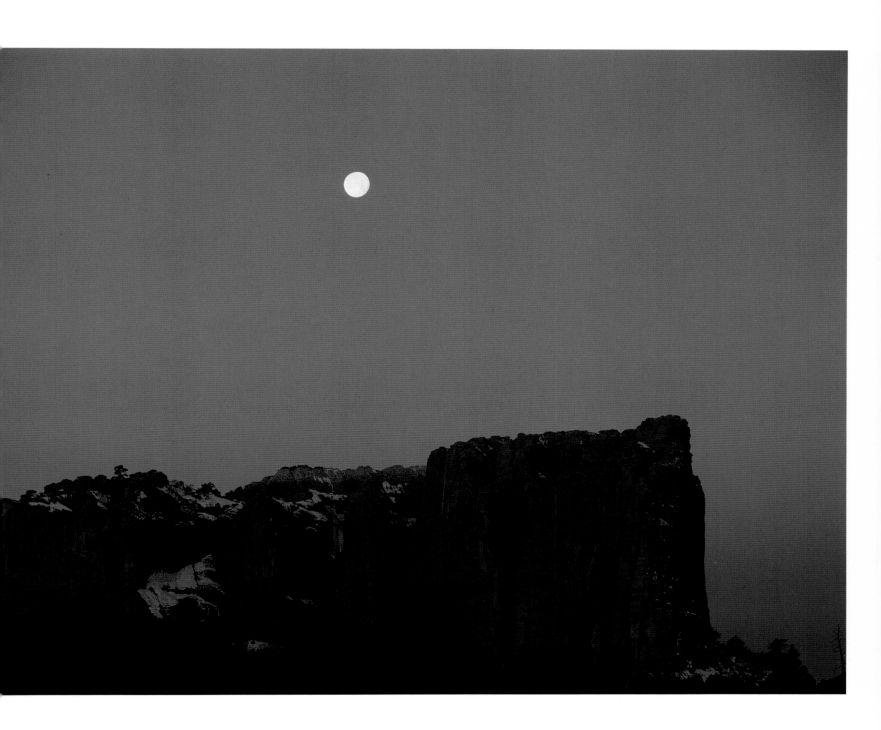

LEFT: THE PUEBLO VILLAGE OF ACOMA HAS OCCUPIED

ITS PLACE ON THIS SANDSTONE MESA TOP FOR CENTURIES.

THIS LIVED-IN, PREHISTORIC VILLAGE

HAS BEEN CONTINUOUSLY OCCUPIED SINCE A.D. 1073.

## ABOUT PHOTOGRAPHS AND PICTOGRAPHS

New Mexico is a land of stark, expansive beauty. Earth and sky come together here with a significant power. For me, the light intensifies both time and space. Subjects are elemental, sometimes magical, definitely challenging and inspiring. This collection of photographs is my personal journey in discovery and perception, where primal form is transformed by the light into a natural timelessness. To me, much of the landscape of the state is a sacred place.

At the beginning of this photography, I purposely attempted, as best I could, to clear my mind of the usual influences that have commanded much of the creative photography to date, allowing a more personal and intuitive response to emerge. The essence of the New Mexico landscape is found in its very ancient patterns; it is a challenge to see and feel them. This New Mexico portion of the Southwest is a more subtle blend of visual features than are those of neighboring Arizona, Utah, or Colorado. My focus became more a conditioning of mind than a facing up to dominant landforms like the Grand Canyon or Canyonlands.

These resulting photographs became my language. Included are what I call unsung places: forest wildernesses like Mogollon, Gila, Aldo Leopold, Sandia, Manzano, Magdalena, Sierra Blanca, Black Range, Jemez and Brazos, and Sangre de Cristo are, to me, all places unique and unsung in their remoteness. While wandering their many trails, I found a sense of the pristine. From these forest islands in the sky, streams enter the plateau, the desert, and the plains—a more familiar landscape with names like Jemez, Gila, Chama, Pecos, Mimbres, Cimarron, and Zuni. And finally, the famous Rio Grande flows from north to south.

Now a vanished people, the Anasazi achieved their architectural creations in ancient pueblo cities and placed their spiritual and mythological messages on stone—in arroyos and canyons. These petroglyphs and pictographs speak to us, through time, of water, clouds, sun, moon, animals, and birds. Visually, the landscape also shows the influence of the contemporary human fabric, the more recent Navajo and Apache lifeways, the Hispanic culture, and the Anglo traditions. I wonder what messages we will leave?

After numerous trips throughout New Mexico, a poignant awareness of cycles began to emerge. Fragments and parts of something whole came together in a circular continuum. Most obvious is the seasonal cycle of change. Mountain snows give way to a spring advent of flowering trees, on into summer desert heat, and then autumn transitions signal a time for the winter snow again to complete the cycle. Through the clear New Mexico sky travels the sun on its daily cycle, followed by the moon and stars on their track at night. Less obvious, though equally as absorbing for my photography, is the cycle of an architectural life. Taken from the clay earth, adobe that has been used for structures is in constant need of upkeep and repairs, or soon melts back into the earth from erosion caused by the elements of wind and rain. These cycles all join together to relate a beauty between inhabitants, the land and the sky. Photographing this landscape is actually another continuing cycle to this beauty and harmony. Seeing forms and textures with light creates the photograph through lens and film. This is a vehicle of expression with the process of creation continuing to the eye and mind of the viewer.

A few notes on sequence and presentation of the photographs may be of help to the viewer. Presentation of the photographs

BELOW: A CONTEMPORARY PLATE

BY POTTER REBECCA LUCARIO OF ACOMA

DISPLAYS LIZARDS, BEETLES, BUTTERFLIES, BIRDS,

TURTLES, AND FISH THAT INHABIT

THE EARTH, SKY, AND WATER OF NEW MEXICO.

 circle of imagery from the four directions, beginning in the
 thwest, followed by the northeast, southeast, and parting with
 southwest.

 speak through my work. Also, sensitivity of seeing is given to
 grand landscape along with smaller features; details of the
 d we often miss, are integrated to accompany and to empha-
 a connectedness. A landscape photograph, I feel, conveys
 espect for the land, serving as inspiration and motivation to
 ture and care for these places. I hope our combined efforts in
 volume will help to pique an awareness of, and caring for, the
 Mexico landscape.

 here are a few comments I should make relating to the equip-
 nt and film used to make these photographs. The films used
 Ektachrome, Kodachrome, and Fujichrome. The cameras that
 used primarily are: for large format, a Linhof Teknika (4" x 5");
 middle format, a Pentax (6 x 7 centimeters); and for small
 nat a Leicaflex (35mm). Lens focal lengths are represented
 75mm through 800mm with 4" x 5" work; 35mm through
 mm with the Pentax, and 21mm through 560mm with 35mm
 k. A polascreen, 81A and CC5R filters are used sparingly to
 slight gap between what exists naturally and what the films
 ally record. A tripod is used in most instances.

 acknowledgement, a special thanks to Marc Muench for his
 tographs on pages 21, 22, 51, 57, 64, 65, 66, 67, 77, 117, 131;
 to Zandria Muench for her photographs on pages 1, 46 center,
 ower, 62, 74, 75, 159. My deepest gratitude also goes to the
 helpful folks in the National Forest Service, Bureau of Land
 nagement, National Park Service, and New Mexico State Park
 es who were most enthusiastic and supportive.

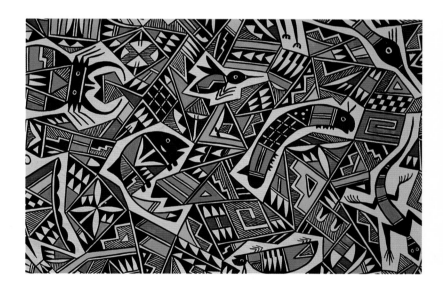

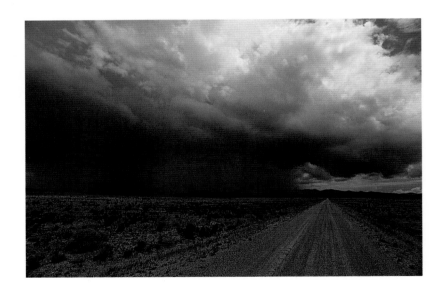